ELEGY
LANDSCAPES

ELEGY LANDSCAPES

Constable and Turner
and the Intimate Sublime

STANLEY PLUMLY

W. W. NORTON & COMPANY
Independent Publishers Since 1923
NEW YORK | LONDON

For information about permission to reproduce selections from this book,
write to Permissions, W. W. Norton & Company, Inc.,
500 Fifth Avenue, New York, NY 10110

For information about special discounts for bulk purchases, please contact
W. W. Norton Special Sales at specialsales@wwnorton.com or 800-233-4830

Manufacturing by LSC Communications, Harrisonburg
Book design by Helene Berinsky
Production manager: Anna Oler

ISBN: 978-0-393-65150-8

W. W. Norton & Company, Inc.
500 Fifth Avenue, New York, N.Y. 10110
www.wwnorton.com

W. W. Norton & Company Ltd.
15 Carlisle Street, London W1D 3BS

1 2 3 4 5 6 7 8 9 0

For Duncan Wu

Acknowledgments

My endless gratitude to my editor Jill Bialosky, whose continued support makes all the difference. And equal thanks to my agent Rob McQuilkin.

And thanks to David Baker, Michael Collier, Howard Norman, and David Wyatt for their close reading of this book in manuscript.

Thanks, as well, to Drew Weitman, Pierce Brown, and Amanda Allen for their technical help.

Especial thanks to the Graduate School and the University of Maryland for their ongoing support.

Margaret Plumly's contribution goes without saying.

Having looked at a work of art, I leave the museum or gallery in which it is on display, and tentatively enter the studio in which it was made. And there I wait in hope of learning something of the story of its making.

—JOHN BERGER

PREFACE

John Constable (1776–1837) and Joseph Mallord William Turner (1775–1851) are almost exact contemporaries and are, invariably, linked in their association and rivalry within the grand tradition of English landscape painting. Both are credited, by different admirers, with a major influence on the subsequent Impressionist movement and even Modernism itself. As artists, they span the Romantic period of Wordsworth, Coleridge, Shelley, and Keats, and survive into the era of Victoria. They are each considered to be England's supreme landscapists—indeed, they are thought to be two of the greatest landscape painters regardless of nation or generation.

Critics and fellow artists generally choose one over the other. As recently as 2002, English artist Lucian Freud curated a large selection of Constable for a Paris exhibition, commenting that "in Constable there is no false feeling. For me, Constable is so much more moving than Turner because you feel for him, it's truth-telling about the land rather than using the land for compositions which suited his inventiveness." For others, Turner's "inventiveness," his transformation of landscape into the constituents of light, his drive

and search for the sublime in the least as well as the great of his sources, and his visionary range in the use of his materials set him apart. Constable is a pastoralist; Turner both an urban and hinterland pastoralist. Constable is a homebody, committed to his boyhood memory; Turner is a wanderer, committed at once to history and experiment. Constable seeks stability; Turner, survival.

Turner's advantages are several. He outlives Constable by some fourteen years, and does much of his most original work in this final phase. He also starts younger and with more success than Constable; indeed, Turner becomes, at twenty-six, the youngest artist to ever achieve full academician status in the Royal Academy. Constable will have to wait until he is in his fifties before he receives full Academy admission. In addition, Turner is a traveler, first throughout Britain, then, again and again, throughout the natural wonders and cultural centers of Europe, all of which, in one way or another, figure in his art. Turner's travels underscore the variety of his subject matter and method as well as the sheer volume of his total output—100 finished paintings; 200 "unfinished" paintings; 20,000 sketches, drawings, and, most especially, watercolors: Turner's watercolors are unsurpassed. Constable, on the other hand, is a purist and in important, perhaps profound ways, a provincial. He understands that his identity as an artist is directly tied to the locus of his limitations, his talent to the landscape of his heart. He develops his art over time and achieves it within an extremely circumscribed homebound agricultural space: he is into his thirties before he begins to find himself as a painter and into his forties when he paints the first of the six great Stour Valley landscapes—*The White Horse*—that he hopes will secure his "immortality."

Turner is apolitical and otherwise agnostic; Constable is a Tory,

who says of the 1831 Reform Bill, that if passed will "give the government into the hands of the rabble and dregs of the people, and the devil's agents on earth . . ." which is an odd opinion coming from an idealist of the country life and country labor. Turner sells his work and becomes a wealthy if tightfisted artist, though, depending on the cause, he can be generous. Constable, who unlike Turner, comes from modest wealth, sells very little of his work, and for not enough of a price. For much of his life, Constable struggles to support his wife and seven children. Turner is famous, Constable hardly heard of; yet by the time of his best work, Constable is celebrated in France as an innovator. Turner is a popular and powerful member of the Academy; Constable is thought of, if at all, as a bit of a prig, who has too many things to say about his fellow artists. The list of differences goes on.

One important difference is that though Turner may be eccentric he is also outgoing; he moves in the world with conviction but, at the same time, with flexibility. His personal life may be private, but his public life is available. Constable, however, is a man of melancholy, who keeps his own counsel. Turner remains unmarried, while Constable needs a family as a stay against his loneliness. Turner, for all the enormous personality of his art, is, when all is said and done, a very practical man; Constable's stuffiness belies his true Romantic nature—he is a poet of the fact of what is in front of him, enhanced by the fact of how he enriches it. He is a fan of Wordsworth. It is believed that Turner is partly responsible for the annual blackballing of Constable's Academy admission to full status; in 1831, once his full admission to the Academy is complete, Constable "uses his position on the hanging committee . . . to replace a picture by Turner with one of his own" (Venning, 2003). Constable

may admire Turner, but Turner does not return the compliment. They are not friends.

My interest in their comparative stories has different beginnings. For one, when they are talked about together it is usually for a brief moment in a brief analysis, and almost always within the context of English and European landscape art, its shared traditions and their relevance to those traditions. Only Anthony Bailey (1998, 2007) has written extensively about each of them, in separate biographies. For another, I found that the idea of the opposing thumbs of Constable and Turner is given credit for similar results—that is, the Impressionists. I thought this apparent contradiction to be both curious and compelling. For a third reason, I realized, after years of looking at their art on the walls of museums all over the world, that they are locked together in time—they are, together and apart, originals who change the subject of what landscape painting is. And as things developed, my chief interest became focused on the fact that ultimately, when their work moves in a different direction, they share an equal motive: the deaths of the two people whose loss changes them.

For Constable, it is the long-suffering illness and death of his wife. For Turner, it is the death of his loving and devoted father, who has served as both parents in the artist's seminal years. The work, for each of these artists, as associated with and after these losses, takes on a more personal, more intimate, more subjective tone: the line fades in favor of the forms, the colors mute into the totality of the light. For Constable, it is the growing abstractionism of what has been immediate in his art: more "snow" as the manifestation of light, more material complexity and ambiguity, and more to look at and therefore more to see, one example of which is his two-year outdoor Hampstead studies of clouds while only a few

minutes away, in their Upper Terrace home, his wife is off-and-on dying. For Turner, it begins with the sacrifice of the detail of the landscape subject altogether, as it is absorbed into the reality of the sun, as if he, the artist, is entering the projected space of the painting in order to join the art of it all itself. Turner, at the end, is completely at one with what he is seeing.

Both of these painters ask us to watch as well as comprehend their paintings; both ask us to stand or sit in front of the best of their work—and at the right distance, within a moment of contemplation—in order to realize how unique that experience is. Turner is commonly regarded as the "more original" of the two, but that perception confuses the matter with the means. Constable remakes the tradition of landscape painting by revaluing the relationship of its parts to the whole, by breaking it down into brushstroke and warm color, and by seeing, as if for the first time, the new in the familiar. Turner is, in the end, more Symbolist than Romantic: he attempts to change what landscape painting is through the disappearance of the line and the exploration of color and the ongoing discovery of light. He is, finally, more interested in the self-reference and self-containment of a work of art than in its connection to the narratives outside it.

February 2017
FREDERICK, MARYLAND

ELEGY
LANDSCAPES

Yes, sir, this is Constable's country.

"An angry neighbor has killed my fine black cat, who used to call me up in the morning, but she had been naughty, and killed one of his ducks. . . . In the coach yesterday, coming from Suffolk, were two gentlemen and myself, all strangers to each other. In passing the vale of Dedham, one of them remarked, on my saying it was beautiful, 'Yes, sir, this is Constable's country.' I then told him who I was, lest he should spoil it"—this associative moment is from a November 14, 1832, letter to John Constable's fellow artist David Lucas. So many things come together between the lines here, three of which are: the fine black cat is part of the Constable household at Well Walk in Hampstead, which is still, in 1832, a country village with plenty of pigs, cows, ducks, and kitchen gardens; Constable is on his way back home from home, so to speak, having attended the funeral of his old friend and mentor John Dunthorne, in East Bergholt, Constable's birthplace; and Lucas is the painter's patient engraver, who has been tasked with transforming several of Constable's paintings into mezzotints.

In a way, an abbreviated outline of Constable's whole life is at

play in this small moment, a moment slipped into a much fuller newsy letter, implicating where Constable has his roots ("the vale of Dedham"), evoking the person who has helped him get started as an artist (Dunthorne), implying his artistic standing of where he is in his thirty-year career (respected but with reservation), and indicating—for more than one reason—the place where he is mostly residing (Hampstead). Interesting as well is Constable's correspondent (Lucas), who, now, acting as a kind of agent in the great artist's later life, is attempting to make more popular Constable's "provincialism," his Dedham Valley subject. And mixed, silently, among these facts of a lifetime is a good deal of recent death, including that of his wife, Maria, his two best friends (John Fisher and Dunthorne), an early supporter (George Beaumont), and a good many of Constable's Royal Academy colleagues and competitors, most of whom hold him in too little regard, a truth in itself that may or may not be behind his odd response to his fellow-traveler's compliment that this Suffolk countryside has taken on his art as a part of its identity. It is as if Constable is fearful this stranger will "spoil" the compliment with qualification: if he knows who Constable is, more than likely he will keep any complaints to himself. Constable is a long critic of any number of his RA contemporaries, though he is chary of receiving the same from anyone who doubts his achievement. His is a personality that does not invite great warmth.

The valley this little assembly is passing through is defined by the more than a fifty-mile wander of the River Stour, on either side of which is Suffolk, on its left bank, and Essex, on its right. The river rises in Cambridgeshire and works its modest way to the estuary at Harwich, and into the North Sea. There are fourteen locks along its lower half, two of which, near Dedham and at Flat-

ford, figure large in Constable's father's and now younger brother's milling business and some of the artist's most important paintings. Historically, late eighteenth- and nineteenth-century England is a pastoral, green country, an apparent grace note whose agricultural economic reality is emphasized and intensified by what, in stark contrast, has become the Industrial Revolution, as mapped in the dark environs of various Midland cities and working-class towns in addition to the manufacturing commerce floated on the Thames in its wide meander through the middle of London. On the extreme political left, William Cobbett pushes—exaggerates?—the theme of agrarian exploitation even further, writing, in 1823, that in "this beautiful island every inch of land is appropriated by the rich. No hedges, no ditches, no commons, no grassy lanes: a country divided into great farms; a few trees surround the great farmhouses. All the rest is bare of trees; and the wretched labourer has not a stick of wood, and has no place for a pig or cow to graze, or even to lie down upon." Where is the beauty of "this beautiful island" if it is sorely limited to "a few trees" around a great house?

In spite of Cobbett's radical if grim assessment of a treeless, pastureless English countryside, pastoral, at this time, in Constable country, also means a healthy labor of another crucial kind: the business of cattle, sheep, and horses; the work of pasture, fields of grain, hedgerows, and wooded areas; the connected worlds of village-size communities, with slow road and small river traffic (whether it be corn or coal or livestock to market); the social life of known and near neighbors, landownership and tenant farmers, and the fenced division of property; and the day-in, day-out rhythms of sunrise and sunset, the workday measured by the length and temperate quality of the seasons. Pastoral, as an ideal, can also mean an appeal to nos-

talgia, to "a green thought in a green shade," to something golden, Virgilian, under the glass dome of the sun, as well as to something actual, such as great century white oaks and maples, common ash and elm, copper beech and weeping willow, and estate lawns the sizes of fields, bordered with chamomile and campion, mullein and thistle. It means longing for what is vanishing—if not vanished— regardless of whether or not, as a fact let alone as an idea, it ever existed, while, down on the ground, it means the spring planting, the summer growth, the autumn harvest, the winter wait. Constable's "broken ruggedness of . . . style" seems to lie on the other side of Cobbett's existential vision in favor of memory and possibility.

As they coach through Dedham Valley along the River Stour, on the way back to London and Hampstead, Constable's admirer seems to be trying to define, in name, "the nature of the beauty" he is looking at, nature and beauty not necessarily the same thing: one, implicitly organic; the other, explicitly aesthetic. The admirer, sitting there with only the frame of the coach window to shape what he is seeing, is, in effect, in two worlds at once—the one in his eye at the moment and the one in his mind's eye, from the memory of one or two Constable paintings. He is, of course, making a quick imaginative leap between the two. Constable appears to be a bit worried that this stranger might find some artistic fault in making and naming the connection between the reality of the landscape he is looking at as opposed to its rendered image. In terms of paint applied to canvas intended to effect the illusion of three dimensions, are we talking realism or naturalism or something else altogether? The admirer, doubtless, is thinking of, or is remembering, one or more of Constable's so-called six-footers, the large Stour landscapes inspired by this part of Constable's birthplace countryside, the land-

scapes sometimes referred to as his sequence of "river paintings"—
work that has been more or less completed over a period of six years
(1819–1825) and annually displayed, with mixed hopes, on the busy
walls of the Royal Academy.

Constable country is, however, as much Constable's agricultural
father's as it is his artist son's. Golding Constable is not only a mill
owner but a grain merchant and farmer of ninety-three acres of this
rich and scenic part of southern Suffolk, with its sandy soil and mild
climate. It is his father's land and the land around it that becomes the
view and vision within the paintings, which makes its substance a
kind of palpable inheritance, like property and bloodlines. The land
and its way of life define Constable's childhood, and childhood—
its understanding as the emotional first take on the world—is at
the heart of what makes Constable an artist: this primary personal
bond with the deep detail of his local landscape is the correlative
that rescues his art from cliché. First and last, over the course of
his career, Constable returns to this source as an archetype—as the
ground and grounding of his imagination, but also as the *spiritus
mundi* of the meaning of what he sees. In the sense of father to son,
the River Stour and Dedham Valley and the working life they rep-
resent become his parental as well as elemental realm. At the open-
ing of his *Two-Part Prelude*, Wordsworth asks, "Was it for this, /
That one, the fairest of all rivers . . . / from his fords and shallows,
sent a voice / That flowed along my dreams?" That same sort of a
haunting rural river voice turns dynamically visual in Constable.

*I associate my "careless boyhood" to all that lies
on the banks of the Stour. They made me a painter.*

T*he White Horse; Stratford Mill; The Hay Wain; View on the
Stour, Near Dedham; A Boat Passing a Lock;* and *The Leap-
ing Horse* comprise the sequence of six six-footers Constable will
come to believe constitutes his possible immortality—and they are,
like Keats's six great odes, a signature achievement—though, because
time is relative, the six years Constable will spend on this river project
will, for Keats, amount to only six months, which argues the differ-
ence between living long and dying young. Except for the *Boat Lock*,
each painting in the Stour sequence is horizontal in dimension—left
to right—while even the lock picture has width, the difference being
the proximity of the close-up view of the lockkeeper's body as he
struggles with the weight of the windlass at the gate. The other paint-
ings in the series take on a broader, longer perspective; they see more
across the plane of their vision than *into* the depth of that vision. But
all six of them are about common labor or leisure to one degree or
another, and all hold the moment of stasis of what that work or that
rest from work is about, without being static or theatrically posed—

indeed, in each of them you feel the potential of the action about to enter the act, whether it is ferrying a horse by boat across a stream, fishing for trout, crossing the river in a wagon, passing through a lock two boats astern, or encouraging a workhorse to leap over a towpath barrier: activity (or inactivity) that is essential to the daily business of farm and mill commerce.

Insofar as it is inherited, this is Constable's father's world—the laborers, "loafers," animals, and equipment more than likely part of a neighbor's or his father's "industry." Constable biographer Anthony Bailey (2007), commenting on the ground-level makeup of East Bergholt, puts it this way:

> About a thousand people lived in this community, with a dense stratum of farm workers and their families at the base and a few notables at the top, including squire Peter Godfrey, who lived across the street at Old Hall, and the rector whose fine house and long driveway was visible through the trees beyond the church, the rectory grounds forming the territory along the eastern border of the Constable estate. Here was a known order of things. Here was a security that for a long time didn't manifest its claustrophobic aspects. Everyone knew young John Constable, and he knew everyone: the family servants, his father's workers, village people, local gentry. The tilling of land and the harvesting of crops, the shipping of grain out and coal in, created a structure to life: what happened when.

It is this inherent social and agricultural structure that underwrites the best of Constable's art, manifested as a small emblematic world that is, in the first instance, evoked in acute particulars, and,

in the second, as a larger, universal statement, instances of which—
as detail and audit—are generated out of a named landscape at spe-
cific times of day, under and within a canopy of varied coastal,
fen-country weather, fleshed out with rain or sun yet always clouds
and a clear suggestion of where the wind is coming from. This is
land and weather you grow up with and that lives inside you, mind,
blood, and bone; this is, as the stranger says on the coach, a place
with an identity, on canvas as well as in nature. It is a place as real
as the imagination is real, both a moment and memory. It is a mor-
tal pastoral, with tools and social hierarchy. "John grew up with an
unquestioning sense of where he stood in the local order of things:
near the top." The six-footers, as a narrative of Constable's commit-
ment to and affection for the soul of his "country," are really parts of
stories in which the land and the people who work it and those who
own it—whatever judgment is placed upon them—are intimately
understood but at a distance, the emotional distance of art, and in
this case, the art of a potential landowner turned artist.

All manner of motif links these six big Stour paintings: the set-
tings themselves, of course, along different close-in parts of the
river, including various boats and work wagons and cottages and
the occasional far-off church; and inevitably the great elms and ash
trees and river oaks, whose spring and summer foliage is not unlike
the flowering cumulonimbus-cirrus combinations of clouds—all of
it weighted with Constable's heavy brushstrokes that in themselves
supply the oil-rich surfaces an aesthetic unity. In addition to the
required human figures, the large-hooved horses that appear in four
of the paintings provide centers of gravity for the work that must
be done—how different these horses are from the standard-bearers
in military art; they become further engines of Constable's human-

ity, so that if they represent a kind of nobility, they also stand for the energy of the farm economy. This is Constable's father's world, and his father's before him. It is a world Constable takes pride in; through them it belongs to him.

"As well as the windmill across the common, his father owned two watermills, one at Dedham and the other at Flatford, inherited from Uncle Abram, the corn-factor in London. 'Corn' was not American maize but any sort of grain, particularly wheat used for flour. There were also two yards and a wharf at Mistley, on the Stour estuary, where the Constable vessels *Telegraph* and *Balloon* . . . loaded grain for London and brought back bricks and manure. Several canal barges carried these goods further inland, to and from Dedham and Sudbury. Although 'trade' underpinned his family existence, and the Constables wouldn't have considered themselves gentry, they were well connected." Bailey adds that it was understood that as a young man "John would come into the business," a broad assumption that will include starting out "doing the accounts . . . buying grain or selling coal . . . helping out with barges at Flatford lock, sitting with a fishing pole beside the Stour backwater below Fen Bridge, and walking to the windmill on a day of scudding clouds to watch the sails swish by, while the grinding stones within sounded a rough susurrus."

Yet Constable will end up being "about his Father's business" in a wholly different way—inspiration rather than participation—as if he becomes not only the maker of his art but an actor in its scenes. The "narrative" of the six six-footers, painted over a period of a coincidental if annual number of six years, presents a sort of album of stories called back from Constable's boyhood within the context of the pastoral world and mill family he grows up in, though this

personal past becomes, as art, no less contemporaneous, since we are speaking of a distance of no more than a generation between Constable's childhood and adulthood. (In fact, the cloud world in the series will be taken from the moment, while the land world will be remembered.) Narrative implies an emotional or temporal movement, a building up and a building down, cause and effect, and a chronological or psychological order. These six emblematic paintings develop in various ways: one of which is to go from the placidity of a white, fully harnessed tow horse itself being towed across the River Stour; to an afternoon off of fishing tranquility involving an elder man and children; to the quiet midstream study of a hay wain, with two black pull horses and two young laborers, headed, probably, downriver toward Stratford Mill; to barges on the Stour being guided by a boat pole past a lock while, probably, the same white tow horse stands off to the side at idle; to the strong young man at the lock about to open it for a barge to pass through (perhaps having also opened it for the barges in the earlier painting); to the massive backside of a plow horse in midleap attempting to clear a towpath barrier. Such is the overt sequence of these scenes, so obviously connected by landscape and work at hand, not to mention the work at hand of the artist. The links between the paintings are not so much linear as simply similar, juxtaposed and remembered as tableaux, representing the business and pleasure of the service canal and its connection to the Stour.

You may add my name to the list. I am a Devonshire man.

J oseph Mallord William Turner sometimes also claims to
have been born in Kent or the Medway Valley or Margate
but never, on record, in Covent Garden, up the road from St. Paul's,
where he has been christened on May 14, 1775, a date itself that he
often plays with (both the day of birth, April 23—Shakespeare's—
and the year), so that when he dies at the end of 1851 it is not clear
whether he is seventy-six, seventy-seven, or seventy-nine, the age
inscribed on his coffin. Late in life, he toys with his "identity" as well,
taking on the last name of the woman with whom he is presently
domiciled, Sophia Booth, from which he extrapolates himself into
an Admiral Booth, an alias that suits his nautical leanings. If Turner
the man seems to have been, throughout his life, liberated from too
much autobiography, Turner the artist is profoundly clear as to his
artistic ambition and to his commitment to having his art live for-
ever, even if his Turner name is backed up by a West Country line of
saddlers, butchers, bakers, and—in the case of his father, William—
barbers. A good many working-class eighteenth-century West Coun-
try families—including the Keats family—will migrate to the heart

of London, including the less expensive Covent Garden area. At the time of Turner's growing up there, this "Garden" will have long since fallen further in civic virtue to a level of boarding and bathing houses, shady pubs and puppet theaters, press-gangs and pickpockets, its "great square of Venus, and its purlieus . . . crowded with the votaries of this goddess . . . The jelly-houses . . . now become the resort of abandoned rakes and shameless prostitutes." It is the perfect social mix for a boy of Turner's imagination and temperament.

Covent Garden is that part of the city that Charles Lamb—also born in 1775—loves and celebrates as if it were a landscape equal in pastoral virtues to the Lake District his friend Coleridge keeps recommending or the Dedham Valley Constable is the laureate of. "I have passed all my days in London," intones Lamb . . . "the lighted shops of the Strand and Fleet Street; the innumerable trades, and tradesmen, and customers, coaches, wagons, playhouses; all the bustle and wickedness round Covent Garden . . . life awake, at all hours of the night; the impossibility of being dull in Fleet Street; the crowds, the very dirt and mud, the sun shining upon houses and pavements, the print shops, the old book-stalls . . . coffee-houses, steams of soup from the kitchens, the pantomimes—London itself a pantomime and a masquerade—." This is certainly a more romantic view of things than the view of the rough commercial and red-light district young Turner is seeing from his father's barbershop on the ground floor of twenty-one then twenty-six Maiden Lane.

Beyond the limited view from the windows of the Turner home and place of business, the young artist's world is bordered by High Holborn to the north and the Strand to the south, with a maze of medieval lanes and alleyways in between and crowding the edges of the open square of the Garden space, where, in the morning, "cos-

termongers were dragging away their laden barrows, or encouraging the donkeys that drew their carts, as they set off to the streets of customers awaiting the day's fruit and vegetables. Empty sieves and sacks and hampers and baskets were being piled up, and streetsweepers were clearing the litter of purply-green cabbage leaves, bits of white-yellow turnip or pale-orange carrot, fragments of red apples and crushed brown chestnuts, shreds of lettuce and sprout tops and onion skins, and discarded paper jackets that had been wrapped around lemons." Bailey (1998, 2007), as the only biographer of both Constable and Turner, makes Covent Garden sound like a village square of Saturday local produce. You might also find, among this spilled cornucopia, "shoeless flowergirls . . . on the steps of the Covent Garden Theatre, tying up their bunches, while others cluster around the pump, chattering and elbowing one another as they water their wilting violets." In the Museum of London there is a fabulous 1750 perspective painting by Samuel Scott, entitled *Covent Garden Piazza*, that presents a rather golden Latinate late afternoon view of this enormous marketplace happily filled with taverns, gambling dens, fruit and flower vendors, and apparently places of ill repute, though in the glow of things Scott's art suggests the energy of a very large county fair. The angles and distances of his painting generalize the closer details of the scene as it disappears into the pale blue haze of an autumnal sky.

And just a stone's throw away from this ancient section of London, at a stairwell depth below what is now the Embankment, looms the Thames—sweet river of Spenser, dark river of Dickens—the river that becomes the first important water in Turner's imaginative and spiritual life, parallel to the way the Stour is central to Constable's imagination and soul. Both rivers empty into a sea that

serves as a water bridge to the continent, a bridge that Turner will cross many times and that Constable crosses only once. But what a difference in the two river bodies—the modest Stour in a deep dream of agriculture, of summer trees and summer clouds, compared to the labored heart of the great Thames working the oily flow of its commerce: the pastoral river narrowed through locks; the other, the industrial, timed and measured with wharves and the traffic of lighters. Although some places along the Thames are built up for the gentry, "in many places," writes Bailey, "the old foreshore was unimproved, with stretches of beach, rotting wharves and remains of pilings. At low tide you could clamber down on to the shingle and strongly smelling mud and find . . . white clay pipes, a ship's block, lumps of coal." None of this detritus is far from William Blake's "London," where "each charter'd street / Near where the charter'd Thames does flow . . . / Marks of weakness, marks of woe." Nor far enough from what will be *Our Mutual Friend*'s harvest of floating bodies, through murder or suicide.

He was known by now as a boy who enjoyed
being kept busy with pencil and paint.

When he dies at seventy-six, in 1851, Turner leaves
behind more than 100 completed paintings, 200
oils in various stages of completion, and nearly 20,000 sketches,
drawings, and watercolors. He sees this trove—a good portion of
which, in his lifetime, he treats with secrecy—as not only his but
his nation's legacy, and wishes—wills, actually—that the best of
what has not already been spoken for, through sale or gift, be avail-
able as a single gallery entity, which proves to be a vain hope, since,
until 1987, much of the Turner inheritance that does not end up
as part of the national heritage ends up almost everywhere else. (In
1987, one hundred thirty-six years after his death, what becomes
known as the Turner Bequest finally finds a home as the Clore Gal-
lery, Tate Britain.) While Constable's homebody career describes a
fairly definitive arc, whose center is his series of 1819–1825 six-
footers and his one hundred and more Hampstead backyard sky
studies (1820–1822) in which summer clouds and almost nothing
but clouds fill the frame—while Constable's career feels provincial,

peripatetic Turner's long life as an artist is all over the place—and places—in Britain and the continent. In his mid-twenties Turner spends a good deal of time with relatives in the well-known areas of Bristol and Bath, but by 1792 he has made his first sketching trip to South Wales and for the next ten years explores the better part of the entire island of Britain, sketching, watercoloring, painting in oils in his studio or sometimes plein air. In 1802 he makes his first crossing of the North Sea into France and north among the Swiss Alps—Paris for the Louvre, the Alps for the Burkean sublime.

For the rest of his life, in city and country, Turner will visit and revisit and make himself at home at more than fifty important markers on the maps of England, Wales, Scotland, France (Paris), Italy (Venice), Germany, Luxembourg, the Netherlands, and Switzerland (the Alps), toting his knapsack of art materials and a change or two of underclothing: wanderings of miles and months, usually in the summer, often in snow-filled mountains, alternately by coach or horse or too much of the time on foot. There will be forty-two years of this searching, enough to wear a path into the earth. As we know, the imagination is made from, not made up, and for Turner his imagination accelerates with travel, with long journeys or long stays in the homes of patrons, and with long thoughts in the presence of great bodies of water, ships at sea, and the architecture of ruins or buildings on their way to being ruins; and profoundly in the presence of landscapes judged by the sun—evening, morning, and the in-between passing of the light. His search for the sublime begins as early as 1794, in Wales and Wordsworth's Lake District (four years before *Lyrical Ballads*); then, on an even grander scale, in 1802, in the Alps (Mont Blanc, St. Bernard Pass, the Reichenbach Falls, St. Gotthard Pass); then, on an entirely different scale, in 1805,

along the Thames; and much later, in 1819 and ever after, in the mists of watery Venice.

Constable's active career lasts forty-one of his sixty-one years, a time span in which he develops his craft slowly in a measured and focused way. "A man sees nothing in nature but what he knows," he says in 1823, the middle year of the sequence of the River Stour six-footers. Constable certainly paints what he knows, and from first (*Moonlit Landscape with Hadleigh Church*, 1796) to last (*The Cenotaph*, 1836) the growth of his learning is not only apparent but surprisingly original—surprising because his raw material seems so consistently familiar. He ends his career, appropriately, with practical lectures (1832–1836) intended to underwrite his aesthetic. "The landscape painter must walk in the fields with a humble mind. No arrogant man was ever permitted to see nature in all her beauty. . . . There has never been an age, however rude or uncultivated, in which love of landscape has not in some way been manifested. . . . The world is wide; no two days are alike, nor even two hours; neither were there ever two leaves of a tree alike since the creation of the world; and the genuine productions of art, like those of nature, are all distinct from each other."

Turner's ambitious career chart, on the other hand, is strictly nonlinear—like the artist himself it is too complex and multiple to describe as a straight or singular narrative. He seems, from boyhood, to have never been without pencil or charcoal or brush in hand, and more often than not, only his hand—"his misshapen thumb" or bent finger or thick fingernail to punctuate a picture. If the lifetime sum of his art is prodigious, it is not profligate: he seems to work every day at something, whether it is sketching, drawing, water-coloring, painting, etching, selecting the right texture and shade of

paper, stretching and preparing a gessoed canvas, finding the perfect primary color or blending a brilliant range of color, finishing off—most of the time—with the most effective varnish, or simply walking to the best place, for perspective, to review the source on the map within his mind. He apparently lives, simultaneously and continuously, in at least two worlds, the one in front of him and the one he is dreaming. Yet whatever his commitment to the art-for-its-own-sake purity of his art, like most of his contemporaries he also creates by commission, assignment, or request, though he is no portrait painter: his portraits tend to be of gentry houses and distant castles. He has patrons and, he hopes, buyers, though much of his work he will not sell and even, now and then, buys back what he regrets having given up. He loves what he does, the process itself the chief romance. But while he may be a poet he is also a pragmatist, even if money, like his art, exists for its own sake. ("Dad never praised me except for saving a shilling.") He is not above charging for the frame as well as the painting.

The art pleases by reminding, not by deceiving.

Although he has been born into better economic cir-
cumstances than Turner and is helped by an allowance
and after his father's passing a modest inheritance, Constable is an
artist on his own, which is to say that in terms of the subject he is
most committed to he needs to but does not sell. Except on assign-
ment. He becomes England's signal landscape artist, yet in order to
support himself for much of his career he is forced to do "some-
thing in the portrait way"—individual portraits, family portraits,
house portraits, church portraits—for more than thirty years. Early
on he writes his RA friend Joseph Farrington that he has been paint-
ing portraits of farmers and members of their families "large as the
life for which He has *with a hand* 3 guineas,—without 2 guineas,"
the most famous of which is the ten-figure *Bridges Family* portrait,
a grand piece that now displaces considerable space at the Tate. Not
all of his portrait work is in oils; sometimes, on the moment, Con-
stable does a preliminary sketch that turns out to be more alive than
the "finished" product. This is especially true of his renderings of
children, particularly the twelve-year-old Maria Bicknell, who will

eventually become his wife. In addition to portraits of such families as the Charles Lloyds (through whom he meets Wordsworth and Coleridge) and the Charles Tollemaches (through whom he makes important commission connections), Constable paints the country estates that amount to extensions of and correlatives for these families. Just five years before his death (1832) and the year of the death of his best friend, John Fisher, he is still receiving commissions such as capturing the Englefield House, Berkshire, an assignment whose surrounding painterly landscape he finds wanting. "All that I have seen of even the greatest names, are either 'pictures' or nothing."

Constable meets Reverend John Fisher through Fisher's uncle, the bishop of Salisbury, also named John Fisher. They become lifelong friends and correspondents, so much so that over time the younger Fisher is the person Constable most confides in and, in many ways, most depends on. To the point: over the course of their twenty-year friendship Fisher often acts as art critic and supporter of Constable's art as well as listener and adviser for Constable's personal life. They meet, naturally enough, through portraiture. In September 1811, Constable is staying with the family at the bishop's palace with an aim toward doing the bishop's portrait and, ultimately, a full-sized portrait of Salisbury Cathedral itself. The nephew and Constable are close in age and interests, and from there the friendship develops. Fisher, most likely, encourages the Cathedral commission, which, in terms of trial drawings, oil sketches, and versions from varying perspectives, turns out to be more than Constable bargained for—or exactly what he bargained for. However many studies and preparatory pieces Constable executes on behalf of the face of the bishop, they cannot match his decadelong devotion to this greatest of English shire cathedrals.

Among his several artistic means—pencil, chalk, oils—and perspectives—near view or faraway—are versions entitled *Salisbury Cathedral from the South-west* (1811), *Salisbury Cathedral from the River* (1820), *Salisbury Cathedral and the Close* (1820), *A View of Salisbury from the South* (1820), *Salisbury: The Close Wall (1821),* and *Salisbury Cathedral from the Bishop's Grounds* (1823). This latter painting is probably the most definitive and the one the bishop worries, in its initial rendering, might be "too dark," notably the skies, so Constable brightens the Cotswold stone and brings out more sunlight in the soaring clouds as a salve to the assignment. But the subject itself is kept at a distance—"perspective"—because of its dominant size: close up the Cathedral tends to overwhelm its landscape, especially its decorative oaks and elms. Constable's solution is to employ the cathedral-like arching of the trees as a frame through which the majesty of the great church is the receding centerpiece, with the summer clouds serving as an uplifting backdrop. The splendor of the Cathedral sits, kept in place, between the cathedral arc of the trees and the light-filled clouds. There is a small stream with a few cattle in the immediate foreground, and off, stage-right, two small human figures—the bishop and his wife?—pointing to the beauty of the church. What is important about the picture is how its subtext becomes the flat, fertile Wiltshire landscape itself, as if the more Constable tries to get his ostensible subject "right," the more it becomes an excuse for the truly pastoral rest of the picture.

Salisbury Cathedral, because of its sheer presence and implied spiritual power, is attractive to painters—it is a work of art if nothing else. Or more practically, a work of architecture. Turner paints it, too, from 1799 to 1805, from both the outside and the inside, though not, significantly, in oil. He makes of its immortal stone

mortal pencil and watercolor on paper. In the future, it will be said of Turner, more than once, that he paints in watercolors as if they are oils and in oils as if they are watercolors. Part of his genius is his ability to make solids dissolve and liquids solidify, whether on canvas or paper. Turner's *South View from the Cloisters, Salisbury Cathedral* is an early example of treating stone and architecture as if they were made out of mist. Like Constable, he understands that the size and volume of the Cathedral, straight on, is intimidating, so he constructs the similar strategy of placing the greater structure within the context of a "smaller" or foregrounding structure, in this case the broken Gothic arch of the cloisters, with a boy at play at the outer edge, stage-left, just to provide proportions. Unlike Constable, he "hides" much of the Cathedral out of frame: we see most of its tower and main body—but by no means all— through the proscenium of the arch. So that the greater form is caught inside the lesser form—literally captured within the close-up circumference of the smaller, in a shape that echoes the arcing-over of Constable's trees.

Constable's sketches and oils of the great church are really landscapes with cathedral; Turner's *South View* is really about architecture, shapes within shapes, without the hard edges. Such distinctions have beginnings. Before he starts his young life-drawing studies at the Royal Academy, Constable is immersed in the detail countryside of his father's Stour Valley corn-mill business, a seminal experience that will inform everything he does. "A man sees nothing in nature but what he knows"—Constable will write this many years in the future but the truth of it begins with what he knows of the fields, the pastures, the elms and oaks, the River Stour, the farmwork and daily life all around his growing up. Before Turner

starts his "probationer" studies at the Royal Academy, he will have had serious apprentice sketching and painting experience working for the London architect Thomas Hardwick, then a little later acting as a part-time scenic artist at the Pantheon Theatre and Opera House, specializing in the artifice of set designs of stormy seas and skies. Turner's *South View* is obviously more about architecture than theater, but at twenty-six by twenty inches it manages to suggest majesty contained; and the fact that watercolor is its medium adds to the implicit tension between matter and means.

Turner's architectural passion will carry over to his sense of the sublime in nature as well as the man-made, whether of great bodies of water or great mountains, though over time his understanding of size relative to the sublime will change, as will his notion of what the sublime is. At the moment, however, he is still not through paying attention to the interior masonry and limestone construction of Salisbury Cathedral. Unlike Constable, he goes to the deep inside, and in an even more subtle use of wash and tone with watercolor creates *Interior of Salisbury Cathedral, Looking Toward the North Transept*, with the emphasis on precision and scale—particularly the traceries, the columns, and the vaults—well-drawn aspects of his art he will in the future obscure if not transform. In his *Interior* it is late afternoon, with a dusty sunlight filling the vast floor-to-ceiling height of things, a height whose dimensions are made extra clear by the diminutive, white-robed human figures heading, in a long trail, toward the organ loft (choristers probably). As much as the verticals and arches of the architecture dominate, the real skill of the picture derives from its depth, in which the pale church window source of the sunlight, at the back, develops, in steps, toward the darker, wider, lengthened foreground, reversing, in its odd way, the usual

perspective. In total, the 66 × 50.8 cm picture seems mostly about empty space alive with light when, in fact, it is about the full luminous volume of that space, its grandeur yet delicacy, its accuracy yet sublimity, suggesting the way all architecture is conceived from the inside out in order to fill an absence.

There is room enough for a natural painture . . .

Constable is a pretty fair portrait painter; the majority of his portrait work is over by 1819–1820, when the best of his landscape art and cloud studies begins. Portraits up to this point have helped pay the bills. They have also demonstrated that he is more than effective with faces and the human figure. His direct portrait style may be at odds with highly styled elegant Gainsborough's that tend to flatter, through erasure, the local gentry, but since he primarily paints the mill owners, neighbors, local clergy, and farmers (and their families) of his parents' social class, people who live on and by the land and landscapes that are his true subject, a fair rendering of flesh and blood is at a premium. Turner may be multifaceted in the range and dimension of what he looks at (as opposed to what he sees)—vast landscapes, seascapes, or imagined history—Constable is, if anything, totally grounded and consistent in what drives him—"Landscape is my mistress"—which is the difference between making a living from your art and living for your art. Portraits may help maintain Constable the artist; landscapes sustain him. "The sound of water escaping from Mill dams, so do Willows, Old rotten Banks, slimy posts, & brickwork.

I love such things . . . As long as I do paint I shall never cease to paint such Places . . . Painting is but another word for feeling." Or as he says later, the "banks of the *Stour* . . . made me a painter." Landscape for Turner may be varietal, international; for Constable, it is local, territorial, familial—it is the place of his "careless boyhood," which makes its experience not only autobiographic but empathic, in the way that home, as T. S. Eliot says, "is where you start from."

"Feeling"—as both an impression and passion—is the vital word here, feeling, as a perception as well as a concept, feeling finding its correlative in a pastoral rather than a strictly natural world. Constable, at heart, is a subversive romantic; that is, he is an inherently melancholy individual, whose first take—in life or art—is usually emotional, in spite of his claim, in respect to painting, that as a treatment it "is a science, and should be pursued as an inquiry into the laws of nature." What he is really saying here is that painting is not projection but comprehension; it is less an expression of self than a separation from the self. Its truth depends on objective, not subjective, readings of its subject—the subject as provided. Accuracy to the moment is what Constable is after in his studies of "nature," not the image of an intervening idea. His use of the word "science" makes the enterprise sound cold, when what he seeks, if anything, is a warm science, which is another way of making painting a "natural painture," a Constable coinage meant to suggest a way of coming to terms with the subject or, otherwise, an attitude toward art in which the artist accepts his subject on its own intrinsic terms, not his. Constable's final complaint against Turner is that, by inspiration, Turner too often substitutes his vision for the view: that what is literally in front of him, on its own, is never quite enough, as if the subject's implied power must be read in order to be released.

And true, Turner is not exactly a realist, nor conventional "naturalist," for that matter, but, then, neither is Constable. Critic Jonathan Clarkson makes the point that "much of Constable's struggle as an artist was to get the facts of things into his paintings without doing violence to their appearance." Turner, of course, seems to be continually committing violence to appearances, while Constable means to get the surfaces "right" in order to more truly represent the appearances—which is to say that for Constable, honoring "the facts of things" is the same as trying to discover the native richness within the raw material. That process of discovery becomes the "feeling."

While Turner's development as an artist seems almost of a piece, from boyhood pencil-and-charcoal draftsman to operatic scene painter to architect's sketching assistant to admission, at seventeen, as a "probationer" at the Royal Academy to exceptional watercolorist to, suddenly, England's most famous "landscapist"—while Turner's growth as an artist seems to occur at the speed of "genius" Constable's evolution is stubborn, slow going, and uncertain. For a good while Constable's commitment to his art appears to surpass his talent for it, he seems to be an eager amateur on a dogged learning schedule that in itself becomes inseparable from his ultimate achievement. Trial and error, work-up sketches, revision, then finished version—in his twenty or so best years as a painter, Constable must absorb his takes and retakes and influences before he can reject or transcend them. He is as hard on himself as a truth-telling artist as he will be on his "mannerist" contemporaries ("I hope by the time the leaves are on the trees, I shall be better qualified to attack them than I was last summer").

But he understands that art, especially "the art of seeing Nature,"

has a past. Seventeenth-century Claude, for example, is just about every landscapist's first love for burnished idealized evening settings, particularly the soft tones emanating from the glowing trees in *Landscape with a Goatherd and Goats* and *Landscape with Hagar and the Angel*; yet perhaps no less loved is the example of the storm skies and dark tangle of foliage in Ruisdael's *Forest Scene*; and certainly no less loved is the honey harvest light and Claude-tinted shocks in Gainsborough's eighteenth-century proud portrait of *Mr. and Mrs. Andrews* among their bounty or what could be some of the Andrews' harvesters riding *The Harvest Wagon* into a perfect sunset ("I fancy I see Gainsborough in every hedge and hollow tree"): again and again, in this first decade of the nineteenth century, Constable will acknowledge his debt to the traditional mood values and coulisse structures of landscape art by accepting them as models in an attempt to bring to life an original Dedham Valley moment, caught up in the soft browns, rich greens, and honesty he looks for in finding the real and living thing.

For most of the time that Constable is painting occasional portraits of friends and neighbors, in the long stretch of his twenties and early thirties, he saves his afternoons for practicing his landscape skills. The spring and summer light, such as it is, even on a good day in nineteenth-century England, is at its best during these full daylight hours; and since England is an island, the winds off the ocean and moorland country play with the light constantly. ("Light and shadow never stand still" [Benjamin West].) The compensation for this instability is the momentary stability of scudding towering clouds, huge cumulonimbus complexities moving at their own nautical speed, though it will be a while before Constable understands

how much the sky, in all its machinations, is inseparable from the gravity of the ground.

Then, in 1809, when he is thirty-three, Constable takes a step into the future: he moves from his outdoor habit of sketching in watercolor and oils on paper and small canvas to something larger and more definite. In late summer he starts and completes a finished oil plein air of a fair 51.5 × 76.9 cm size. Constable is hardly the first painter to paint outdoors. As far back as Claude's *Landscape with a Goatherd and Goats* and as recent (relatively speaking) as Richard Wilson's *Tivoli: The Cascatelli Grandi and the Villa of Maecenas*, oil painting inside the frame of nature, though not all that common, is praised for its immediacy and vitality. For Constable, painting on the scene is a further kind of commitment to his notion of fidelity to his subject and to the more practical matter of bearing his supplies and easel on-site. The interesting thing is that the assigned plein air subject, in this case, is not "nature" but architecture, a portrait of a house owned by Henry Greswolde Lewis, whose ward, the beautiful Mary Freer, is the original reason for the invitation to visit. (The portrait of the young Mary is one of Constable's best, her big dark eyes set within a classic roses-in-her-cheeks English face. She is lightly holding her bonnet and resting her arms on her vivid red cloak.)

The portrait of *Malvern Hall from the Lake* has its own classic beauty, too, but at a distance, in a more measured perspective than Constable's studies of Salisbury Cathedral. As per his method, he makes lots of preparatory sketches of the Hall, worked at over a period of two weeks. The main oil piece, however, is more or less started and finished within the weather of one or two afternoons,

probably touched up later. The reason for the long-distance view in the best-known Salisbury Cathedral painting is the imposing, dominating presence of the structure itself. Here, with *Malvern Hall*, while the building is four solid stories high and flanked with two three-story additions, Constable is less interested in architecture than in nature. He keeps the scale of things in measure with the manicured surroundings. Jonathan Clarkson describes the scene this way: "The house is central, under a clear bright sky, and is seen across a stretch of water and bordered by regular rows of carefully maintained trees. Sheep graze discreetly under the trees, and swans glide across the water."

But Clarkson's description is more of an outline than a reading of the painting. The pictorial setup is certainly a formula taken from traditional pastorals, including sheep and swans and a border artifice of foliage, sans nymphs and mythic figures. The differences are apparent, too: Constable's rough try-out sketches have their own original dynamic life; there are no human figures in the finished oil to invite the possibility of a narrative; and without the help of a title, as a portrait the house is diminished to a kind of anonymity— even though the house itself implies people, family, and society, a quality of detail generally important to Constable. Here the real difference between tradition and discovery lies in the execution or "materiality" of the realization of the subject itself, which attends to the "foregrounding" of the property landscape. The well-tended trees are small clouds of trees, many of which are magnified in reflection in the water; the lake is pond-like, with lilies and cattails dominating the presence of the swans; the sky may be bright but it is not clear—it is a thin wash of luminous cloud cover, serving as a canopy over the whole scene and glazed, also, in the water.

(Half the house is reflected too.) In fact, "clarity" is an issue, since Constable—perhaps because he is painting "on the spot"—translates the vitality of the trees with a certain quick-study opacity and dense texture. The grounding this side of the lake bank is right up against the viewer and thick with various greens, as the eye follows into the lake, the reflections, then the lawns and arrangement of the trees, then the lift into the open sky, accentuated with a far toss of birds. The whole composition is meant to be as faithful as possible to what Constable is seeing across the lake in the life of this moment, but the ultimate emphasis is on the application of the paint itself: how it quietly dissolves the line in favor of the total forms—their kinesis, density, and vibrancy.

Though I am here in the midst of the world I am out of it.

E arly on in his Phaidon edition of *Constable*, Jonathan Clarkson (2010) states that the artist's "art was consistently autobiographical," by which he means something emotional rather than simply literal, or to put it in a different grammar: Constable's art is the autobiography, regardless of the apparent subject, of a feeling. For example, Constable becomes seriously involved with his future wife, Maria Bicknell, in 1809, in spite of much resistance from her family, particularly her grandfather, the rector at East Bergholt, Dr. Rhudde, who thinks that Constable is not only not of his granddaughter's class but "seemed to be a weak man," an opinion shared by Lady Beaumont, wife of Constable's vague admirer, Sir George. "Class" is one thing, "weak" here suggests a judgment beyond money as much as a comment on character. And true, even with the promise of eventual funding from his father's estate, Constable the suitor is barely making it, while Constable the man is often aloof, arrogant, and "underemployed." This combination of economy and personality will be a lifelong issue for Constable. You cannot separate the individuality of the artist from the fact of the man. So what may appear to be

weakness to some may, in truth, be an implicit strength, a core iden-
tity. Making a portrait of a mansion, say Malvern Hall, as an excuse to
paint a landscape is character winning over commission.

Painting buildings, for Constable, is not all that different from
painting people—it is a way to get to and value something else, such
as, for example, *A Woodland Scene* (1801), placed next to *A Wood*
(1802). Each painting demonstrates Constable's early penchant for
trees—not only a feeling for but a Wordsworthian connection to
trees, an aesthetic appreciation that in no way compromises his "sci-
entific" respect for what they are. (His tree studies precede his cloud
studies by a good many years.) Trees represent, for him, natural yet
at the same time animate beings, alive in their particularity. Trees,
indeed, may be Constable's first intimate understanding of what his
real subject is, nature as a pastoral; nature as content as well as con-
text. The *Woodland Scene* oil is almost gothic and fairy tale–like in
its darkly saturated, luminous, and sensuous quality, the aging sil-
very texture of the bark of the two main looming trees the bright-
est objects in the picture; while a year later, in *A Wood*, the scene is
muted russet browns and hinted greens, with the trees themselves—
under a soft blue sky and one fair-weather cloud—nearly a blur
filling most of the space. The latter painting is more mature, more
Constable, and more preoccupied with what would soon bother
several of his would-be patrons: too much brown. Then there is the
further issue, in both paintings, of no human figures, no laborers
or idlers, no one walking the road, no gesture—as of yet—toward
narrative. At the moment he is practicing detail.

In the wake of the use of a deeper perspective in *Malvern Hall*—
as the architecture becomes secondary to the trees—Constable will
continue for the next few years to feature the long view: his Ded-

ham Valley oils—some of which are outside works, some studio paintings—will keep their distance, as if he is decorating the scene with strategically placed trees and farm animals and a paint stroke or two of a farmhand, then far off, toward and within the horizon line, evidence of a farm, a church, or part of a village. Is he afraid, at this point in his young career, of the visual demands of the near view (as in a portrait) or is he, with the wider take, looking for something?—something that will key him into a richer understanding, as in a close-up in which detail and plurality—in "dabs and dashes"—blur yet matter most. That something else will take him well into the future. But in the near term, in 1815, *Boat-Building Near Flatford Mill* stands as his first important painting where the organization of a close-up becomes, on its own, the subject, where incidentals and accidentals act as the relevant odds and ends that enhance the setting.

Boat-Building, according to Constable's biographer, C. R. Leslie (1980), is another of his rare plein air paintings. Indeed, Leslie makes much of the fact: "In the midst of a meadow at Flatford, a barge is seen on the stocks, while just beyond it the river Stour glitters in the still sunshine of a hot summer's day. The picture is a proof that, in landscape, what painters call warm colours are not necessary to produce a warm effect. It has indeed no positive colour, and there is much of grey and green in it; but such is the atmospheric truth that the tremulous vibration of the heated air near the ground seems visible." Constable's own version of painting "out of doors," in a letter to Maria, is that "I am considered rather unsociable here—my cousins could never get me to walk with them once as I was never at home 'till night—I was wishing to make the most of the fine weather by working out of doors." The finished oil, done the summer before it

was exhibited at the Royal Academy, is probably Constable's most "finished" painting up until then—it is certainly one of his least rough and most finely tuned pieces ever. The common complaint against Constable—besides being "too brown"—has been that the overall look in his work is "too unfinished"; that clean lines, good color, and perfect nature have been missing—a shortsighted complaint that will reverse itself later on; the final "finished" version, whatever the painting, will seem to many friends, patrons, and critics too finished, work that looks too much like "a sop to public taste."

At least *Boat-Building* has an object other than trees and familiar farm matters in it; even "building" is a pun. Actually, for all of its popular-appeal delineation of its subject, the painting is one of Constable's best so far, but less for its finish than for the complexity and perspective it provides. It continues the traditional landscape habit of trees as framing devices, yet in the total picture the different trees—both near and far—function as a measure for depth of field, beginning in the foreground and lengthening across the river, through three levels, and into the distance of the horizon line. Constable varies the framing formula by loading the right side of the picture with the tallest, most prevalent trees—river trees, though their old age is more definite than their kind. The genius of the tree arrangement is that on the boat side of the river he creates a sort of right-to-left perspective out of them—as opposed to front to back—in which the trees on the farther side of the picture are naturally lower, suggesting an invisible downward line drawn from the treetops on the right to those on the left, while the bow of the massive boat, a little right of center, rises in perspective to intersect that tacit line. It is the major tension in the picture, the way the imagined line from the pointed end of the boat rises to become perpendicular to

the "line" between the trees (the tree-line falling, the front end of the boat lifting, as if in water).

That is the gift in the energy of the painting, the big landlocked boat taking us into the presence of the trees. Below the waterline of the river, however, everything is grounded with weight. The detail, the scattered tools, the pot of pitch on a fire, workmen here and there, and what seems like a child at the right margin of a wooded area, and most of all, the dark, wide back end of the boat scaffolded above the building pit, almost directly under which is the white-shirted builder sitting in some sort of activity or brown study: all of it in balance, all of it the vital still life of a narrative that amounts to a working pastoral—regardless of the fact that a boat has taken the place of a wagon as a "farm" vehicle. The boatyard belongs to Constable's father; the barge is being built in order to ship grain to the wharf at Mistley and hence to London; the doing of the painting itself is the painter's job of work whose daily evening's close of the workday is determined "by the pillar of smoke ascending from a chimney in the distance that the fire was lighted for the preparation of supper for the labourers' return for the night." Awkwardly put, though Constable's point is made. The chimney smoke is likely rising into the painting's overcast white and gray sky, which takes up half the picture and soft lights the landscape and its business.

Boat-Building Near Flatford Mill marks a serious transition in Constable's painting life. His from-the-upstairs-window panoramic 1815 view of his parents' flower and kitchen (vegetable) gardens is also well drawn and lineated in oils—first, in the foreground, the gardens, then, in the background, the larger neighboring spaces all the way to the sky and big clouds. You feel you could almost step into the gardens and select the flowers and vegetables for the day, or, if you prefer, keep

on walking. But mostly such crowd-pleaser paintings are exceptional, especially when compared with Constable's commitment to sketches, quick studies, fresh on-the-spot opportunities. In both watercolors and oils, whatever the ostensible subject (as opposed to the secret subject of landscape), these start-ups have an in-progress, immediate, *there* quality that the more finished, polished pieces sometimes have resolved out of them. *East Bergholt House* (1810) is a beautiful rose of a tonal painting that sweeps across a view of much of the whole of East Bergholt village. The oil study of *The Village Fair, East Bergholt* (1811) is nearly abstract in the blending pace and quiet russet color of its rendering, as if the artist has quickly wiped the wet paint from the canvas with a dry cloth. While the later *Dedham Lock and Mill* (1820) is somewhere between acute and interpreted—it is alive to the extent that you can feel the weather, the wetness, the storm coming on. For Constable, English weather is drama.

These "tryouts," in their differences, in this decade of his thirties, present a painter in search of the confidence to do as he pleases, saleable or not. Constable thinks he knows what he wants—nature as landscape for what it is, not what we wish it to be; or, as he will write later, "Painting is a science, and should be pursued as an inquiry into the laws of nature. Why, then, may not landscape be considered as a branch of natural philosophy, of which pictures are but the experiments?" And when is a painting—scientific or philosophical—complete rather than "finished"? Are the sketches the real experiments? Finished has such a furniture sound to it: sanded, polished, rubbed, sanded again, polished, especially when it comes to such major works as the Dedham Valley six-footers. (Art historian William Vaughan [2015] makes an interesting distinction between Constable's "adopting the unusual and virtually unprece-

dented habit of making full-scale sketches for his six-footers instead of scaling up from small studies as other artists habitually did." Vaughan argues that "why he did this is not known, but it would seem to be related to a desire to work out effects experimentally on a large scale before committing himself to a final version." Is Constable's "finished work . . . a sop to public taste" or a compromised gesture to the Royal Academy?)

"Finished" is the watchword of the Royal Academy. Not only is landscape art held in low regard, somewhere behind history painting and portraiture in the culture's hierarchy, but even now, in the early nineteenth century, its very subject is deemed without content—after all, the real and better thing is readily available to anyone interested in taking a country walk. Moreover, the Academy, according to Sunderland (2014), "followed certain accepted conventions about how foliage should be painted, how the composition should be built up and organized, what colours should be used, what should be included and what should be left out." Around this time, Constable's new friend John Fisher suggests "that cheerfulness is wanted in your landscapes; they are tinctured with a somber darkness. If I may say so, the trees are not green, but black; the water is not lucid, but over-shadowed; an air of melancholy is cast over the scene, instead of hilarity." Constable begins his young studies at the Royal Academy in 1799, when he is twenty-five; he exhibits his first Academy painting, entitled *A Landscape*, in 1802. He will display his work there, sometimes three or four pieces in a single show, for the rest of his life, even though it will be 1829 before he is elected a full member, an "Academician." It may or may not be true that more than once, in the years ahead, Turner's is the vote that blackballs Constable's ongoing applications.

Turner is the only landscape painter of genius in Europe.

T his Henry Fuseli opinion is quoted by an anonymous reviewer in *Arnold's Magazine of the Fine Arts* in 1833 when Turner is fifty-eight years old. The writer goes on to add that the painter's most recent work is "far superior to his earlier." One question with Turner is the question of the dividing line between present and past, now and then, recent and "earlier," greater work and great work—not to mention the degrees of "difference" within the scope of these poles—a question further complicated by tradi-tional and modern aesthetic judgments on either side of that line: is the work before, say roughly 1835, stronger and more definitive than the work after, say that aging period in which Turner seems to "go mad" and to produce nothing but "glare and glitter," obscurity and "indistinctness"? Is the 1815 *Dido Building Carthage, or The Rise of the Carthaginian Empire* Turner's masterpiece or does it rise or fall in stat-ure when placed beside Claude's 1648 *Seaport with the Embarkation of the Queen of Sheba*, which is how the two paintings presently hang, at Turner's request, in the National Gallery? (He himself is on record believing he would "never be able to paint anything like that picture,"

though he intends his *Carthage* to be an homage to Claude's *Sheba*.) Is *The Burning of the House of Lords and Commons, 16th October, 1834* more original and powerful than *Rain, Steam and Speed—the Great Western Railway* (1844), or is the comparison, like so much in Turner's total output, apples and oranges? What about the watercolor *Boats at Sea,* executed sometime in the 1830s, which is "nothing more" than two soft strokes of color—a thin red and feathered black (with a bit of notation above it)—in the middle of a washed 22.2 × 28 cm section of pale brown drawing paper: is this meant to be an abstraction or transformation?

Sam Smiles (2007), among Turner's most articulate modern admirers, sees the dividing line this way: "with respect to his reputation this critical polarity had the curious effect of pitting Turner's past against his present, the young artist against the old, as though he were not one painter but two: the accomplished developer of the European landscape tradition and the restless innovator." Turner's first great sponsor, the young critic John Ruskin (2005), takes the split even further and divides Turner's career into thirds: starting with *The Decline of Carthage* (1817); followed by *Ulysses Deriding Polyphemus* (1829); and ending with *Peace—Burial at Sea* (1842), Turner's tacit elegy for his friend David Wilkie. The convenience of Smiles's career division is that it anticipates what, for Ruskin, would have to be a fourth phase, the late period of Turner's most aggressive innovation and the period judged by many to be his decline, the period of *The Angel Standing in the Sun*. However divided and judged, there is obvious carryover from one part of his career to another, a good deal of the mixture having to do with commercial and/or commission appeal.

Part of the marvel of Turner is the numbers, including the mix of subjects and experiments and secrets of work he finished or had yet to complete, work he made public and work he kept to himself. His obsession with ships and storms, architecture and ruins, fire and water, burning and brilliant sunlight, impermanence and the sublime obtains throughout his painting life, early or late. How he treats these themes and images does, in fact, change or evolve, relative to the medium and the degree of "melting" of the content he commits to. Or, to look at it another way, Turner's method "grows," primarily in one direction, from resolution to dissolution. At his death, when he leaves a total of 100 finished paintings, which he intends to be his bequest to the British nation, and also leaves 200 "unfinished" paintings, he seems to have ignored the difference as a qualification of some inadequacy since he is famous for often finishing a painting on Varnishing Day in front of an amazed Royal Academy audience and even after that attempts "following" the piece back to his studio or to the home of the purchaser. Unfinished, to Turner, means "to be finished" at the appropriate time, whenever, since all his work is in process, on its way to its realization sooner or later. Remember how from the very start he has a pencil or brush always in hand: among the some 20,000 sketches, drawings, and watercolors he leaves behind are some of his finest achievements, especially in watercolor, a medium in which, to reiterate, he may be the best ever. And he sells well or he does not sell, depending on his buyer or his mood; nevertheless, he understands that he is in the art business, and, sometimes, the property business. At the end, he leaves an estate of 140,000 pounds, translated into today's money at close to 6 million pounds.

So where is the dividing line between earlier and later art, better or not? And when is a landscape not exactly a landscape but a topography of another nature altogether? Turner's first reputation is of seascapes, though hardly of the placid marine blue variety. In 1805, at thirty, he paints a picture he calls simply *The Shipwreck*, whose action is really the moments just after, with the survivors—some thirty or more perilous souls—hanging on to life in three small vessels. The sea is in torment, mostly white rage spilling over and under the lifeboats. The boats and survivors roiling in great whitecapped angry water make up the foreground; right behind this panic looms the immense blackness of the wilder ocean building toward the broken horizon and the night sky. It is a half-and-half picture, dark sea filling the frame in front of us and darker sky taking over the top of the picture. In the near background roils the lost wreck of the ship. All of this has just happened and is still happening—that is the energy and dynamism of the painting: not so much what it has captured but what it has caught. The canvas is alive, 170.5 × 241.5 cm. Not everyone finds Turner's early oils all that effective, especially his seascapes. Sir George Beaumont—friend of Wordsworth and sometime admirer of Constable—finds Turner's treatment of water too much like "the veins on a Marble Slab," a somewhat facile complaint since it suggests a static rather than dynamic rendering, as if Turner is painting in stone, which would be marvelous if the stone is of the Elgin Marbles. Beaumont invariably tends to be full of himself as a critic and connoisseur; he is not entirely happy with Constable's "muddy" paintings either. *The Shipwreck*, as one example of Turner's talent with ships-at-sea "action," is hardly static or of stone; it speaks for itself as a poetry of proto-kinesis.

Then again, in 1840, thirty-five years later, Turner deals with the theme of "shipwreck" at a wholly different level, as a potentially political issue, though the fundamentals of a life-threatening storm remain more or less the same. This time, however, the real destructive element is human in the "face" of nature. Yet *Slavers Throwing Overboard the Dead and Dying—Typhoon Coming On* is less a polemic than an aesthetic argument of how much violence a single moment of tragedy can contain. (Critic Albert Boime complains that the picture subverts "human suffering to the taste for high tragedy"; while Ruskin—who eventually owns the picture— feels that on this "single work" rests "Turner's immortality.") This is a portrait of "hell on earth," we like to say, but in this case hell is in the heart as well as in the depths of the deep. The dead have already gone under while the slaves who are drowning dominate the ocean foreground, still in chains, many of whom are being devoured by strange fishlike creatures. The winds have whipped the sea into a roil of black and sick green. The slave ship itself is midpicture, off to the left, suffering the beginning of the storm. Is it a Spanish or Portuguese slaver, a barque *espagnole*? The overwhelming sky is a fire of reds and yellows, as if a moral force is about to make its judgment—or as if the sun has cleared the skies in order to consume this evil. Is Turner, uncharacteristically, being didactic in this painting or is he, characteristically, being hyperbolic? There is no doubt of his interest in the weather of violence and in finding in his storm an angry correlative in color and mass of application.

Slavers is one of those paintings Turner seems to feel he must double down on, so at its showing at the Royal Academy he attaches—as a part of its entitlement—a stanza from his own on-again, off-again epic poem "Fallacies of Hope":

Aloft all hands, strike the top-masts and belay;
Yon angry setting sun and fierce-edged clouds
Declare the Typhon's coming.
Before it sweeps your decks, throw overboard
The dead and dying—ne'er heed their chains
Hope, Hope, fallacious Hope!
Where is thy market now?

In 1842, in yet another storm and boat painting, he will substitute exposition in the title for what he has otherwise tried in poetry. *Snow Storm: Steam-Boat Off a Harbour's Mouth Making Signals in Shallow Water, and Going by the Lead. The Author Was in This Storm on the Night the* Ariel *Left Harwich* is as much a headful as it is a mouthful. So many curiosities here, not the least of which is the fact that Turner refers to himself as the author rather than the painter of the picture, which one critic calls "possibly the greatest depiction of a storm in all art." Turner, the sometime fabulist, famously claims the experience to be completely existential, profoundly inside out: "got the sailors to lash me to the mast to observe it; I was lashed for four hours, and I did not expect to escape, but I felt bound to record it if I did." Turner would have been sixty-seven when he purports to have endured the four hours of this snow storm, tied, like an errant sailor, to the mast—a storm of icy cold in a deadly wind. The facts do not support Turner's melodramatic story, a mariner's story that is too similar to a documented narrative offered a few years before by the French artist Claude-Joseph Vernet.

No matter. What is most impressive is that this exceptional depiction, *Snow Storm*, is exactly what such a storm, in winter, might be like from inside the experience. The painting is aggressively subjective—

indeed, more than an impression, it feels, in its use of vortex and chaos and the brilliant exchanges of storm seas and storm skies, as if the observer (the painter) is also, simultaneously, the participant (the reporter). The action is about projection, about *like*; about the reality and accuracy of *as if*; therefore, it is all about the reality of the imagination, not fantasy: it is what serious art is about, a verisimilitude, a made thing, a thing apart, not made up. Of course, talent has something to do with it. Turner has sublimated his penchant for exploiting primary color into an actual representation of the blinding off-blacks and off-whites and off-green-grays that the projected eye would be subjected to: the canvas is a total storm held up in front of us, with the disappearing steamboat *Ariel* absorbed in the maelstrom.

Ships and storms are essential to Turner's signature, and they are lifelong. They fit the profile that ruins, church architecture, classical settings, mythic figures, castles, and Venetian palaces all share as ostensible subjects (as well as props) within the landscape, seascape, participating sky, and very atmosphere brought to life at the heart of that hour of light. Turner recycles these subjects as familiars, friends, and reassurances throughout his career, though in each incarnation there is a natural change, usually in the direction of more and more dissolution of line and distinction. But like the work of Constable, the familiar, over time, as it acts more and more as a means to another end, will permit the setting of the apparent subject to take precedence, to the point of superseding that subject altogether, as if figure to ground has been reversed. In the end, a kind of internal, corresponding landscape of the mind will emerge. Michael Bockemühl (2007), in fact, in his book on Turner, focuses less on the troubled steamboat in *Snow Storm* than on the brushwork itself and the way in which it builds the storm consuming the total canvas,

a brushwork that "starts out from the centre towards the upper left, then follows . . . a general form encompassing the whole picture . . . a 'whirling' movement." The violent content of the circular brushwork is made alive, of course, by Turner's unique combustion of colors, as if the color wheel is being turned and converted into the blended hues and shades of nature—in this instance, a snow- and ice-laden storm at sea in winter. As the sweeping, storming action of the brush becomes the aesthetic reality it calls attention to the paint itself, to the reality of making art.

Representations not properly of the objects of nature as of some medium through which they were seen . . .

In 1926, in his book *Hours in the Tate Gallery,* James Bolivar Manson tries to define what is likely Turner's last phase as an oil painter: "Now pure colour had become an instinctive part of his perception and the essential means of his expression . . . infinite suggestion and convincing truth is obtained by colour alone . . . form has almost completely disappeared. It is a dream of colour. . . ." This echoes William Hazlitt's brilliant analysis, 110 years earlier, that Turner's most impressive pictures are "representations not properly of the objects of nature as of the medium through which they were seen." He adds, more cryptically, that "the artist delights to go back to the first chaos of the world," as if Turner's landscapes, in particular, "were *pictures of nothing, and very like.*" The phrase "very like" is interesting here in that it implies what the ultimate subject of a painting tends to be, a picture of something very like something, even if, in Turner, the "something" seems to be something else, perhaps nothing. The Tate has for many years been Turner's first home, the place where the different parts of his career can be seen more or less side by side. Hazlitt

is obviously unaware of Turner's late art when he offers his 1816 insight, yet his statement is perfect for the salient example Manson is referring to in his pure color comment—*The Burning Ship* or as it was soon retitled *The Disembarkation of Louis-Philippe at Portsmouth, 8 October 1844*. The painting *is* a dream of color, and it continues toward abstraction, toward the "dissembling" of Turner's usually overannounced subject matter, a dissembling that begins who knows when, perhaps almost from the start of Turner's learning process.

The title change from *Burning* to *Disembarkation* . . . is a curious and typical Turner move, suggesting an ongoing concern of his—in spite of protestations to the contrary ("I don't paint to be understood")—that a good bit of the time the "themes" of his paintings cannot speak for themselves. Therefore, his paintings' titles tend to explain or put a stricter frame around the work. Apparently, the title *The Burning Ship* is not specific enough, nor limiting enough, since it seems that only one ship is front and center, so to speak, and that "burning"—though it may be a Turner signature—is less to the point than "disembarkation." Perhaps the *Louis-Philippe* is being "abandoned" in order to be burned or disembarked because it has caught fire. (How, one wonders, is it being "disembarked," since there is no indicator or clue to such an activity?) At any rate, this late oil is a fairly perfect example of how Turner's art after, say, 1835, is profoundly "impressionistic," which, in terms of his long-term development, means that the color application of oil has begun to produce its own meaning, including the "lighter" translucence of a watercolor (for example, from 1830, the watercolor *A Ship on Fire*).

The color and intensity of fire as a motivating source, in *The Disembarkation of Louis-Philippe at Portsmouth, 8 October 1844*, is suggestively opaque if not obscure. Critical viewers of the later Turner

are always looking for the figure in the carpet when the carpet itself is the figure. The fire here, as a browned-out red, becomes a marked if less vivid major motif in the picture; mostly it melts into the cooler colors of the sea and what comes over as the white and gray storm in the sky—sea and sky dominate. As a composition, however, Turner has balanced the burning ship(s) in the left portion with the "burning" white sunlight filling the right portion of the picture. This is a painting about consumption, about burning everywhere, notably at the end of Turner's brush and visceral brushstroke. Yet it keeps its distance; it does not exactly confront the viewer. Finally, it is a symbolist work of art, with the idea of the thing the informing image—or the image of the thing the informing idea. It is about the internal eye and the passion to unify. Whatever the artist's technique—brush, palette knife, fingernail, wipeout just after the paint is applied—whatever the conducting principle of Turner's vision, this painting is sublime to a near degree of silence. Turner has certainly painted loud fires and what sometimes looks like apocalyptic burnings before (as in *The Houses of Parliament* and *The Slave Ship*), but this newer piece is closer to an idea—an idea of fire within the fire of light, in the same way that the sea is a brilliant reflection of the sky. The ship or ships are the mere, truly and only, apparent subject.

Around this same late hour in his life, in an oil of almost exactly the same size (94 × 123 cm) as *Disembarkation*, Turner will apply almost exactly the same color combinations to a wholly different subject and effect: *Landscape with a River and a Bay in the Distance* (1840–1850). Bockemühl (2007) states that "spatial definition has become quite impossible" in this picture. "Various shapes—hills, a valley, a tree, water, clouds—develop out of formations on the sur-

face in gentle transitions and modulations of color, and then reconstruct themselves." He concludes that it is "no longer possible to give anything—no matter whether pictorial or representational—a precise and indisputable definition." Indeed, this oil washes like a watercolor, so that precision and definition must yield to a different burden. The objects in it, however, are fairly suggested—hills, a valley, a tree, a river, and a bay, and of course, a broad skein of very white clouds over the sky.

It is how these "objects" interact that seems to blur the tradition of landscape painting, a blurring that is now common in Turner's method of seeing nature. The dark, rather dense knot of red-brown, like a clot in the middle of the river, is central if odd since it is so similar to the color of the fire in *Disembarkation*; as such, it appears to have been bled into by a sort of autumnal ground cover or foliage on either side of the river—autumn because the red-browns are also the color of the leaves in the one tree. The inference is that whatever this interruption of/in the river may be, it is natural, crucial. It resembles a burning ship, if we accept the image of the *Disembarkation*. Turner, here at the end, is less interested in equivalency than poetry, the image on the eye of how the light is emanating from an intermediate world: this moment of land and water brought to its various visual life by the sun. Why the color scheme, in this work, reiterates the scheme in *Disembarkation* is an open question, though it does speak to what Turner's not-so-secret subject really is.

In 1925, in order to celebrate the centenary of the Norwich Castle Museum, a loan exhibition was organized to show the aesthetic connections between the countries of Europe. Sam Smiles (2007) writes that this "would be the first time that a collection of pictures

exemplified [the] modern view of art history, using eleven panels, most of them showing British and continental artists side by side." The artists included ranged from Rubens, Claude, Corot, Gainsborough, Constable, Turner, Delacroix, and Manet, to Monet. James Bolivar Manson attends the opening and writes, "The Turner was hung at the end of the gallery, and divided the old from the new. The effect was striking—not only was the picture signally modern in feeling and style, but it held its own with the best examples of the French Impressionist masters painted thirty or forty years later." The painting in question may be the later retitled *The Burning Ship*, but Manson's (1926) comment fits even better the major painting that in a very few years follows it. It is surely no accident that *Landscape with a River and a Bay in the Distance* is the first Turner oil owned by the Louvre.

I shall endeavor to get a pure and unaffected representation of the scenes that may employ me.

An issue for Constable, long after his death, will be a question of convention as opposed to originality, a question complicated by the fact that he invents the terms on which he will be sometimes dismissed; in other words, he appears to create the clichés he will often be accused of, clichés too easily imitated. The need to accept commissions is very much a part of his aesthetic problem—"a gentleman's park—is my aversion." *Wivenhoe Park*, painted in 1816 and commissioned by Major-General and Mrs. Slater-Rebow, is a perfect example of art by assignment: it is an excellent prospect of an Essex estate in which the house plays a distant secondary role to the well-tended land and property bequest that supports and surrounds it. The land variety—pasture, pond (artificial lake), copses, single trees, and scattered livestock—is both beautiful and practical, a combination of themes at the center of Constable's mission, while the diminished placement of the house suits his inherent bias for nature as a pastoral.

Constable's mixed feelings about commissions are not to be con-

fused with his promise to excellence. The year before the major-general's commission he has proved his ability with large-minded foreground-background perspectives, again, with two "window shots" from one of his parents' upstairs rooms: *Golding Constable's Flower Garden* and *Golding Constable's Kitchen Garden*, both of which emulate the modest size of the point of view without sacrificing depth of field. We see what the eye can see through the window's frame. The two paintings are companion pieces, and—considering where the viewer is sitting or standing—each includes a tremendous amount of information, though recorded at different times of day: the flower garden in the evening, the kitchen garden in the early afternoon. The demarcations of light from shadow mark the times of day. Both gardens graduate from the density and richness of their respective immediate foregrounding to a middle distance of ripe fields, then on to far-off farmhouses and barns—some more central than others— then a horizon line of trees, and finally fair-weather clouds filling pale skies. Nice days these, in which the ground tones are picked up by the reflecting color in the clouds. What defines this pair of paintings is definition—strong lines, sure forms, what's what. The coloration is equally clear if subdued, as if the sunlight has cooled to muted gold intensities.

Wivenhoe Park is almost twice the size of the garden paintings, if for no other reason than the fact that Constable is on scene, working in sunlight, standing on the far side of the man-made lake, with drawing materials, then painting materials; paper, then canvas. It will take him more than a week, summer day after summer day, end of August, start of September, to complete the painting. It is one of Constable's most panoramic and bucolic, with a camera sweep that on the viewer's left includes the owner's daughter in her donkey

cart and on the extreme right, at the far end of the lake, two fish-
ermen pulling up their line. In between is everything "important,"
elevated by balances: the cumulonimbus clouds matched by the full
foliage of the trees, seemingly in imitation, just under them; on
the left of center drift four grazing dairy cattle, on the right two
gliding swans; in the upper left, in the deep background, a dam for
controlling water levels, then closer in, in the foreground, a pasture
fence leading down to the lake; and very nicely, in the middle of
the picture, a cloud-white reflection of light pouring over the far
red brick house into the water in front of us. Even the light-shadow
interplay divides the painting, though by a percentage of 60:40 the
darker part dominates. One critic—Malcolm Cormack—calls the
painting "a triumph of naturalism"; another—Leslie Parris—speaks
of its "bold design with a wealth of convincing detail."

Constable himself, writing to Maria (close to the time of their
marriage), is concerned that "the great difficulty has been to get
so much in as they wanted to make them acquainted with the
scene—on my left is a grotto with some Elms—at the head of a
peice of water—in the centre is the house over a beautifull wood
and very far to the right is a Deer House—what it was necessary to
add, so that my view comprehended to many degrees—but today
I got over the difficulty and I begin to like it *myself*." One way
Constable is able to "comprehend" the total view that is desired
by the family is to glue three and seven-eighth–inch strips of new
canvas to the unfolded tacking edges on either side of his original
canvas in order to accommodate the deer house and the fisher-
men's boat. And he does so with such skill as to make the additions
indistinguishable from the rest of the painting. This last part is, of
course, accomplished and touched up inside, in the studio rather

than outside, in landscaped nature. It is artifice upped a notch—reality amended.

Wivenhoe Park will prove to be one of Constable's most "finished" paintings—meaning, finished-looking. It fits well into his career-long, creative method of working through a series of drawings and oil sketch drafts, before arriving where he believes he needs to be, where "I begin to like it." Yet there have been differing opinions about Constable's creative preparations for final, so-called finished pictures, especially those paintings that matter most to his reputation. He is a self-taught artist; it is as if early on he realizes the need to practice and practice his way to the best version of his vision. The question has been, for primarily twentieth-century viewers, which version is best—one of the lively, immediate-looking oil drafts, or the final, reconciled product? In his own time—that is, the need to join, as a full member, the Royal Academy—the more finished the painting the more promised the reward, but after his death, when Constable is being thought of as an influential modernist, "finish" seems a throwback. As late as 1973, the draft-versus-finished subject comes up in a poem entitled "The Painter," by no less than Robert Lowell: "But in his sketches more finished than his oils . . . / Constable can make us *see* the breeze . . ." Even later, in 2014, Andrew Wilton writes, in an essay entitled "Turner and Constable: Poetics and Technique," that Constable "formed the ambition to transform the practice of landscape painting by adapting the language of the sketch into a vehicle for creating large-scale exhibition pictures . . . Constable wanted to preserve the spontaneity and intimacy of his rapid methods." This involves, according to Wilton, "noting what [Constable] saw en plein air . . . in front of his subject," then progressing "to making a sketch on a canvas the size of his projected exhibition piece."

Constable's approach to drafts, in and of itself, tells a story: for example, the 1820 take on *Dedham Lock and Mill*, begun in 1809 as a pencil sketch of his father's corn mill on the River Stour is developed intermittently over the next ten/eleven years as oil sketch after oil sketch before becoming three "finished" versions—imitations?—of the same scene. Based on the original pencil drawing it is remarkable how consistent, from sketch to sketch, the structures of what Constable is seeing are. The mill itself sits off-center to the left, mid-picture, with the distant Dedham church exactly in the middle—in perspective, the mill and the church are the same height. In a boil of leaves at the far right and filling most of that third of the total space is a stand of, probably, elms. In the detail in between is the lock with a young man working the sluice and, of course, the water itself, under control and pooling right in front of the viewer. In the first oil sketch the water is being released and moving fast, and like everything else in this "capture" the paint has been applied quickly and impressionistically—it is the most active of all the versions, with a sky, no less than the trees, in a further boil of white and gray clouds.

This first 1816 oil sketch will serve as the template for what follows. A year later, in an "unfinished" rendering, the scene is stormier, darker, browner, the sky threatening, with rain about to fall, yet the river is calm, the trees more rustic, all of it—the whole setting—more delineated, especially the mill and attendant buildings reflected as deep shadows on the water. Are these two "sketchy" versions a matter of different days and different weather and a desire to get the moment just right? Or are we attempting to perfect the same, indelible moment? The next three years represent the three finished versions, each with its own variations: in 1818, the first of

the final readings of *Dedham Lock and Mill*, the scene is essentially a repeat of the setup of the last oil sketch, the difference being the refinement of line and detail and definition of object; the two 1820 so-called imitation versions are more amendatory than imitative since they add elements and clarify, with even more delineation and precision—they add a second draft horse under the dominant trees, they add a river sailboat on the lower left, opposite side, they "freshen-up" and brighten the clouds in the formerly gloomy skies, and they sharpen, by yet one more turn, the focus of what we are seeing. If anything, the second copy-painting is that much sharper. A fourth major difference is that the two copies are both smaller than the original final picture by several inches.

It is always impossible to know what a picture wants till it comes to the last . . .

Why make "duplicates" of your art in the first place? The motive is not unlike the reason for commissions, though as an idea it is certainly different. Money is one motive. Having sold, rather quickly, the 1818 version of his Dedham Mill scene, Constable apparently hopes to cash in on what he perceives is popular material—that is, an honest moment from England's pastoral life brought to new life through art, a moment that just happens to be autobiographical, personal, and therefore all that more authentic. Why not, then—harsh word—exploit it; why not, in fact— a better motive—improve upon it through a few emendations that point toward an even more successful final picture? The question is important because it goes to the issue of inherently loved material so familiar, so "naturalistic," and so effectively made that, once it is established as a part of British art culture, it can in the future be too easily copied or plagiarized; indeed, repeated by amateurs and passed off, after a suitable intermission—say, in a late nineteenth-century

marketplace—as the real thing, as art so popular as to become a cliché of a Constable English landscape.

This will be exactly, down the road, what happens: Constables as calendar art, purchased at a fair price, whether as a cheat or as a homage. In making copies of this exceptional Dedham painting—however much or little he alters them—Constable potentially participates in a diminishment, unless the variation of elements and subtle changes in the weather make enough difference to distinguish such "copies." A painting is meant to be unique, however much detail is or is not carried over, copy to copy, and it is unique to the degree that, copy to copy, changes are introduced. The irony is that the practice of "self-plagiarism" speaks to a kind of condescension toward the possible buyer. In the event, Constable has had to borrow back from its owner, one J. Pinhorn, his 1818 version of *Dedham Lock and Mill* in order to make his second and third copies, for which he never finds buyers.

Judgments can be facile, too easy. "Copying yourself" is a curious artistic issue, particularly since so much of Constable's signature art is identified with "Constable country" in all its specifics, atmospherics, and emblems, including his Hampstead cloud studies. The same "scene"—drafted as well as finished—can be looked at in terms of any number of perspectives, depending on the moods of weather, painter, time of day, season, and year. But making a more-or-less facsimile copy for profit, however slightly various in detail and however pressing the financial need, is not the same as pursuing or obsessing on a subject, a scene, or a moment in time—that is, in the nature of inspiration and knowing what your sources are. Very little of the best of Constable's nearly forty-year career is devoted to

landscapes and skies outside the Stour Valley and Hampstead Heath, and there is nothing in nature he cares for more than absolute fidelity to the "rustic" and working world he grows up in, his father's world, if you will, and the world of its specific elms and oaks, its corn mills and the River Stour, its broad fields and dark lanes, its farm and mill laborers and their families, and the villages of East Bergholt and Dedham. He is, like his contemporary Romantics, a poet of place; place is his emotional center and correlative. It is no accident that Dedham Lock and Mill is owned and operated by his father, and that just months before the first drawing and first oil sketch of the lock and mill Constable's father has died. It is no accident that in this same circle of time, summer and autumn of 1816, he and Maria Bicknell marry. The *Lock* series of revisions and versions and copies is at once a compound elegy and a commodity; it is at once spiritual and practical, the cause of the one the death of his father, the cause of the other the price of his marriage.

Obsession, for Constable, is inseparable from his positive provincialism. (Any catalogue of his life's work leaves no doubt as to the geography of his heart—indeed, he returns, thirty years later, in a heavy sepia drawing, to the central portion of his *Dedham Lock* painting—Dedham church featured between the frame of large blots of trees.) Nevertheless, in 1817, both his marriage and the need to promote his work persuade him to establish a residence in London, first on Keppel Street near the new British Museum, then on Charlotte Street near Russell Square, both addresses a fair day's ride from his sources, and a living situation that may further explain the drawing-to-oil, sketch-to-canvas method he comes to depend on in drafting different versions. Now his plein air sketches will turn into studio art, an adjustment that will help account for an elevation of

his attitude in the next phase of his career, starting in 1819—that is, the Stour six-footers and the high romance of defining, by name, Constable's remembered home landscape.

Every landscape artist has his territory (or in Turner's case, territories), whether literally on scene, in memory, or discovered in imagination and whether here and now or in myth or in history. Aelbert Cuyp may enjoy his moment of combining, in *A Herdsman with Five Cows by a River*, the bucolic (the best cows ever painted) with river sailboats, but it is the glorious Netherlands sunset filling up the canopy cloud cover that outshines over the water and the shore. Ruisdael's *Forest Scene* may suggest nature as Dutch melodrama, but the tangle of fallen birch trees, the dark upsweep of trees still standing, and the yellow-gray storm light above it all give weight to something close to a tragic vision. Claude's *Judgment of Paris* may be imbedded in the mind of ancient Greek fantasy, but he needs the wild and golden Campagna to ground his painting in a verisimilitude of mythic reality. Gainsborough may seem to be looking at *Mr. and Mrs. Andrews*, but his eyes are suffused in a gold-leavened harvest day-ending light that gives meaning to the gathered grain. Richard Wilson may share Claude's affection for perfectly suffused Italian light, but his perspective version of *Tivoli* is a self-portrait of the artist in cliff-side rough nature painting himself painting.

Landscape and the so-called natural world are too often spoken of interchangeably, including poets and artists themselves. In terms of England, Wordsworth's Lake District and Coleridge's Exmoor might qualify as wild, though Mount Snowdon, in Wales, and the Swiss Alps, where they both spend time touring, are wilder. Yet each of them more commonly and famously writes about more pas-

toral and local settings, whether the point of view is from a distance above the ruins at Tintern Abbey or in the memory of a serious walk in the lush park and deep woods at Nether Stowey, Somerset. Is James Thomson's epic *The Seasons* about actual nature or about well-turned, domesticated estate landscape? "Say, shall we wind / Along the streams? Or walk the smiling mead? / Or court the forest glades? Or wander wild / Among the waving harvests?" Is Keats's mournful nightingale singing in a more natural setting than the lounging corn goddess Ceres during harvest? Human beings have been corrupting nature for survival agricultural purposes since forever, while, conversely, wild nature, alien nature, by these lights, may be sublime but it is also dangerous. Turner loves the mountains and mountain passes and the ocean in its fury; for Constable, "the solitude of mountains opposed his spirits," perhaps because, in spirit, "I live almost wholly in the fields, and see nobody but the harvest men."

Nineteenth-century pastoral landscape requires a certain human intervention and dwelling, property rights and dividing up, ownership and parceled land, inheritance and tenant farmer, aristocracy and servant. The meaning of landscape is what is meant by after the fall, when the garden must be cultivated, tended, and worked. Not unlike the way a painting must be cultivated, tended, and revisited.

Much has been made of Constable's reason for moving to a much larger surface for his landscapes. The most pragmatic reason seems to be the way paintings are presented at the annual Royal Academy show, chockablock to chockablock, wall to wall. A smaller, more normal-sized work disappears among the blur of frames and themes and color. It is obvious that a given size displaces and calls attention to itself. Since the best known of Constable's large landscapes

is the sequence of Stour six-footers brought to finish over a period, appropriately, of six years (not that he does not paint other successful studies and pictures in that exceptionally productive time), it is important to take him at his word that "I do not consider myself at work without I am before a six foot canvas." So he writes his friend Fisher in the middle of the Stour project. There is, then, perhaps a less mercenary reason for the wider canvas and, ironically, the complex and close-up intimacy it offers. Constable has commonly painted "bigger" pictures within smaller spaces, spaces that take on the panorama of the full pastoral, spaces meant to include as much as possible within the sweep of his camera—this is as true of his busy garden pictures from the window of the family home as it is of his time at Brighton looking down the big beach toward the horizon. But the feeling is different in these cooler garden, seaside, more objective works—Constable seems to be standing well outside his subject, acting as the artist. In the famous six-footers he seems to be as much participant as artist, as someone who is a part of the picture, inside the held moment of the story. They represent an imagined personal history while at the same time Constable's artistic present tense.

There has never been an age, however rude and uncultivated, in which the love of landscape has not been in some way manifested.

Perhaps because they were completed at different times over the six years of their composition; perhaps because he painted significant other pieces, including his cloud studies, within this same period; perhaps because they were unplanned as a sequence and developed in their own time as an ultimately implied unified group; perhaps because their unity suffered its own kind of diaspora, as pieces ending up here and there in various galleries and museums; perhaps a lot of things: the six Stour six-footers become an idea of a collected whole only in conception, on reflection, primarily in imagination. They become a book in the mind. In order, *The White Horse* (1819) is housed at the Frick; *Flatford Mill* (1820) is part of a private collection; *The Hay Wain* (1821) is now at the Victoria and Albert Museum; *View on the Stour, Near Dedham* (1822) is finally at the Huntington Library and Art Gallery; and *A Boat Passing a Lock* (1824) and *The Leaping Horse* (1825) are at the Royal Academy of Arts. The

fact that Turner requested that his hundred finished paintings be kept together as a gift to the nation and, by implication, mounted in some sort of selection and chronology, confirms his confidence. But that did not happen, not exactly and not immediately. At least insofar as his six-footers are concerned, Constable appears never to have considered his oeuvre a totality, let alone a coherency of these sequential paintings.

Character may ultimately be fate but it is also behind the immediate personality of one's art. Constable is an extremely self-contained man, if at times uncertain. He is forty the year he marries Maria Bicknell, and forty-three the year he paints his first six-footer, the same year that he is elected as an associate of the Royal Academy, a distinction Turner, at twenty-four, receives in 1799 before becoming, in three short years, a full Royal Academy member. Constable will have to wait until he is fifty-three to be a full member (and even then perhaps only out of sympathy with his wife's recent passing). The point has to do with the relative value members of the Academy place on Constable's work as well as what they experience, individually, as a lack of fellow feeling. Perhaps Constable is still perceived as an improving "country artist," whose single subject is too single; perhaps he comes over as too much the Tory farmer out of his depth in the city; perhaps he has dismissed the art of too many Academy artists, a habit he shares with history painter Benjamin Haydon, though Constable's complaint is aesthetic while Haydon's is political.

Constable is obviously a man of strong opinions, notably about the art of landscapes, his landscapes. He is also an inward man, with a singular vision of what true landscape art is—that is, what ordinary functional country life and actual natural country settings amount to as inspiration. His melancholy bearing, even isolation,

will grow, in the course of time, right up until his death, though it will become profoundly apparent in the aftermath of his beloved wife's long dying, just after the birth of their seventh child. ("Constable . . . was never a worldly man in the sense that he found it an easy place to live in" [Sunderland, 2014].) For now, with the personal six-footers—personal tragedy aside—we are trying to evoke the common soul of what a tableau of Suffolk working farm life might be like within the world of memory or proposed memory, whether it is nothing more than stopping at certain moments in the process of planting and harvesting the corn, milling it, and shipping it down the river system to the London docks; whether it is simply paying honest attention to the millwheels, windmills, barges and their horses; or whether it is seeing sunlight and cloud impressions on the water, and especially the soft or storm winds in the crowns of the trees. "I was born to paint a happier land, my own dear old England."

My dear old England, therefore, the making of *The White Horse*, which was originally and uninspiringly entitled *A Scene on the River Stour*. It is his friend and the painting's purchaser, John Fisher, who retitles the painting. Constable is consistently terrible with titles, as if he were attempting, rather self-consciously, to avoid overstating his art's mission. But as if he is as much a writer as painter, Constable does understand the organizing principles of content in his pictures, the way objects in warm relation to one another can form a plot to effect meaning. "My own dear old England" is the very idea he must transform. Why is the white horse being ferried when the likely normal "old England" business of a draft horse in such a harness is to tow a boat (barge), not ride in one? John Walker (1978) states that the painting "shows a part of the Stour downstream from Flatford

Mill, where the towpath changes from one bank to the other because it is interrupted by tributary streams. At this place it was customary, as there was no convenient bridge, to ferry the tow horse across the river." In other words, this is the most interesting choice of moments in the daily life of the work schedule—and the most ironic, since the roles of the horse and pole man are essentially reversed.

The painting is well received, both by view and review. It is Constable's first large picture on display at the Royal Academy, its size itself compelling attention. Yet the focus of the work is not panoramic but dramatic, close in and relatively close up, wonderfully fleshed out in local natural detail. *The Examiner* praises its "outward lineament and look of trees, water, boats, etc." as better "than any of our landscape painters." Curious that the reviewer (probably Robert Hunt) does not mention the horse, its whiteness, nor the whiteness of Willy Lott's house a little in the distance, nor the contrasting red of the ferryman's shirt. Nor does the reviewer notice the three important cattle drinking off to the right of center. It is a picture you could walk into. There seems to be no adequate language yet for the kind of concentration Constable has proposed. Another observer writes that "this choice falls happily on the picturesque, and the river scene is clothed, like the pictures of Ruysdael and Hobbima, with a rich variety of forms, on which the artist has displayed his usual skill in the truth and character of the detail."

"Picturesque"—a much maligned term—will haunt the popular opinion of Constable's work for a good long while, as will the perception that he has "clothed" nature. Are his paintings too rough or too dressed, too irregular or too regular? Are they truthful or beautiful? Accuracy and detail are much more to the point. The "lineament" of the trees, water, and the boat certainly do have a "look"—the look of

knowledge, intimacy, love—along with the horse, the buildings, the grand white fair-weather clouds, they represent a maturation animated from inside the experience as well as inside the frame the painter has placed around it.

Separation can make the heart grow fonder and the skill sharper. *The White Horse* is a London picture, painted in Constable's Keppel Street studio. It is based, as always, on a preliminary pencil drawing more or less on scene; it is the product of his first attempt to do a final oil sketch in the same size as the finished version. That sketch, now hanging in the National Gallery in Washington, D.C., is once again, as an example, interesting and arresting in its own right. In fact, it is really another painting altogether, rougher, darker, stormier, bleaker; therefore its mood is totally different. Instead of the light-filled Frick version, the oil sketch looks as if night is falling, the workday ending, and a moon rising, rather than a time of day in which the sun, in midafternoon, is luminous with clouds—the sketch of a kind of melancholy undertow to the implied happiness of the finished painting. And while not as magnificent as the version at the Frick, it has its own quality and identity, freer, more sudden. Whichever version, being removed from the source seems to have intensified and enhanced Constable's keen understanding of what is fixed in memory—memory that acts as a changer as opposed to the imitator of an inspiration.

In no time Constable is filling out oil sketches for his second six-footer *Flatford Mill*, or more generally, *Landscape*, then, for expository reasons, *The Young Waltonians*. The trick here, as it was in the first six-footer, is to play with expectation: the mill is hardly visible, snuggled off to the far left side of the viewer's perspective, helped in its small notice by the river trees bent in its direction by the wind.

("The principal group of trees exposed to the currents of wind blowing over the meadows continually acting on their boles inclines them from their natural upright position and accounts for their leaning to the left side of the picture" [Lucas].) The real focus—even, apparently, in the now lost first pencil notes—is the anglers, whose obscurity as individuals is ultimately clarified the closer we get to the accepted version. Each of the full oil sketches, in fact, moves closer in clarity to the whole scene, and each has standing, having been placed in such venues as the Hart Collection, the Yale Center, and in private hands. The basic stage setup is generational, with two young boys, nearest the viewer, fishing from the channel edge while immediately to their left is an older man doing the same. On the other side of the sluice is a figure—a teenager?—also fishing, and across the main water, in a small barge, are two workmen. A young girl, a white tow horse (our earlier white horse?), and a figure far left watering his bay have all been painted out over the course of things. At ground level the majority of configuration and action is to the left. The peace and calm of a fishing afternoon seems to be what Constable is after, sans the distraction of too many individuals, animal and human.

Fleshed out, the Langham Hills are just visible on the horizon, a bit to the right, in order to establish distances; they are woolly with vegetation and trees. As an addition, the river has curved in their direction. And right above the hills and pressing forward toward the tall river trees that dominate the center of the picture is a sky animated with beautifully active brilliant clouds, the most attention to clouds Constable has so far created, as if to counter the familiar complaint about the preliminary sketches that they are too often too much "tinctured with a somber darkness" (Watts). As with *The*

White Horse, the final version of the mill painting, through its great skies, means to transcend the deeper sketched-out mood; indeed, once again Constable has worked through the process of some sort of spiritual if not emotional connection to his material through yearslong studies of his central subject. And once again, *The Examiner* acknowledges Constable's superiority as a landscapist, writing that *Flatford Mill* offers a "more exact look at nature than any picture we have seen by an Englishman, and has been unequalled by very few of the boasted foreigners of former days, except in finishing." Who and how far back the comparison of these "boasted foreigner" painters goes is a question, though the mixed compliment is intriguing as to the matter and convention of taste, since "finish," from a more contemporary reading, is exactly what Constable is resisting and re-creating.

13

The power of Chiaro Oscuro is lessened—but it has rather a more novel look than I expected.

That novel look is the look of Constable's third, and peak, six-footer, originally called *Landscape—Noon* but more appropriately, and ultimately, entitled *The Hay Wain*. As for chiaroscuro—that often laded use of light and shadow in paintings—Constable's 1820 preliminary oil sketch uses up much of his portion: it is a wonderful mess and mass of contrast in which shapes become almost amorphous in an obvious quick study, with an emphasis on *quick*, as in spontaneous, alive. Yet, even so, the overall design of the sketch is clear, with Willy Lott's cottage returning as a stabilizing structure at the extreme left, backed up, in a later, full-sized oil sketch, by looming river trees that work their way to the middle of the picture, while behind these two motifs lies a far horizon line of trees under a big cloud-filled sky, details to be clarified later. ("The stark transitions from light to dark in the sketch have given way to the serenity of a summer's landscape at noon" [Cormack, 1986].) The crucial hay wagon itself, in each of the versions—notably the final version—is midstream, just a tad right of center, flanked by a hunting

dog (puppy?) on the left, at the waterline of the shore, and a man with a pole (an angler?) on the far right side, in a small boat, apparently busy among the cattails and water foliage. The two young men in the wagon are being pulled by two large black canal horses decked in a very red harness; the boys face each other, side to side, rather than an expected side-by-side arrangement. They appear to be in animate conversation, the younger one making a point with a raised right arm. The narrative of the empty hay wain itself indicates that the hay load has been delivered and that the young men are headed back home or back to the field, which is now warmly off in the upper right distance and peopled with harvesters and another wagon.

The Hay Wain is Constable's most famous picture, and, considering its size, balance, and complexity, it is a painting he brought off in fairly short order—that is, compared with the majority of his large work: done in five months, and that timeline includes preparatory sketches. In its own subtle way *The Hay Wain* marks an advance over the first two six-footers in its degree and gradation of detail: which is to say it sublimates its use of chiaroscuro to the extent that the edges of figure and ground—river and shore, field and tree line, architecture of the one building, the wagon in the water, the various crowns of the trees, and especially the more involved depths of the clouds—soften keen contrast in favor of graduation, singular focus in favor of equanimity, and color emphasis in favor of unity, as if the painting's saliencies were equal, or almost equal (that is, the red harness), in the overall.

The Hay Wain articulates the romance of essentially all of Constable's major pastoral ideas: the implied truth and value of farm- and millwork; the in-medias-res moment of the capture of that truth; the absolute commitment to that moment's vibrant and illuminat-

ing detail; the honoring of the domestic life supporting these values (Lott's cottage, the spaniel on the shore); and most of all, the warm natural setting—no, world—in which the inherent story of these themes is enacted. *The Hay Wain*, as well, is a work executed in the studio, so that memory and imagination—and, yes, nostalgia—play a basic role. At one point Constable writes his brother Abram for advice on "the exact appearance of the hay-wain," to which in reply his brother sends him "John Dunthorne's outlines of a Scrave or harvest Waggon." What helps make a masterpiece of this painting is its tone, the modulation of the way detail seems to flow from quiet color to color, edge to edge, the way, for instance, we can track the wagon wheels in the water and the way the water-reflected trees and Lott's cottage nearly disappear into the bottom. Yet the total picture is perfect in perspective, the depth of the literal field leading easily to the horizon of a wide woods. Then there is the sky, which seems to have profited from Constable's practice, in Hampstead, of his cloud studies—they have that much more personality and force as they push and exceed the top of the painting in a wind that drives them higher across the sky beyond the limits of the canvas. The total luminous surface, though—its appeal to "wetness," via "Constable's snow"—is what lifts this painting into life. It shimmers.

"I hear little of landscape—why? The Londoners with all their ingenuity as artists know nothing of the feeling of a country life (the essence of landscape)—any more than a hackney coach horse knows of pasture." This in an April 1821 letter to his friend Fisher. Insofar as the Royal Academy is concerned, *The Hay Wain*, by example, suggests Constable's—conscious or subconscious—attempt to finally set the record straight. Though when it makes its appearance on the Academy walls in that same month, same year, this great "land-

scape" is received with respect but little else, except by two French visitors: Théodore Géricault and Charles Nodier. Géricault, curiously enough, is one of the leaders of the French avant-garde; Nodier is a leading art critic. They, unlike their English counterparts, are impressed. Nevertheless, like the bulk of Constable's work—minus the in-house support of friends—*The Hay Wain* does not sell, so it goes on exhibition again at the beginning of the new year at the British Institution, where it at last does receive an offer of seventy pounds, which the artist turns down, in spite of needing the money "dreadfully." The French art dealer John Arrowsmith, who wants to buy the picture, eventually manages to talk Constable into a deal involving several smaller paintings along with *The Hay Wain* and *View on the Stour, Near Dedham* (the fourth six-footer in the series) for a price of 250 pounds, a fact that Fisher responds to by excoriating the "stupid English public, which has no judgement of its own. . . . You have long laid under a mistake. Men do not purchase pictures because they admire them, but because others covet them."

Nodier, in his essay on his visit to Britain, had written that the "palm of the [Academy] exhibition belongs to a large landscape by Constable, with which the ancient or modern masters have very few masterpieces that could be put in opposition." No faint praise, indeed. Constable, however, in his usual contrarian mode, has his own long view of things. A few years later, in commenting on the French response to Arrowsmith's purchase, he writes Fisher that "They are very amusing and acute, but very shallow and feeble" (speaking of his French admirers).

Thus one—after saying, "it is but justice to admire the *truth*— the *color*—and *general vivacity* & richness—yet they want the

objects more formed and defined, & c, and say that they are like
the rich preludes in musick, and the full harmonious warblings
of the Aeolian lyre, which *means* nothing, and they call them
orations—and harangues—and highflown conversations affect-
ing a careless ease—&c&c&c—Is not some of this *blame* the
highest *praise*—what is poetry?—What is Coleridge's Ancient
Mariner (the very best modern poem) but something like this?"

No wonder Constable could not accept the invitation to come
to Paris in order to receive a gold medal from Charles X; such a
reward for *The Hay Wain* must have seemed off the subject. What
is the subject? What is it about *The Hay Wain* in particular and
Arrowsmith's other Constable acquisitions to so cause the French
such excitement? Stendhal, in the *Journal de Paris*, praises "to the
skies" these *paysages magnifiques*; another viewer speaks of the larg-
est of purchased paintings (the two six-footers) as "a miracle." The
French see something of the future in these Constables, something
new in the application of the paint, via hard brush or palette knife.
They see something in Constable's use of "snow." In his essay on his
visit to the London art scene, Nodier makes a further brilliant point
about what he is seeing in the horse-and-wagon painting: "Near, it
is only broad daubings of ill-laid colours, which offend the touch
as well as the sight, they are so coarse and uneven. At a distance of
a few steps it is a picturesque country, a rustic dwelling, a low river
whose little waves foam over the pebbles, a cart crossing a ford: It is
water, air, and sky; it is Ruysdael, Wouverman, or Constable." It is
actually neither of the first two—it is Constable.

It is, moreover, an early example of Constable's fine touch of
white spots or flecks or "daubings" that will become a signature

in his art as he attempts to give wet texture to the angularity of the light—a "snow" that highlights while being absorbed into the objects of the coherency of the composition once the viewer keeps his or her distance. "Though the director, the Count Forbin, gave my pictures very respectable situations in the Louvre in the first instance, yet on being exhibited a few weeks, they advanced in reputation, and were removed from their original situations to a post of honour, two prime places in the principal room . . . I must do justice to the count, who is no artist I believe, and thought that as the colours are rough, they should be seen at a distance." Constable adds, in this answer to a letter from Fisher, it is "the richness of texture and attention to the surface of things" that seems attractive to the French. Fisher had written from Paris that "You are accused of carelessness by those who acknowledge the truth of your effects; and the freshness of your pictures has taught them that though your means may not be essential, your end must be to produce an imitation of nature . . . I saw one man draw another to your pictures with this expression, 'Look at these landscapes by an Englishman— the ground appears to be covered with dew.'"

If time allows I shall excell my other large pictures.

I n the course of the next four-plus years Constable will complete what becomes his cycle of six-footer River Stour paintings, beginning with *A View on the Stour, Near Dedham* (1822), a picture he feels will elevate the vision he has tried for in the first three pictures, particularly the accomplishment of *The Hay Wain*. Indeed, each of these new river works intends to further elevate and round out Constable's meditation on the pastoral, practical work life of the valley, the river, and their representational beauty. "If time allows" is a melancholy grace note typical of Constable's popular mood regarding his art, yet at the same time an indication of the informing tone of that art. *View on the Stour, A Boat Passing a Lock*, and *The Leaping Horse* will each leave their trail of sketches and preliminary oils and various subtractions and additions of figures and elements; in each case the painter will feel he has excelled in nature, texture, and dramatic effect, when, in fact, in each of these new paintings he will have met and mastered a separate challenge.

About the *Stour* painting, for instance, he fantasizes "a canal . . . full of the bustle of incidents of such a scene where four or five

boats are passing with dogs, horses, boys, & men & women & children, and best of all old timber props, waterplants, willow stumps, sedges old nets &c &c &c." This busy business is not exactly what he ends up with. About the *Lock* painting, he writes Fisher that "I was never more fully bent on any picture than on that on which you left me engaged upon. It is going to audit with all its deficiencies in hand—my *friends* all tell me it is my best. Be that as it may I have done my best. It is a good subject and an admirable instance of the picturesque." Deficiencies, whatever they are, aside, the *Lock* is picturesque in only the most severe test; it is about work, backbreaking work. As for *The Leaping Horse*, Constable's comment is that the scene is in Suffolk—as if we needed to be reminded—along the "banks of a navigable river, barge horse leaping on an old bridge, under which is a floodgate and an elibray, river plants and weeds, a moorhen frightened from her nest—near by in the meadows is the fine Gothic tower of Dedham." Busyness again, in a wholly imagined action, much of which busyness is ultimately painted out in favor of other objects and detail, including the subtraction—or "obscuration"—of the moorhen.

John Sunderland (2014) describes the artist's evolving method as "staccato stabs of thick paint" and Constable's snow as "dragged specks of white pigment." These last three large river paintings mark the real step up of Constable's technique of trying to ignite the surface of his subjects with brilliance—"I have filled my head with certain notions of *freshness* and *sparkle*—brightness—till it has influenced my practice in no small degree, and is in fact taking the place of truth so invidious is [the] manner." Close up you cannot even begin to see these newer Constable paintings; they come over as chaos. You need an organizing distance in order for the eyes to

focus but also for the eyes to feel the "stabs" and "specks" of the reality of the paint transforming the reality of the shapes within the frame. This is especially true of *The Leaping Horse*, the most active and ignited of the six-footers. Much of the magnificence of the painting derives from a kind of visual pointillist-like synesthesia in which the driven life in the great clouds and wind-blown river trees becomes mixed up with the rushing of floodgate water, so that *they*, together, act as the source of light and brightness and sparkle emanating from everything seemingly solid, which is also broken into "stabs of thick paint." And nothing is more solid in Constable than the body and backside of his leaping horse, outfitted full with harness and rider, a horse trained to leap, to defy the gravity of its own and extra rider's weight. It is as if these sources of "Constable's snow" are intended, ever so much, to make an abstraction of light, refracted and reflected. And not abstracted sunlight exactly, nor even sunlight as such, but its intermission through intermediaries. Sunlight separated, scattered, falling through clouds, lifting what it touches. Sunlight helping to lift the horse.

I should like to see the sun again.

This being the actual utterance of Turner his last December, in 1851, instead of the sun-haunted last words Turner's chief sponsor, John Ruskin, turns the utterance into—that is, "The sun is God." Although Turner probably thought the sun is God, he likely did not, as such, say so, certainly not with his final breath. How curious that there is only one sun for the one earth, yet how far apart Constable and Turner are in how they see it. For Constable it is a national star, even local, ranging in its Englishness from the Stour Valley to the cloud-filled skies over Hampstead to the expanse of Salisbury Plain to the coastal line at Brighton. For Turner the sun is international, multicultural, historical, ranging up and down the entire island of moody Britain, then over to the continent of the Swiss Alps, the countrysides of France, Italy, Germany, and the Netherlands, plus the cultural cities of Paris, Rome, and, notably, Venice—always a brilliant sun or a morning or evening sun at the still point of the picture.

Turner, indeed, is all over the place, the sun his center of gravity. His need for and love of travel parallels his commitment to having a pencil or brush in hand, seemingly, at all times in all weathers, out-

doors or indoors. And travel surely parallels the number and variety of drawings, watercolors, and oils that define his peripatetic and very private way of life. Movement is his metaphor, restlessness his mode, as if attachments (with the exception of his father) are impediments, whereas everything else in the objective transient world is subject to his eye, especially favorites such as—in more or less chronological order—ships in one kind of stress or another, far-off half-ruins of castles, well-delineated fantasies of classical history, severe and sublime grandeur, and, finally and most importantly, small moments in small parts of places. The one constant, among Turner's great catalogue and within his great spectrum of finished and so-called unfinished work, is the source of light: it is his singular clarifying image as a painter of range, ambition, and various genius of "indistinctness."

Andrew Wilton, in an essay on both Constable and Turner, says of the latter that as early as 1802, "Turner had effectively two careers: as a topographical watercolourist, and as a high-flying painter of histories, heroic landscapes and seascapes." Turner's ambition, he goes on, "was huge: to bring his two careers together into a single ambitious programme in which landscape painting acquired the seriousness of history, and watercolour took on the power of oil." Wilton concludes that "in the long run, which he clearly planned," Turner wished "to create a body of work that would rival not only the artists of the past but also his own contemporaries, many of whom he quite openly imitated, in what was obviously a determination to prove himself equal if not superior to them, but also in friendly rivalry with his artist 'brothers.'" This compacted summary of a twenty-seven-year-old Turner's young labor in the art of painting is just that, a summary; for the time being it may be fair but it is also a compressed reading of what will become a profoundly complex,

thorough-going, ever-challenging nearly sixty-year employment of deeply realized talent. It is accurate insofar as the originality of Turner's ultimate lifelong relationship of oil-to-watercolor, watercolor-to-oil technique is concerned; it is less accurate insofar as Turner's dynamic relationship to the art of the past and present is concerned: throughout his career Turner richly admires and often emulates the landscape history of painting; and he has an ongoing playful yet competitive attitude toward his brother artists: but he is in no way derivative or condescending toward either category. He will endure as a landscape traditionalist who transcends tradition. Constable, too, starts by honoring the pastoral past only to end somewhere in the future. For each of them what is classic, timeworn, and loosely labeled as landscape art will change what it is looking at and seeing.

Constable's considerable nationalist claim as a landscape painter is always in front of us, always familiar, always definite in his residence range of choices. Turner's position as a landscapist—in spite of the national landscape role he is again and again assigned—is at once more encompassing, more exotic, and more and more, technically, indirect, in part because, unlike Constable, he claims no one home ground or single territory to identify with. His places are all over the place, beginning with his early travels throughout the British Isles. Oddly enough, in 1796, the very first picture he hangs on the wall of the Royal Academy is of the moon, not the sun god, dramatically visible over the southwestern end of the Isle of Wight. It is entitled *Fisherman at Sea*, whose content is a small vessel moving along the surface of a high swell, the central scene of which is spotlighted for the viewer by a full moon rising just under dark storm clouds, while in the midrange left side of the picture looms a large rock formation that resembles ghost ships in full sail. The painting is

taken from sketches from a visit of the year before. The most inter-esting moment in the piece may well be the haunting pale shade of the night sky immediately under a moon that resembles a portal space leading to some spectral mystery.

Boats associated with either natural or man-made violence fas-cinate Turner from the outset as do the ruins or half-ruins of cas-tles and the massive ship-like architecture of cathedrals and the mountain and glacial passages of the Alps—then there is the hom-age to history, both actual or aesthetical, whether to Claude Lor-rain, Nicolas Poussin, Aelbert Cuyp, Rembrandt, Richard Wilson, Joshua Reynolds, or to the building up and tearing down of Car-thage. The plurality of Turner's work speaks for itself, the quality and emphasis of the performance, from phase to phase, also speaks for itself: though more often than not it is his intense handling of a wild sky and charged source of light—regardless of the ostensible subject—that is the difference between his raw talent and his genius. The fact that Turner's contemporaries love his early seascapes is tes-tified to by his early admission (associate in 1799; full membership in 1802) into the Royal Academy: ships at sea is familiar enough; ships truly at sea, in a froth of stress, is another subject altogether.

We do not even have to go *out to sea* in order to have the Turner sea experience. *The Iveagh Seapiece, or Coast Scene with Fishermen Hauling a Boat Ashore* (1803) is one of Turner's best renditions of a sea in turmoil, this time right up against the mudflat of a beach in which not one but two boats are being "hauled" by not one fish-erman but at least nine—the ambiguity lies in the opposed direc-tions of the two prows, the larger, more difficult boat being pulled toward the land, the other, smaller boat being pushed in the direc-tion of the water. Then there is the third boat already heading out,

its four-man crew at half-sail and in some likely trouble; things may improve once this group has made it past the shoreline, a shoreline that foreshortens the horizon, emphasizing the wall of water now all thirteen of the men are up against. It is the sky, however, the storm light of what is probably an early morning sky that becomes the most ominous presence in the picture: it looks not only dangerous but deadly, almost animal in its potential violence. *Calais Pier, with French Poissards Preparing for Sea: An English Packet Arriving* (also 1803) is just as violent and no less double directed in its boat activity: one boat, the French, embarking, the other, the English boat, trying to disembark. Thus the froth and near fury of the water pressed against the pier is busy with passengers leaving and arriving in at least two boats, with other boats close in or shadowed in the distance. Full sails help magnify the storminess. The sky, again, is dark and ominous, with a hopeful blue break in the storm clouds in the high middle of the picture; the sky is the great weight over everything. In both the *Seapiece* and the *Pier* the sun is the numinous ignition behind the gathered, threatening cloud cover.

How small these people are: the fishermen, the passengers. In Constable, the common working people in his paintings are crucial to the meaning of his working landscapes; they are integral to the balance of machine, domestic life, trees, the river, and beneficent clouds. They are part of the nature of things. In Turner, particularly in his art before the 1830s, the human figure is just that, a sometime necessary diminished detail in a larger, apocalyptic scheme in which a vortex of energy has taken over. Greater nature becomes the antagonist. In the late work the human figure has completely disappeared. When you compare, for example, two of Turner's snow storm paintings, one from 1812, *Snow Storm: Hannibal and His Army Crossing the Alps*, the

other from 1842, *Snow Storm—Steam-Boat Off a Harbour's Mouth Making Signals in Shallow Water and Going by the Lead. The Author Was in This Storm on the Night the* Ariel *Left Harwich*, the difference of thirty years is telling. In *Hannibal*, the "background" completely supplants the foreground—the human figures (including the tiny gesture of an elephant) become like tokens of a dwarfed humanity, even if they are soldiers. The overwhelming sky—three-quarters of the picture—becomes a caldron of color and energy, turning in its circle of brilliant light and menacing dark within a celestial wind, as if it were a judgment. The actual pure yellow circle of the sun, so far away in this mixing bowl of natural power, seems held up like a lantern.

In *Steam-Boat*, Turner's claim—as an author rather than a painter—to have been lashed to the mast in order to receive the truth of the snow storm, is irrelevant to the fact that as the point of view figure in the piece he disappears, becomes at one with the boat and the storm. In *The Story of Art*, E. H. Gombrich (1995) praises how Turner "gives us the impression of the dark hull, of the flag flying bravely from the mast—of a battle with the raging seas and threatening squalls. We almost feel the rush of the wind and the impact of the waves." As for Turner's role as author rather than mere painter, Gombrich asserts that "We have no time to look for details. They are swallowed up by the dazzling light and the dark shadows of the storm cloud. I do not know whether a blizzard at sea really looks like this. But I do know that it is a storm of this awe-inspiring and overwhelming kind that we imagine when reading a romantic poem or listening to romantic music." Romantic, yes, if by "romantic" we also mean modern or, in Ruskin's (1834) *Modern Painters* terminology, drafting "truth to nature," creating an existential sense of "first-hand experience."

Soapsuds and whitewash . . .

That is the popular opinion when *Steam-Boat* is first mounted on the Royal Academy walls, suds and wash. By now—1842—a good deal of Turner's late work is being scrutinized as slightly mad. But in 1812, perhaps because there is an announced subject and the subject is Hannibal and war, current as well as ancient, the wild vortex of the sky ("vortex" becomes the popular critical adjective for this wilder side of Turner) is less threatening or more appealing to the viewer's participation. According to art historian Barry Venning (2003), the painter C. R. Leslie—biographer of Constable and friend of Turner—records that *Hannibal* "was almost obscured from view by the astonished crowds surrounding it. They were struck by the startling originality of its vortex-like composition, which Constable perceptively described as 'so ambiguous as to be scarcely intelligible in some parts (and those the principal), yet, as a whole, it is novel and affecting.'" Venning adds to Leslie's observation that "It is significant that Constable, who devoted himself to rendering humble scenery as faithfully as possible, could acknowledge the power of a work so different from his own."

When we think about a vortex we imagine a whirlpool kind of motion around an axis—a centripetal or centrifugal flow that, in art, is as much vision as visual. By implication or inference, the sun is at the center of Turner's vortices, and the sun—as opposed to sunlight— is the inspiration for the weather in what is perceived as the violence in a good portion of Turner's long painting career. Violence, as an implied or active principle, is a fundamental element behind his early notion of the sublime, especially in oils: in the heavy texture of oils a certain color kinetic energy is shaped and released, just as in the muted, subtler tones of watercolors the force of that energy— to no diminished degree—is more withheld, understated, intimate. The 1834 watercolor sketch-like version of the *Burning of the Houses of Parliament* is fierce yet pale in its white heat and pastel reds against a smoky water-blue night sky. The oil version of *The Burning of the Houses of Lords and Commons, 16th October 1834*, with its "range of paint media, including various waxes and resins," applied with "scumbles, delicately coloured glazes and thickly impasted paint," is on fire in yellow, as if it had been absorbed, in the night, by the sun. The story goes that, based on on-the-spot sketches, Turner worked on most of the painting during Varnishing Days at the British Institution and that a small crowd gathered to watch "this chaos turn into a creation," a sort of artistic turnaround, which is to say destruction turned into construction.

Venning's narration of the event provides a public notice of Turner's witness.

On the night the old parliament buildings caught fire, Turner was among the crowds who watched the destruction from the south bank of the Thames, and at some point he took to the

river on one of the boats that were charging sightseers for a better view of the blaze. The subject was bound to appeal to him for its topicality, but also because it was a rare example of the cataclysmic power of the elements in a modern urban context. Despite the sublimity of the scene, however, many of those who watched as the buildings were razed to the ground were entertained rather than terror-struck.

You can see in the preliminary sketches, the watercolor, and the finished oil Turner's own fascination with, and confirmation of, the violence of nature and the vulnerability of the mere man-made. Here were ruins in the making; here was life and death intensified—and purified by fire—to the umpteenth degree. All he had to do was find it, to rediscover and transform it, as a witnessed experience, on paper and canvas.

Soapsuds and whitewash are interesting metaphors for not only the lather of Turner's sense of violence but the chaos it suggests—both of which, the violence and the chaos, take his work in the direction of its "indistinctness." John Berger (2015) follows these suggestions back to Turner's father's barbershop, with its "water, froth, steam, gleaming metal, clouded mirrors, while bowls or basins in which soapy liquid is agitated by the barber's brush and detritus deposited." He goes further: "Consider the equivalence between his father's razor and the palette knife, which . . . Turner insisted upon using so extensively. More profoundly—at the level of childish phantasmagoria—picture the always possible combination, suggested by a barber's shop, of blood and water, water and blood." Sooner or later the water and blood are in the Turner skies, the blood—literally and figuratively—in the water. The metaphoric

synthesis of blood and water is fire, the sun's fire, both its heat and its light, as manifest in its full color-wheel spectrum.

We will not find much of an incendiary presence in Turner's early cathedral watercolors or oil homages to classical myth and history and classic art from Claude and others: fine-line delineation and crepuscular tones will be the hallmark of the best of these more conventional Turners, though by the time, in 1817, he is painting with full confidence a work like *The Decline of the Carthaginian Empire*, he will have subverted the Arcadia of the architecture and the diminished population into the totality of a sunset, a quietly consuming pale fire about to melt into the harbor in a wash of yellow. The center perspective of the painting pulls the viewer absolutely in the direction of the end of the day, the decline, if you will, of empire. In its own way, the gravitational pull of the dying sun creates a vortex. The Carthaginians, flanking the sun path, are compelled to watch it. The whole feel of the thing is tragic, grandly sublime. A few years later, in a completely different context and completely different tone, Turner will repeat the dynamic perspective of centering the sun down the middle of the water in a piece entitled *The Harbour of Dieppe (Changement de Domicile)*. Because, in this case, the scene is contemporary and the economy suggested by the boat traffic is so positive, the softer yellow on the harbor is mirrored by a bright sky in white, as if the sun has a veil over its face. The overall wash of light could mean morning or early evening, but whichever, it is not a threatening light. If anything, it is reassuring. It is illuminating. What *Decline* and *Harbour* share is a precise and realistic sense of line and structure, an honoring of tradition, in spite of complaints that the artist, in this phase, is suffering from "yellow fever." In both cases, the only "disintegration"

or blurring of topographical lines lies in the diffusing yet mastering power of the sun.

But are these harbor views really landscapes? Or are they a species of sea pastorals? For Turner, if there is water involved, there is a boat, usually more than one. Of his roughly 100 finished oils (plus nearly 200 "unfinished pieces") and almost 20,000 watercolors and drawings (not to mention hundreds of sketchbooks), a goodly portion have boats in them, which is to say that such work is generally classified as seascapes. Are seascapes landscapes? Some of Turner's most prominent and famous art involves boats of one kind or another in full sail or jeopardy of one kind or another, though there are quite a few nautical paintings in which boats seem incidental, such as gondolas on the edges of scenes set in Venice. It is possible that the evolution of Turner's entire career in oils can be tracked by boats, from *Dutch Boats in a Gale* or *The Bridgewater Sea Piece* (1801) to *Calais Pier . . .* (1803) to *The Shipwreck* (1805) to *Sun Rising through Vapour* (1807) and the reworked *The Wreck Buoy* (1807) to *The Wreck of a Transport Ship* (1810) to *Dort, or Dordrecht: The Dort Packet-Boat from Rotterdam Becalmed* (1818; "I think the most complete work of genius I ever saw" [Constable]) to the *Regatta* series near East Cowes Castle (1827) to . . . and here, in the 1830s and 1840s Turner's attitude toward his boat-themed canvases takes a turn. In stress or becalmed, his boats have so far tended to be reality-rendered players in the larger theater of the sea and sky, the one acting as a dark mirror to the other. And it has been a story of violence released or, for the moment, withheld. The solar vortex of the action—what comes close, consistently, to being a maelstrom—has been one of Turner's ongoing subjects and challenges.

Indistinctness is my forte.

Or did he say, "Indistinctness is my fault"? Depends on who is doing the hearing. Early on, Turner's ambition is to be a great painter in respect to and out of respect for the past—both in terms of individual artists and the landscape history of art itself—but he is also a businessman who paints for himself yet understands the public value of his talent. So when New Yorker James Lenox, in 1832, asks Constable biographer C. R. Leslie to purchase a Turner oil, the price is five hundred pounds and the painting is *Staffa, Fingal's Cave*, the place in itself a natural marvel of island architecture, with its "honeycomb of purple-black columns" rising out of seemingly "pure crystal," as described by Aileen Ward in her biography of Keats. (Keats visited Staffa in 1817 and used it as the setting for his *Hyperion* poems.) Turner's perspective is imagined from the sea, looking back at his steamer as it passes near the island, in the midst of a sunset and a wind blowing up a storm. The wind has, in fact, picked up the boat's smoke trail as it drifts into the white aura or cloud halo of the setting sun. Typically, the steamer is small, vague in the scheme of things—it is the black steam as it melts into the light that

is the important detail in a seascape that is almost totally dark sea and brilliant sky, with a perfect gold coin of a sun on the horizon. The buyer, on receipt of *Staffa*, finds the painting "too indistinct," a "fault" Turner takes the blame for. He advises Lenox to wipe the picture with a silk handkerchief, as if to clarify the mist and distances.

Staffa marks the publicly acknowledged beginning of Turner's change, development, growth—whichever—from being a painter of more-or-less definition to one of more-or-less indistinctness, from a painter honoring and transforming tradition, competition, and Royal Academy lines to a painter celebrating aggression, discovery, and transformative originality. In the time ahead, his indistinctness— admired or dismissed—will be qualified as not only soapsuds and whitewash but a superficial blurring, an archetypal-poetical, ethereal and prismatic, grand atmospheric haze; or looked at otherwise, as structures of light, painted mists, a symphony of mist, tinted steam, or a vaporous sublime. Sam Smiles (2008), usually a critic of definitive prose, writes with some indistinctness of his own in trying to pin down Turner's development: "Turner's increasingly complex understanding of the observable world required the adoption of a technical procedure capable of dealing with fugitive effects and using formal equivalences to suggest the interconnectedness of discrete phenomena. The 'fault' of indistinctness was thus a necessary and hopefully temporary price to pay until critical understanding matured"—making Turner a symbolist.

Smiles's very roundabout, perhaps outré observation means to praise Turner's growth as an artist capable of making art that is both, at once, about itself as such and about itself as a subject. This dialectic will sooner than later become a synthesis. After *Staffa*, in a sequence of transitional seascape examples covering the next seven

years, Turner's indistinctness will translate mostly into his favorite contextual terms of sea and sky, starting with *Keelmen Heaving in Coals by Moonlight* (1835), followed by *The Fighting Temeraire Tugged to Her Last Berth to Be Broken Up* (1838), followed by *Slavers Throwing Overboard the Dead and Dying—Typhoon Coming On* (1840), followed by *Peace—Burial at Sea* (1842).

Each of these pictures, in its individual way, represents Turner's keen interest in the new world around him, the world of the machine, of what participates in the unfolding Industrial Revolution. And each of the pictures seems to be theme based, with an attitude about that world, yet an attitude absorbed by the larger, natural world—sea and sky—surrounding and dominating the theme. In the *Keelmen* painting the work being done, the nighttime heaving of fire coal, is placed off to the right, among ships' masts, while the picture's wide center is sun-moon lit, filling the sky and spilling molten white light right down through the heart of things. The *Temeraire* piece eulogizes an old warhorse of a fighting ship (Battle of Trafalgar) being towed to the salvage yard by a new steam-powered tugboat. One review of the painting (*Morning Chronicle*) comments that "There is something in the contemplation of such a scene which affects us almost as deeply as the decay of a noble human being." The review goes on to say that "Mr. Turner has indulged his love of strong and powerfully-contrasted colours with great taste and propriety. A gorgeous horizon poetically intimates that the sun of the Temeraire is setting in glory." Another review (*Athenaeum*) picks up the idea of the scape itself: "A sort of sacrificial solemnity is given to the scene, by the blood-red light cast upon the waters, by the round descending sun, and by the paler gleam from the faint rising crescent moon, which silvers the majestic hull, and the towering masts,

and the taper spars of the doomed vessel, gliding in the wake of the steam-boat. . . ."

Temeraire, whose elegiac subject is a great national symbol, is one of Ruskin's favorites, as is *Slavers,* one of Turner's most controversial, largely because of its heightened—even exaggerated—depictions of the typhoon seas and strange, gothic fish swallowing the drowning slaves at the bottom right corner of the picture. The colors, too, are pushed to extremes—death red in the storm skies, sick green in the deadly water. The violence of the piece is demanding, as the sun itself seems to have exploded into yellow fire, with a patch of it smeared across the water in the middle of it all. The toy of the slave ship is caught in the upper left side trying to outride these intensities. Ruskin's defense of the painting is no less heightened, calling *Slavers* "the most noble sea that Turner ever painted, and if it is so, then without doubt the most noble that has ever been painted. . . . If I were forced to consign to immortality a single work of Turner, I think I would choose this one." Ruskin adds, against majority opinion, that the painting's "colour is perfect . . . his shading is as real as it is wonderful." *Peace—Burial at Sea* is an elegy for Turner's friend, the Scottish painter David Wilkie: unlike most of these recent works it is a wholly imagined scene, set off the coast of Gilbraltar, where Wilkie died (probably of cholera) onboard the SS *Oriental* after an 1841 visit to the Middle East. The ship is as black as Turner can make it—not black enough he later says—with black sails and black steam smoke blowing into a stone-white sky. At the back of the picture a ceremonial shroud-white flare has been sent up from the great peninsula, while the foreground water is scudded with black rubbings and black vertical shadows from the ship that seem to go right down into the depths.

And to repeat: even *Snow Storm—Steam-Boat . . .* (also 1842), Turner's famous inside-the-frame point-of-view picture in which he is supposedly lashed to a sail pole in order to experience the sensation of a sea storm firsthand, becomes that much more indistinct—indeed, it would have completely confounded the New York buyer of *Staffa*. But it is a masterpiece, yet a masterpiece of what? Even as its magnificent vortex of a sky finds its foreshadowing thirty years earlier in the *Hannibal* painting and even as its emotional equivalency cannot match the elegy for David Wilkie, it has a clarity, a purity of vision, and a calm at its center all its own; it suspends the moment as if it has been caught on film and suddenly held in stop time. Turner, in a comment of pointless self-defense, states that "I did not paint it to be understood, but I wished to show what such a scene was like; I got sailors to lash me to the mast to observe it; I was lashed for four hours, and I did not expect to escape, but I felt bound to record it if I did. But no one had any business to like the picture." This in answer to its reception at its opening at the Royal Academy. "This gentleman has, on former occasions," according to the *Athenaeum* reviewer, "chosen to paint with cream, or chocolate, yolk of egg, or currant jelly,—here he uses his whole array of kitchen stuff. Where the steam-boat is—where the harbor ends—which are the signals, and which the author in the Ariel . . . are matters past our finding out."

The fact that the reviewer in this case is a stick-in-the-mud, longing for some previous version of a Turner seascape, does not effect the technical advance and brilliance of *Snow Storm*—which repeats the palette of *Peace* while moving, apparently, in the opposite direction, from movement within stillness to stillness within movement. The storm painting looks to be a whirl as well as a denial

of the coloring Turner is so infamous for: its black and gray and violent masses engulf a pale patch of slate-blue sky against which the boat is helpless, as are all human beings and their projections in Turner's maelstroms. There is an especially dark touch as the heavy curl of smoke from the overworked steam engine of the boat joins the storm substance of the closing ceiling of the clouds, kind for kind. The greatness of the work lies not in any fantasy first-person point of view but in the reality of the imagination. Turner, in his heart and mind, is in the storm, yes—but more importantly, he is in front of a canvas in his studio filling the white space of the abyss with a lifetime of sea-lover experience. Unintentional puns give us away: Turner says he "felt bound to record it," bound, indeed, to the mast, for four wind-drilling icy hours. The genius of *Snow Storm . . .* is that we see and feel it, immediately, just at the edge, just outside the frame enough to be, by extrapolation, inside. Which is the way, ironically, the imagination internalizes experience, outside to inside. Turner, as a passenger, has no doubt suffered storms at sea, which were dangerous, but not suicidal.

Pictures of nothing, and very like . . .

" Someone said of his landscapes that they were *pictures of nothing, and very like.*" William Hazlitt does not identify who the someone is, though he and the someone are extremely perceptive here in 1816, so many years before Turner's pictures become more and more about what appears to be nothing, or very like nothing. Verisimilitudes of nothing. It is hard to generalize about Turner—he is at once resolutely secretive in his personal life yet expansively outgoing in his social circle; as an individual he is seen as solitary and eccentric yet as an artist he is committed to the club of the Royal Academy as if it were family; his landscapes are as much marine as land based and incrementally more continental than local yet he is viewed as a supremely British landscape artist. And there is so much of his art to deal with. One quality, however, is fairly consistent and at one, once you get past the games he plays with influence, homage, and ambition relative to the masters (such as Claude, Poussin, and the Dutch). That quality, notably from 1830 on and which will ultimately lead him to his almost total "indistinctness," notably in his best-known oils, is at the heart of his watercolors, where his skill with

indirection, subtlety, and lengthened depth of field become, for him, the result of the medium's gift for transparency, its painted mist, its vaporous sublime. Venning (2003) sort of speaks to part of this when he writes that "as a rule [Turner's] watercolours are less sombre than his oil paintings." By "less sombre" Venning is talking about tone, intention, mood. But somber also refers to the darkness of chiaroscuro, the umbra next to the light. And true, there is less umbra, less direct contrast, by nature, in watercolor, a painterly fact that becomes a lovely and major tension in Turner's use of the wet and dry mix of water and color, since he is looking for blended, ethereal, disappearing effects, however solid or tenuous the world he is looking at, what Venning calls a "dematerialized landscape." Less somber also means less heavy, less weighted with applied texture.

One pairing of watercolor to oil is at the cusp of Turner's change from being an artist of "materialized" landscapes to being one of "disappearances," and the change comes from early on, not long after his election to the Royal Academy. The year is 1802, Turner is still in his twenties, taking his first trip to France via Switzerland through the Alps, and naturally following one of the most dangerous routes—the narrow paths under overhanging rocks at the St. Gotthard Pass. One thing about landscapes is category: Turner posits six for his later aborted project (*Liber Studiorum*) of highlight engravings: historic, mountainous, pastoral, marine, architectural, and elevated pastoral. Notions of the picturesque or beautiful are dismissed in favor of Turner's ongoing goal of coming to terms with the sublime, or in Burkean terms, the Sublime, which translates in the capital *S* sense as awe, heroic, alien, or an overwhelming encounter with the terrible natural world—in response to which

the mind and heart are transported. Just the idea of watercoloring the Sublime sounds like a surpassing challenge. Yet Turner's first full draft of his Alpine experience of crossing through *The Passage of Mount St. Gotthard* is exactly in watercolor.

The Passage finds him thousands of feet above his favorite sea level, literally among the clouds, fog clouds that fill the Gotthard ravine between the peaks. On the sun side, the left side of the painting, the rich brown side where the cliff-edge main path walks a small stone bridge and works its way with two pack animals (no people), the illusion of the mass of the rock is amazing, especially since the medium is a fine wash; on the darker side on the right, the rock wall turns into a mud-brown color and, as the eye follows down the ravine, a kind of water blue. The piecemeal mountain clouds pick up these shades and lead us, in perspective, to the back of the picture to whiter clouds that emulate the grandeur of the scene. It is a vertical painting, yet it goes background deep, with its curving to the left in a sort of blind sweep toward an invisible horizon. The genius of the piece is twofold: one is its intimacy, as if the artist were situated in midair between mountainsides, close up; the other is its suggestion of solidity, as if watercolors were the thick equal of oils. The oil version, *In the Pass of St. Gotthard, Switzerland*, done in the same time frame, is generally darker, with all the shapes more delineated, more "materialized." This version creates a certain majesty as well as accuracy and feels heavier, as if the density of the rock were real; but it also looks like a painting trying, perhaps too hard, to be real, art in an unintended exposure of its somewhat awkward artifice. It has none of the "vaporous sublime" of the watercolor, none of the grace of the light lying quietly on the sun side of the

stone. It has none of the watercolor's lift. Both versions occupy the same time of day, but the oil, by comparison, really is somber, wetter, more saturated in its dulling colors.

Based on numbers, watercolor becomes Turner's busiest—happiest?—medium, sometimes as a notion, sometimes as a preliminary sketch, more often as a work itself. He seems more comfortable with its immediacy, quickness, leavening of feeling, as if he is that much closer to painting indefinite shapes and airy effects of light as opposed to the implicitly dense and shadow weight of oils. Watercolors, in fact, will have the determining impact on his growth in oils, in paintings that achieve the sensitivity of water mixed with color. This is Constable's point when in a thoughtful moment he says of Turner that he "seems to paint with tinted steam, so evanescent, and so airy." Turner's oils of *The Burning of the Houses of Parliament* and *Lords and Commons* (1834, 1835), for example, come directly from watercolor studies that prove Constable's insight precisely: they may be sketchbook pieces done more or less on scene but they "get" the intensity and totality of the event just right, a great burning of great buildings as if consumed by the sun, veiled in waves of heat and blinding light, magnified by the dark of the sky and city, while the oils dematerialize the living ruins of the process of the fire in such a way that the canvas itself feels overwhelmed and becomes conflagrant with the death of things—the death, too, of what critics refer to as "closed pictorial form."

Michael Bockemühl (2007) characterizes this shift in Turner as the "abolition of the pictorially clear coherence of compositional structures" in favor of "open structures"—"open" here means a melting of definition toward suggestion. It means that even when we can discern the detail of offside boats or distant architecture

in a watercolor, whether early or late in his career, and whether looking from the Thames or *Venice Looking East from the Giudecca, Sunrise*, Turner, over time, develops ghostlier and ghostlier forms, as if he were seeing *inside* the proposed subject or in between its presence and its absence. An 1819 watercolor entitled simply *Tancarville: Colour Beginning* may well be a beach sunset or it may be a sunrise—its paling out of bars of color (from ground level to sea level to the sky) is bright enough to be either. (The barring idea will be a formalism Mark Rothko will put to use more than a hundred years into the future.) Yet "bright" is not quite it. The quiet sunlight in *Colour Beginning* is straight on, frontal, outside the frame; unusual for Turner, the title functions as a metaphor: the fade-out colors are just beginning or perhaps beginning to end. Wherever the painting is coming from, whatever it is a picture of, it is, of course, about the imagination—a setting placed in mist, a ghost place, a place of possibility, a place in at least two places at once, a place real as reality and real as art.

For sure, Turner's watercolors—compared with his passion in oils—are nonviolent: the whole method of application, the nature of the materials used, the medium of water as opposed to linseed oil argue against the aggression he brings to his oil painting. The candle power of the light is muted, too, as if what he is seeing is a different subject. The closest he comes to firing up a scene is in a waterwork like *The Sun Setting among Dark Clouds* (1826), in which a red sun lies above a black grounding—a low cloud line above the sea?—while above, the sun scars a streak of red-black thinning clouds that seem to have been executed in a hurry. Red is certainly a motif in *The Scarlet Sunset* (1840), a watercolor that looks down the Thames toward a rebuilt set of ghostly government buildings where the most

beautiful yellow-gold sun, to the far right, sits practically on top of the Waterloo Bridge while its yellow-gold wriggle of a reflection runs just out from under the bridge. The river water is mostly soft blue with red echoes; the upper sky is a soft blue-green above a width of sunset red. Red is the violence in these pictures, but it is natural rather than projected, inevitable rather than imposed.

19

The most sublime thing cannot exist without the element of mystery.

John Ruskin, in his defense of Turner, gets to the heart of the matter here—mystery over mystification, even as mystification is the "quality" in the maturing Turner some of his contemporaries find to be more often true. Mystery, on the other hand, from Turner's point of view, refers, richly, to something that is not yet fully understood, which is to say, in art terms, mystery is the result of open form. "I do not know which to prefer, / The beauty of inflections / Or the beauty of innuendoes, / The blackbird whistling / Or just after." These early twentieth-century lines from Wallace Stevens evoke the essence of open form, the inflections, yes, but not without the innuendoes, a dialectic of whistling *and* just after. The preference is both, at once. It is not so much that Turner in his twenties is locked into "a merely topographical register" from which he must escape as it is that, over time, he comprehends and puts to use his self-discovery of the real mystery in his material. His watercolor sketches of Mt. Snowden and Dolbadern Castle, in the 1790s, are just that: temporal vital renderings of the immediacy of what he is looking at, combin-

ing watercolor paint, pencil, and "scrapings-out" with both palette knife and thumbnail. They, like so many other watercolor sketches of this period, anticipate experiments in the medium to come.

So that following the first quarter-turn of the new century, the landscape watercolors, regardless of location, become more and more inward—more sensitive, temperate, naked, a vision of surfaces removed, of light redefining the object, of color distilled and combined, edges dismissed, a secret sought for, and the "violence" of weather so prevalent in the signature oils now sublimated, reversed, if still resonant with tension, like the tension on top of water. Two comments, both from Michael Bockemühl (2007): "In describing a painted landscape, we easily forget that what is described there is *not* nature: that which the observer has before him has not been formed from organic or physical matter, as is the case with every thing in the living organism of a landscape. . . ."; and, "With hindsight, we can observe that Turner belongs to the first artists for whom the creation, the act of painting, began to play a role for the picture." These perceptions may seem obvious to us, but they were not obvious in the first half of the nineteenth century. Watercolors, for Turner, over time, come to provide the original expressive means to arrive at the idea and act of artifice in the realization of his subject, which apparent subject is, fundamentally, landscape, including the drama of the sea. The real subject, however, and however acknowledged, becomes the act of art itself—whether, for example, Turner's best watercolors look at and transform nature in specific ways, or whether they also call attention to themselves as pigment and vehicle, as to *how* and not simply *what* they are. This is as true of the parts and pieces of watercolors as of the finished watercolor and later oil work. When we think of the sublime on a smaller, more

intimate scale we need to be aware of the inseparability of the how from the what.

It would be convenient if the most impressive of the watercolor work were located in an easily rounded time frame based on a natural artistic learning curve. In fact, the most remarkable and consistent watercolors emerge following Turner's father's death on September 21, 1829. There is no exaggerating his father's practical and emotional importance in his son's daily and creative life—from being artist's assistant to crucial parent to loving audience. After 1829–1830, the tone in both the watercolors and oils changes, with the watercolors serving as templates for what the oils can be: less material, more spiritual; less public, more personal; less history, more elegy. The sometimes didacticism, ambition, and quasi-realism of classical themes and shipwrecks that dominate before 1830 tend to disappear into a self-addressed medium, be it watercolor or oil. For instance, the watercolor *Study of Buildings above a Lake or River* (1834) is perfectly titled for the generality of what we are seeing: so-called body colors (gouache) of yellowish, reddish, purplish building shapes scraped down to pale versions of themselves on gray paper, which is allowed to act as itself—a surround of gray sky, gray water with hints of blue. The oil entitled *Venetian Scene* (1840) is almost indecipherable and even more general than *Study,* unless it is thought of as a suggestion of the scene, whatever it is, with its dark-and-red moment scratched into the lower right of blurry darkish water and positioned below an enormous white light of what we guess is a cloud or fog lit up by the background city (night?) acting as a substitute for the sun or full moon—or is the backup lighting celestial? "The impressions," writes Bockemühl, "are so fleeting that they disappear in the moment one points to the colours. As with the objects that are to be imagined, so

with the colour: it is only in the process of its manifestation that one becomes aware of it—not only representationally as the colour of the atmosphere, but also as the colour used in the painting."

Bockemühl calls this process "the principle of manifestation itself." For Turner, the principle is the practice. "Every glance is a glance for study, contemplating and defining qualities and causes, effects and incidents, and develops by practice the possibility of attaining what appears mysterious upon principle." This is one of Turner's most cogent statements concerning the paradox of being both in and out of the moment at the same time, that moment in which memory is alive with the present tense and art is alive with its making. Watercolors, for Turner, grant the most immediate access to such moments, and, more often than not, the most effective examples for his oils, each of which, after 1830, deepen in their associative, evocative, and self-referencing structures and textures. What is *Boats at Sea* (1830), one of Turner's most unusual watercolors; what is this apparent abstraction except three floating feathers (one red, two black) of different sizes (two parallel; one smaller, behind and above) placed in the middle of a canvaslike space with just the barest suggestion of a horizon line; what is this marvelous rendering except three boats, one well behind the other two, moving in a dead-slow calm, in which sea and sky are one and nowhere? It represents the antithesis of so much of Turner's most established work, or is it the synthesis of his future art?

Another 1830 boat watercolor, *Ship on Fire*, loves its mystery no less. It looks like a mistake, an abortive study, or a take that does not quite arrive. Turner has a penchant for black boats, on fire or otherwise—boats that resemble the shadows of boats. This boat is engulfed in a cloud of smoke that is the substance and washed-out

color of the water it rides. There is a touch of orange-red at one end of it to indicate the source of the fire, but it is largely camouflaged in the roar of the overwhelming film of pale gray drawn from the sea flaring into the sky, a sky that mirrors the sea. The work as a whole seems to be dissolving into the water of the watercolors, water performing as fire. This painter of various conflagrations in reds and yellows and sky-borne vortices has chosen here to mute, in the perfect medium, the reality of the view in favor of his vision, a vision that means to enter the emotion, the interior of the event, the correlative of what will elevate it beyond the mere outline imitation we interpret as realism in order to make something apart in its own right, something new, an art of the imagination of the experience. The longer you look at it, the more you realize that the sublimation of violence in *Ship on Fire* is itself sublime—through its medium, yes, but also because of its mystery, "obscurity."

The Bishop likes your picture—"all but the clouds" he says.

Constable moves his growing family to the high village of Hampstead at the end of summer 1820. Hampstead will become a second, summer residence, then, later, a permanent home. His wife, Maria, has just given birth to their second child. Hampstead is known as "the lungs of London," far enough north at a little over four miles from the river damp and smog of the Thames and only three miles from Constable's London studio to be worth any commuting coach rides back and forth from town. The move will be better for the health of his young children and certainly better for his wife, who suffers from early serious symptoms of consumption. John Keats has lived there for the same reason. The Constables will start out at Albion Cottage, Upper Heath, and move in subsequent summers to Lower Terrace, a place with more room and excellent views at the western end of the Heath. ("I have cleared a shed in the garden, which held sand, coals, mops, and brooms, and have made a workshop.") Hampstead Heath, the largest open natural space within the environs of London, is a favorite with painters as well as poets, including artists William Crotch and Francis Towne, and poets Wil-

liam Collins, Leigh Hunt, Samuel Taylor Coleridge, and, of course, Keats. The moorland that sits right up against the village is still largely wild, even as the growing community is becoming a gathering place for culture and literate dinner parties.

That first abbreviated summer Constable spends most of his time taking in the Heath with a pocket-sized sketchbook, learning the weather, watching the changing patterns in the sky, enjoying "the transparent glow of colours on a fine evening," and paying attention to workmen filling wagons with topsoil. His Hampstead landscape oils, over the next three years, will be filled with scenes combining these details, as if he is practicing and refining the kind of pastoral material he will pursue in his Stour Valley six-footers. Indeed, after the move to Lower Terrace, the Constables' second, longer summer, his emphasis will shift from sketching to open-air "oil-on-paper-laid-on-canvas" studies set more or less just outside his front door or within a walking mile of home. The setups will tend to be the same, depending on time of day, the condition of the sky, and where he is standing. More often than not the titles of these oils—whether on paper on canvas or simply canvas—begin with the phrase "View from" and propose horizon perspectives that include, in the foreground, a line of dark, dark trees, a spread of open moor, and in the far distance blue land as undulant as the sea. The skies are evening skies, so that the middle of the pictures brighten with a sun just gone. The colorful skies vary from soft and reassuring to dramatic, sometimes almost Turner-like in their dominance ("Wind fresh at West . . . Sun very Hot. looking southward exceedingly bright and vivid & Glowing. very heavy showers in the Afternoon but a fine evening. High wind in the night").

One notable exception to the horizon paintings is *Hampstead*

Heath (1822), which subtracts the mass of foregrounding trees and concentrates on the vista and moorland browns and grass greens of how expansive the Heath actually is—a mile or more leading to the middle of the picture, then big puffy fair-weather clouds floating east in their passage. Here and there on this rather barren landscape are workmen with their soil carts, a farmhouse, and a few cattle way off to the left. Several things distinguish the painting, including its size—not quite a six-footer, but large enough—and its marvelous sensitivity to the various shapes, textures, and surface colors of the ground and especially the dark immediate cloud shadow at the very front of the picture that leads the eye from a sort of gravel pit to the spreading light of the rest of what we see, all the way to distant fields and pasture.

Biographer C. R. Leslie (1980) waxes and distorts a bit but he understands the Constable signature when he writes of *Hampstead Heath* that the

> sky is of the blue of an English summer day, with large, but not threatening, clouds of a silvery whiteness. The distance is of a deep blue, and the near trees and grass of the freshest green; for Constable could never consent to parch up the verdue of nature to obtain warmth. These tints are balanced by a very little warm colour on a road and gravel pit in the foreground, a single house in the middle distance, and the scarlet jacket of a labourer. Yet I know no picture in which the mid-day heat of Midsummer is so admirably expressed; and were not the eye refreshed by the shade thrown over a great part of the foreground by some young trees, that border the road, and the cool blue water near it, one would wish, in looking at it, for a para-

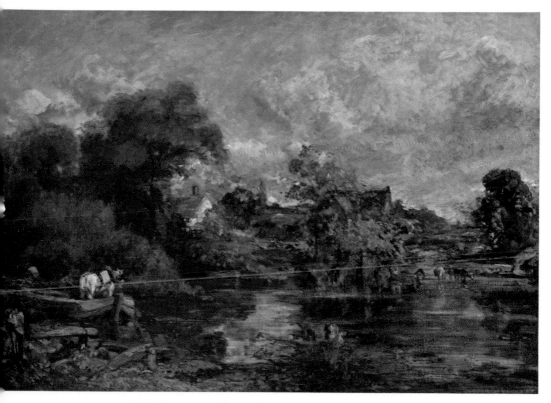

The White Horse, 1819, oil on canvas, Constable, John.

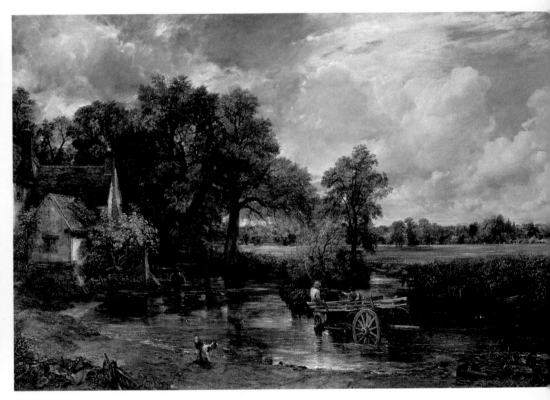

The Hay Wain, 1821, oil on canvas, Constable, John.

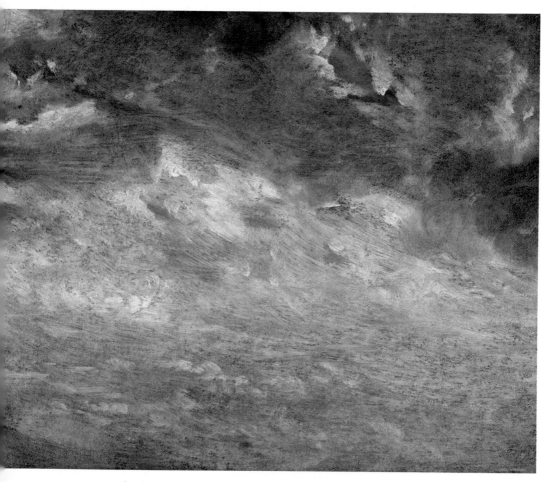

Cloud Study, 1821, oil on paper on board, Constable, John.

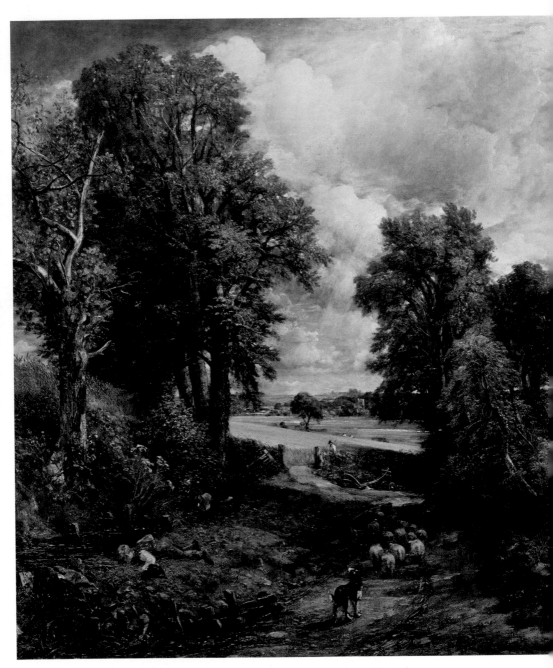

The Cornfield, 1826, oil on canvas, Constable, John.

Boats at Sea, 1830, watercolor on paper, Turner, JMW.

Landscape with a River and a Bay in the Distance, 1840–1850, oil on canvas, Turner, JMW.

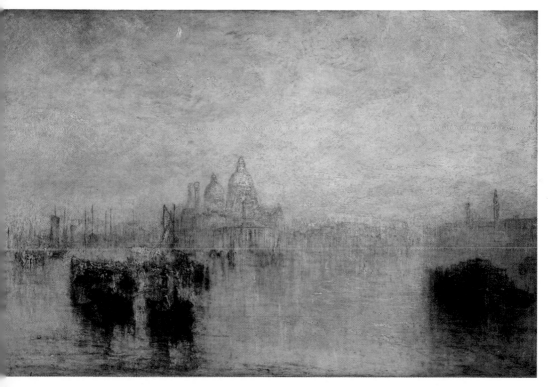

A View of Santa Maria della Salute, 1844, oil on canvas, Turner, JMW.

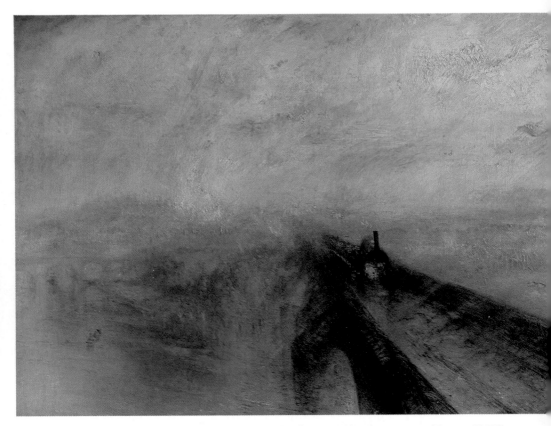

Rain Steam and Speed, The Great Western Railway, 1844, oil on canvas, Turner, JMW.

sol, as Fuseli wished for an umbrella when standing before one of Constable's showers.

There are no "young trees" in the immediate foreground of the picture; in fact, almost obscured in the darker color combinations at the back edge (left side) of the full-frame foreground shadow is a black donkey appearing very much like the donkey in Benjamin Haydon's *Christ's Entry into Jerusalem* (1820). The lonely donkey is looking straight out, at the viewer. The source of light in *Hampstead Heath*, the source of the artist's typical use of natural chiaroscuro, is offstage; we almost never see, directly, the fact of the sun in Constable, only its effects and normally through clouds, all possible kinds of clouds; and in this particular panoramic view of the Heath, from above Branch Hill Pond, the clouds are like a blessing over the land, full of light, but also filled with the impression of warmth and texture. ("The sky is the source of light in nature—and governs every thing.") All of which makes the full-frame shadow at the bottom of the picture all that more interesting: the entire movement of the scene is away from darkness toward light, in the direction of the great pastoral that the Heath is and into the depth of the horizon where the sky starts and regraduates the perspective of the ground.

The oils of this period more and more feature the whole of the sky animated with clouds, almost every possible weather system of clouds, whether fair or between rains. Constable, for good reason, makes no attempt to paint Heath rain. In addition to his affection for the moorland landscape around the edges of Hampstead and his commitment to the memory of the river landscape of his East Bergholt boyhood, there is Constable's growing awareness of the grounding value of the "immense canopy" of the sky, at this time

the north-of-London open country sky that is constantly changing while remaining "the '*key note*,' the standard of '*Scale*' and the chief '*Organ of Sentiment*' in a painting." Now in his early forties, what Constable seems to be realizing, and saying, is that the emotion in pictures lives in the sky, which is curious since he also studies the sky as if he were a meteorologist and speaks of art in general as if it were an applied science. On the one hand, he appears to be talking about technique; on the other hand, he is projecting, or finding, *feeling*.

In terms of his present—and existential—living situation here in Hampstead, where does this further projected feeling come from? Well, one major source is the reason for being in Hampstead in the first place: his wife and her health issues. She is dying, very slowly but relentlessly, and has been since who knows when, her late teens likely. Two years before their marriage, at twenty-five, she apologizes to Constable for not writing longer letters: it is impossible because "*thinking* hurts my chest . . . I really think it does me good to be ill for a day or two, one enjoys so much the more returning to one's usual occupations, and the charm of breathing the fresh air." Bad days, then good days—the classic symptoms of consumption, a rhythm that intensifies as the disease progresses.

Already, in quick succession, in the springs of 1815 and 1816, Constable loses his mother and father, respectively ("I often find myself overcome by a sadness I cannot restrain . . ." [July 1816]). With Maria, as with so many in nineteenth-century Britain, it will only be a matter of time (1828) before "the wasting disease" ends her life—after ten-plus years of marriage and seven children. The clear air of Hampstead will help prolong but not solve the question. For Constable, however, Hampstead and Lower Terrace will offer, ironically, an opportunity to deal with his inherent melancholy and

the anxiety associated with Maria's long suffering through the therapy of art. It will involve moving from eye level with the ground to obsessing on the real sky and the cloud landscapes of the sky as opposed to "the vacant fields of idealism." It will also involve, as he writes to Fisher in October 1821, a certain cloud objectivity: "Their difficulty in painting both as to composition and Execution is very great, because with all their brilliancy and consequence—they ought not to come forward or be hardly thought about in a picture—any more than extreme distances are—But these remarks do not apply to phenomenon—or what the painters call accidental Effect of Sky—because they always attract particularly. . . ."

I am a man of clouds.

During the summers of 1821 and 1822, Constable will paint, in oils on paper attached to board or canvas, approximately one hundred "cloud studies," of which fifty-one survive. The painting materials themselves will have a certain cloud vulnerability, just as the choice of paper as the substance of their capture will stand as a kind of correlative for the meaning of his almost daily mission of sitting in his Lower Terrace front garden with an easel looking up for hours at the sky—as if he were challenging the clouds' and sunlight's mercurial natures by working against the speed of their changes on a paper surface no less temporary, no less mortal. "Sepr. 10. 1821, Noon. gentle Wind at West. Very sultry after a heavey shower with thunder. accumulated thunder clouds passing slowly away to the south East. very bright and hot. all the foliage sparkling and wet." Constable is looking at and trying to paint essentially island clouds, clouds moving west to east, from the Irish Sea and Atlantic to the North Sea. So it is not simply the changeable personalities of the clouds but the range of summer weather, sub-

ject to water temperatures, land temperatures, and variable winds, especially north of the Thames. Many of the first studies involve the tops of some of Hampstead's ancient oaks and elms, providing a bottom border to mostly massive cirrocumulus and cumulonimbus formations blooming into great light and shadow. The crowns of these big trees, as always in Constable, take on the aspect of the big clouds—leafy, full formed, filled with life and the direction of the wind. These early studies are usually titled, straightforwardly, *Study of Sky and Trees.*

The cloud studies of the summer and early fall of 1822 lift sight from the treetops to the sky exclusively. There is no question that Constable's focus on clouds and their filtering effect has its own positive effect on the major Stour six-footers and Hampstead Heath landscapes at this time: the English landscape and the English skies are inseparable as far as he is concerned; the connecting tissue is the seemingly infinite variety and shapes of the nations of clouds, both realms conditioned by the weather, and both realms, in the Dedham Valley and Hampstead Heath landscapes, painted as unities. Yet in his second year of "skying," Constable isolates the sky and treats his tremendous clouds as science and at the same time as emotional—spiritual?—correspondents, with the result that they come to resemble abstractions of themselves, Rorschachs, pure entities very like a whale. They fill the frame as worlds, and stand as much for feeling as for seeing. He likes working midmornings and midafternoons, soft rain or shine, and likes the quick-study aspect, usually no more than an hour at a sitting. The idea of real rain or bright sun falling and mixing with his oils on the tacked-down sheets of paper must be appealing since it is so organic, physical, actual.

In these 1822 versions, the sky takes over, becomes a near and far landscape all its own. Biographer Anthony Bailey (2007) puts it this way: "Rarely a few birds wheeled. Most often the scudding, drifting or towering clouds and gaps of sky were the sole subject—and one could read (between the lines as it were) the weather of the moment—rain showers, impending thunder, clearing skies, the sun coming out. It was a completely different routine from that involved in assembling the parts of an exhibition six-footer—parts which were static, formed already in his memory or imagination. Here he was dealing with impressions—moving elements, parts of air—while the wind stirred the grass around him and smoothed or disheveled the sky above." Bailey further comments that "Constable obviously didn't intend to exhibit his cloud studies. They seem to be closely observed expressions of wonder at the beauty and variety of creation." Bailey seems to think that Constable's clouds are practice toward a practical purpose—familiar, complete, signature pastoral landscapes. But a hundred sky studies, in consecutive summers, practice exercises only?

The science motive is clear, concomitant with Constable's attitude toward the art of painting altogether, that it should be approached with the acuity of science and backed up by close reading on the subject of clouds in such new weather writing as Luke Howard's *The Climate of London*, in which the author, a chemist, sets out to classify cloud types and to establish how cities alter local climates. Constable is a fan of Howard's book; as a source it gives thought and knowledge to his painter's vision. He could have also, easily, looked into Thomas Foster's recently published *Researches about Atmospheric Phenomena* or John Dalton's lay essays on water

vapor. Even Constable's own words on the subject sound vaguely scientific:

> The natural history . . . of the skies is this: the clouds accumulate in every large and dense masses, and from their loftiness seem to move but slowly; immediately upon these large clouds appear numerous opaque patches, which, however, are only small clouds passing rapidly before them . . . These floating much nearer the earth, may perhaps fall in with a stronger current of wind, which as well as their comparative lightness, causes them to move with greater rapidity; hence they are called by wind-millers and sailors "messengers," and always portend bad weather. . . .

Nor is Constable the first painter to take clouds seriously. Directly behind him are such seventeenth-century artists as Jacob van Ruisdael, about whom Constable lectures that "Ruysdael . . . delighted in, and has made delightful to our eyes, those solemn days, peculiar to his country and ours, when without storm, large rolling clouds scarcely permit a ray of sunlight to break the shades of the forest. By these effects he enveloped the most ordinary scenes of grandeur. . . ." Then there is the eighteenth-century French landscapist Claude-Joseph Vernet, who specializes, like Turner, in storms at sea and close-in harbors, and who works out of doors in order to get clouds' temporal color shades "just right." Vernet's student, P. H. de Valenciennes, is interested in "the movement of cloud" because that is where "landscape studies should begin," with the weather-driven dynamics of the sky. Among pre-Romantic

British sketch artists, Joseph Wright, Samuel Palmer, and Thomas Kerrich are devoted to on-scene pencil-and-chalk renderings of the ephemera of clouds, while Alexander Cozens and Thomas Girtin use watercolors to elaborate their inner qualities of light and dark. Of course, Turner, in both sketch studies and watercolors, is the master of "clouds . . . formed by the expansion and cooling of ascending damp air," clouds that streak and swirl and gather around and/or cover the sun, clouds painted more from memory than in the moment, clouds almost as thin as the atmosphere, clouds of mist and fog and smoke, clouds that feel generated by an idea as much as eyes.

Meteorologist Jean-Baptiste Lamarck, in the 1770s, lectures in Paris on the "thousand bizarre shapes" of clouds, developing a kind of "taxonomy" of clouds, as critic John Gage puts it. Lamarck at first comes up with five types, then twelve, then back to ten, then back to eleven. Two of his general types are the most that matter: one, cumulus (*nuages groupes*), in which "clouds are . . . so tightly-packed, or with their parts so pressed against each other that in this state they form peculiar groups, usually isolated and in various forms representing mountains, castles and a thousand other pleasant or unusual objects which the imagination is happy to find there"; and two, cirrus (*nuages en balayures*), in which, "like a curl of hair or brush strokes," clouds twist around or twirl or float away like gossamer. (Turner fits the more two-dimensional cirrus category fairly well; Constable is definitely a three-dimensional cumulus cloud painter, clouds in sympathy with the richness of his trees.) Luke Howard could have just as well entitled his city weather book *The Climate of London* since he ties specific types of urban atmospherics

to his own five classifications of clouds, classifications that supposedly inspired Shelley's impressionistic point of view in his poem "The Cloud."

> *I wield the flail of the lashing hail,*
> *And whiten the green plains under,*
> *And then again I dissolve it in rain,*
> *And laugh as I pass in thunder.* (nimbus)

> *I bear light shade for the leaves when laid*
> *In their noon-day dreams.* (cumulus)

> *From my wings are shaken the dews that waken*
> *The sweet buds every one,*
> *The orbed maiden with white fire laden,*
> *Whom mortals call the moon,*
> *Glides glimmering o'er my fleece-like floor,*
> *By the midnight breezes strewn;* (cirrus)

> *When I widen the rent in my wind-blown tent,*
> *Till the calm rivers, lakes, and seas,*
> *Like strips of the sky fallen through me on high,*
> *Are each paved with the moon and these.* (cirrocumulus)

> *I bind the sun's throne with a burning zone,*
> *And the moon's with a girdle of pearl.* (cirrostratus)

Imagine to yourself how a pearl must look through a burnt glass.

Constable writes this in an 1800 letter to John Dunthorne, when starting out as a student at the Royal Academy. The whole of the sentence reads, "I sometimes see the sky, but imagine to yourself how a pearl must look through a burnt glass." In spite of the fact that he will live a good portion of the rest of his life in London, there is, here, an ambivalence toward cityscapes Constable's country upbringing will never quite resolve—the pearl refers to either the oyster-cast color of the sky or to the mother-of-pearl color inside the oyster of the cloud cover, the one the result of the other; but the burnt glass is smog and smoke, fired by fog and coal. So it is no surprise that he will spend a good bit of time "commuting" back and forth from his new student residence in London to East Bergholt and its open and alternately sea-blue and various skies. About this time, on one such visit home, Constable meets twelve-year-old Maria Bicknell. He is now twenty-four. He paints her portrait, *Study of a Girl with a Bonnet*, with big dark eyes under a spit curl. At some point, in the future, he falls in love with the girl who has become a young woman as well as that part of his memory of the

picture of the girl, and typical of Constable and his absolutist nature, he eventually marries her, even if it does take fifteen years to get to the ceremony at the altar in St Martin-in-the-Fields, when she is twenty-eight and he is forty.

They are married on October 2, 1816, a date that in itself may not mark a turn in his painting life but that does dictate an acceleration in his development, and his ambition. Compare, say, his 1812 *Flatford Mill from the Lock* (originally titled *A Water Mill*), with its ragged textures and very dark tones and simple composition and about which *The Examiner* writes that although it is "the artist's best performance to date," it still "wants a little more carefulness of execution"—compare this oil to the 1816–1817 version of *Flatford Mill*, with its clarity and definition and complexity and density of detail and beautiful depth of field and skies, and you realize that moody Constable's improving personal life has a good deal to do with his growth as an artist. But why does it take so long to go from love to marriage? Three basic reasons. One, Maria's grandfather, the Reverend Dr. Durand Rhudde, the "Grand Caesar" of the family, thinks that Constable is inferior in class and inadequate in prospects as a suitor. He does not want his granddaughter to end up "church poor" and burdened with unhappiness. Maria's parents may be less firm in their opinion about Constable but they are at best ambivalent if not unconvinced he can provide for their daughter in the style to which she is accustomed ("My dear John, people cannot live now upon four hundred a year, it is a bad subject, therefore adieu to it"). Maria herself, in anxiety over Constable's apparent lack of prospects as a painter and her family's reasonable objections, at one point feels compelled to write Constable "to think of me no more but as one who will ever esteem you as a friend."

Two, the cold fact of money. In these early years, and even well into his career, Constable is a landscape painter who paints portraits to make a living, though not a very great living—in his best years as an artist he will not sell enough of his landscape art to be independent of an inheritance from both his and his wife's family estates. When it seems to her that the two of them may have no future together Maria writes Constable more than once about "that necessary article Cash . . . To live without it is impossible, it would be involving ourselves in misery instead of felicity." The fact that it will require the deaths of both their parents in order to create the "felicity" for their marriage cannot, in itself, be healthy. Three, landscape art. "Landscape or me?" asks Maria as far back as 1812, perhaps forgetting or ignoring that painting, regardless of the subject, is Constable's one profession. His mother, too, not long before her death, wants him to be practical: "You can now so greatly excell in Portraits, that I hope it will urge you on to pursue a path, so struck out to bring you Fame and Gain." To which the answer is— as he writes Maria—"Landscape is my mistress—'tis to her that I look for fame." Fame, however, is not necessarily gain. Irony may not cover the paradox that Maria's presence in his life is a catalyst for, as well as an inspiration to, his art while at the same time his art and his love of his birthplace landscape—all on its own—is the soul of what he is about. A wife on the one hand, a mistress on the other. And then there are the children.

Five years before his marriage, Constable hears from his Uncle David Pike Watts that "My opinion is, that cheerfulness is wanted in your landscapes; they are tinctured with a sombre darkness"—the trees are not green enough, the water not clear enough, and melan-

choly rather than "hilarity" is like a cast over the scene. Constable is still a few years away from his classic six-footers and his "native scenes," let alone his Hampstead landscapes and its skies. The artistic conflict so far has been between roughness and finish, sketches in oils and the oils themselves; there are ongoing assessments and complaints on both sides of where Constable's art is headed—heavy emotional investment or finely drawn convention. True art, of course, makes that choice involuntarily; it is never an objective choosing: one's personal life, for one thing, tends to be at the heart of the matter. Marrying Maria, with the stability and gravity she represents, helps bring not only inspiration but reality to Constable's choices. But Maria is also vulnerable, mortal, finite within the intensities of the time she and her husband have together. One might well, given such life circumstances—between 1816 and forever—begin to concentrate on what, profoundly, one's art is about. Memory, for sure, is crucial: memory of those landscapes of a real and/or imagined childhood that are the parent of one's personality. And crucial, as well, is the existential question of actually achieving what one is committed to.

Constable once wrote to his friend Fisher that "My life is a struggle between 'my social affections' and 'my love of art.'" Maria, for sure, helps to solve that conflict—by her obvious place in Constable's life, yes, but also by her own day-to-day struggle against physical deterioration. By her very presence in his life, Maria's consumption gives greater gravity to Constable's art and provides permission for his inherent melancholy, his "sombre darkness," to elevate that art to something sublime. Constable's genius may be more fully represented in the beautifully textured Stour six-footers,

with their balance of farmhouse (or cottage) to field to river to near and distance groupings of well-delineated trees to skies of real English weather to real workmen to sideline figures fishing or witnessing the scene—Constable's Stour Valley paintings may offer indelible narratives of lost time, but they are left and right of the center of Constable's now slowly building grief once the family has moved to Hampstead. By comparison with his six-footer series the Hampstead landscapes feel more like keeping your hand in, staying in touch, even as their static practice quality may in part be due to the separateness of the landscape itself: open, vast, often undifferentiated, unpeopled. . . .

But the Hampstead skies are different—they are island skies: dynamic, driven, under constant revision, weather in, weather out. They are indeed where emotion can find its correlative, its expression, its other life. The Constables will rent in Lower Terrace for six years before leasing a house in Well Walk in 1827. In those years Constable will make his way back and forth—between Hampstead and Charlotte Street—on a fairly regular basis, "three miles from door to door." His big oils will be studio work; his cloud studies, however, will be front garden, out-of-doors. These years will become the best years of his achievement, including, naturally, the Stour paintings, yet also the hundred or more summer studies of the Hampstead skyscape, not including those sketches in which a bit of landscape serves as a literal grounding for the sky and what is in it. What is interesting is that the great majority of the cloud studies will occupy just two of his summers, 1821 and 1822, which means that—subtracting his time in town—he must do at least one painting each working day.

The math is important because it suggests the degree of the

obsession, the need to deal with the clouds on an intimate, fluid basis—his skies, his clouds, right over Lower Terrace, whose place name is at least an oxymoron and a tad misleading, since it sits high, as if Constable can almost touch what he is looking at. *What* is he looking at and *what* is he seeing? His habit, on the back of his paper studies, is to take note of the day, time of day, immediate weather, and so forth, as if to lay claim to meteorology over psychology. "Sep. 28, 1821 Noon—looking North West windy from the S. W. large bright clouds flying rather fast very stormy night followed." Or some two weeks before, at eleven o'clock, "Sultry with warm gentle rain falling large heavy clouds . . . a heavy downpour and thunder." Art historian Timothy Wilcox (2011) refers to these notational references as "proto-narratives" that inscribe what the art describes as the weather. These indicators mean to nail down the moment, the quickness of the moment as well as its passing; they seem to serve the purpose of trying to reinforce the stability over the fragility of what Constable is looking at.

Constable himself speaks of his cloud studies as "an attempt . . . to arrest the more abrupt and transient appearances of the CHIAR'OS-CURO IN NATURE; to show its effects in the most striking manner, to give to 'one brief moment caught from fleeting time'" what Wilcox calls "a lasting and sober appearance." So what Constable is seeing in his clouds is the manifestation of something well beyond the fact of warm air rising into the cooler blue of the sky in order to create "visible masses of condensed water vapor" floating at different heights in different shapes with different purposes. He is certainly seeing more than what an anonymous writer for *Landscape Architecture Magazine*, in 1793, is seeing: "Sometimes they seem truly the fleecy clouds, wanton in every imaginable shape, and float in

transparent thinness: at other times they speckle the heavens, and distribute themselves in airy films throughout the celestial expanse. The motions too of clouds occasion a thousand compositions of one against others; and, as they are at different heights, and often pursue different courses, they introduce an infinite variety into the moving picture."

I have done a good deal of skying.

Curious anachronistic words, "films" and "moving picture," one of which addresses texture, the other two words, action and structure. Constable sees a picture, sometimes a dark picture, when he is looking up into the Hampstead sky; he sees movement, the filmy wind within the cloud; and he sees the equivalent of the invisible made visible, something beyond vapor. He sees the manifestation of feeling, or what he dubs "sentiment." (". . . my skies have not been neglected, though they have often failed in execution, no doubt, from an over-anxiety about them, which alone will destroy that easy appearance which Nature always has in all her movements.")

Because Constable likes to think of painting as a science, emphasizing actuality over sentimentality, accuracy over generality, address over anywhere, his idea of art as science only seems to contradict the idea that painting is feeling when in fact it is the "science" of observation and the "science" of technique that represent the hard evidence that gives truth to the emotion. Constable's clouds are real clouds insofar as paint can make them, they are dated and detailed,

but they are also investments, brushstroked and imagined. Turner often quotes poetry—both his and otherwise—to try to give some emotional context to a painting or else he sometimes attempts to give everything away in a lengthy, expository title. Constable lives within the frame; his clouds are projections as much or more than they are records. Their ephemeral, local, quixotic nature is, to him, individual. The big towering cumulus types are one day, one way of seeing things; the cirrus, gossamer, mare's-tail types are another day. Sometimes the clouds resemble worlds, other times ragtag leftover tatters. Either way, they evoke, they imply, they suggest. Cumulus or cirrus, they can be ghostly—they are, most days, emblems of the spirit. "I change, but I cannot die," writes Shelley in "The Cloud." Constable may prefer the looming, floating armada types that appear more dramatic, but that is because he wants the sky to enlarge, to grow more vertical, to lift and fill everything in the picture, to dominate even the sun.

Timothy Wilcox, again: "The cloud studies are one area where the painter comes face to face, in a direct way, with the question of how the concept of duration can be represented by a static image." Constable's answer to this question is the wind, the effects of wind on the object, be it a tree or a cloud. You cannot paint wind but you can paint what it does. The frames around the cloud studies are intended to present the isolation of this animated moment, this movement within stillness; as such, they are very powerful examples of kinesis within stasis. But why isolate them in the first place as if they were practice when they almost all take on the aspect of finished works? Maria, clearly, in the early 1820s, and in spite of periods of apparent health and regardless of her success at bearing children, is dying—consumption is a long lingering. She and her husband are

in Hampstead because of her health. Hampstead's skies seem to be a kind of solace, a meaningful distraction; watching them is a way of measuring time, just as their clouds are the embodiments of time. The cloud studies are like grief studies. That is why, for the most part, there is nothing else in the picture but their unique, temporal, and majestic forms. Unlike landscapes—that are relatively fixed in time except for the infinite varieties and angles of light—skies filled with clouds are continually changing, reforming, and mostly dis-appearing. Constable must feel not only reassured but reconciled in his attempts to hold his clouds in place, to see them as art, to make them mean something.

The ups and downs and long-term nature of consumption are well-enough known—periods of pallor and indolence followed by periods of intensity and lucidity, sometimes over years, sometimes for decades. It can be a wearing process just to witness its slow wast-ings away. By 1828 the Constables will have tried the balm of the English seaside as well as the purer air of Hampstead. Brighton, June: "My wife is sadly ill at Brighton. . . . Hampstead, sweet Hamp-stead, is deserted." Hampstead, August: "I believe Mrs. Constable to be gaining ground. Her cough is pretty well gone and she has some appetite, and the nightly perspirations are, in a great measure, ceased. All this must be good, and I a great deal cheered." Finally, in November, in the house at Well Walk, on the same street where a very young Keats and his younger brothers have set up house and where Tom, in 1818, dies of consumption—finally, Maria Consta-ble passes. Her consumption has lasted all the years of their marriage and more. Writes C. R. Leslie: "Mrs. Constable's sufferings, which she endured with that entire resignation to the will of Providence that she had shown under every circumstance of her life, were occa-

sioned by pulmonary consumption. I was at Hampstead a few days before she breathed her last. She was then on a sofa in their cheerful parlour, and although Constable appeared in his usual spirits in her presence, yet before I left the house, he took me into another room, wrung my hand, and burst into tears, without speaking."

At the beginning of the new year, 1829, Constable and his children move back to London, Charlotte Street, while keeping the place in Hampstead for the summers. Constable writes Leslie to "not believe me to be either ungrateful or negligent in that I have not called on you, or taken any notice of your kind attentions to me on my coming hither. You know that I have my seven children here. This is a charge I pray God you may never feel as I do. Six of the seven are in lovely health, but I grieve to say my darling boy John is in a sad state. . . . In this sweet youth I see very much that reminds me of his mother; but I must not trust myself on this subject; my grievous wound only slumbers." John will die in his young twenties of scarlet fever as will his sister Emily, at fourteen. Only one of Constable's remaining five children will marry. They will all, obviously, miss the warmth and care of their mother, a role Constable will do his best to fulfill. After his death in 1837, Charley, the oldest surviving son, and Minna, the oldest surviving daughter, will have a falling-out over the value and inheritance of their father's pictures— "I begin to feel the loss of my mother now more than ever," says Minna in a sad, wistful moment.

Constable's "skying," because of Hampstead, becomes ever more the active keynote, the standard of scale in his paintings as much as it is the chief organ of sentiment, even in work that does not measure up to his classic Stour landscapes, those few paintings, for instance, that he completes at Brighton, when he and Maria try the sea as per-

haps the answer to mitigating her illness. These Brighton paintings, in fact, suffer as much by comparison to his own best work as they do with Turner's high dramas of the sea, which, at their best, are incomparable—Turner, at one point, dismisses Constable's ability at painting boats. (He has apparently forgotten Constable's 1815 *Boat-Building Near Flatford Mill*, which, of course, dry-docked, is another kind of boat altogether.) Constable's beach scenes generally have a passive, inert, ordinary quality, in which the sky, especially in *Chain Pier, Brighton*, is the one thing of interest. *Chain Pier* has at least a Constable subject, men at work: colliers, at the water's edge, unloading coal for the new holiday businesses along the shoreline. *Chain Pier*'s great storm boil of a sky could be a Hampstead sky; everything under it—the beach hotels in the far distance, the periodic figures closer up, the workboat off to the extreme left—is diminished by the storm clouds' personality. More typical of the Brighton interlude is the oil-on-paper *Beaching a Boat, Brighton*, about which even a fan like Fisher says that "Turner, Calcott and Collins will not like it," and for good reason: it feels like a rough sketch, it looks like a rough sketch, and plays like practice for something better, though Constable sees it as a "usefull change of subject" and, stubbornly, shows it at the Academy, where it gets "a poor reception." Maria, at Brighton, declines further and becomes more "sadly ill."

24

An odd little mortal . . .

Constable is tall for the nineteenth century, about six feet, and he is handsome, judging by witnesses and self-portraits. Turner, according to a self-portrait, circa 1799, painted when he is twenty-four, is a fair-haired good-looking young romantic. Constable's self-reflective claim on vanity is probably closer to reality than Turner's—who was five feet four, had a beak nose, "like a parrot's," a large head in proportion to his somewhat corpulent body, big feet, bandy legs, and was often confused in overall demeanor with the aspect of a sailor or a coachman. Looks are looks, and first impressions are just that: "The man must be loved for his works; for his person is not striking, nor his conversation brilliant," notes engraver Edward Dayes in a memory of Turner. It depends, as always, on who you are talking to. In an 1813 letter to Maria, Constable writes that "I dined at the Royal Academy last Monday in the Council Room—it was entirely a meeting of artists (none but the members and exhibitors could be admitted) and the day passed off very well. I sat next to Turner, and opposite Mr West and Lawrence—I was a good deal entertained with Turner. I always expected to find him what I did—he is uncouth but has a wonderful range of mind."

When he is still a young artist Turner tries a portrait of his mother, Mary, a picture that has not survived except in the prose of biographer Walter Thornbury, who writes that this was "one of Turner's first attempts . . . There was a strong likeness to Turner about the nose and eyes; her eyes being represented as blue, of a lighter hue than her son's; her nose aquiline, and the nether lip having a slight fall. Her hair was well frizzed—for which she might have been indebted to her husband's professional skill—and it was surmounted by a cap with large flappers. Her posture . . . was erect, and her aspect masculine, not to say fierce; and this impression of her character was confirmed by report, which proclaimed her to have been a person of ungovernable temper, and to have led her husband a sad life."

Who knows the starting place of ultimate anger? There are likely several such places. For Mary Turner one place is certainly the death of William's younger sister, Mary Ann, at age four, though this tragedy probably compounds other, earlier psychic injury. The year after Turner's unfinished portrait of his mother she is admitted to Bethlehem Hospital—Bedlam—for the insane. It is not William senior who admits her, but his brother Joshua, who states that Mrs. Turner "has been disordered in her Senses." Her "ungovernable temper" as manifested in fits of violence becomes—not unlike, apparently, the sister of fellow Covent Gardener Charles Lamb, who one day murders their mother—finally not containable. At least, this becomes the diagnosis, a diagnosis rendered by Dr. Thomas Monro, Bethlehem's principal physician and an art patron who actually runs a Friday evening "school" for young artists, such as Turner and Thomas Girtin. (As if to combine his interests and talents, Monro will also minister to psychically suffering artists, John Robert Cozens among them.)

After a year Mary Turner is moved to the ward ("the snake pit")

for females considered incurable. She will never leave that ward. A little texture is called for: in his fine biography of Turner, Anthony Bailey (1998) has this to say of Bedlam:

Bethlehem Hospital—originally the Hospital of St Mary of Bethlehem—was an elegant building in Finsbury Circus, backing on to the north side of London Wall and facing out on Moorfields. On the piers of its gates were carved two figures—one representing "Raving," the other "Melancholy"—sculpted by Gabriel Cibber. . . . But the site and the architecture were the only magnificent features of this ghastly institution. Patient-care was primitive. Although by this time the hospital had ceased to allow visitors on Sundays and holidays to gaze at the inmates, a popular mid-eighteenth-century leisure activity at a charge of a penny, the therapeutic regime at Bedlam still involved cages, chains, beatings, blood-lettings and straitjackets.

Bailey adds that Royal Academy member Henry Fuseli had heard from an acquaintance that "the greatest number of those confined there were *women in love*, and the next greatest class was *Hackney and Stage Coachmen*, because of the effect on the pineal gland of constantly shaking they are subject to." This last point follows well—if sarcastically—the fact that Mary Turner's father was a butcher, a profession given, in the public mind, to suicide, madness, and murder. In Turner's later years, when it seems his art has taken a direction ever more alien, the accusation of inherited madness rings with poignancy and hurt, though it does nothing to change his artist's mind about where his imagination is headed. Turner's father, having retired from his wig and barbering business (partly because of a new

tax on wig powder) and now living alone, moves in with his son and becomes odd jobber, art supplier, grocery shopper, canvas preparer, cheerleader, and total parent, mother as well as father. Turner is absolutely committed to and loving toward this man who represents the goodness in his world. On the other hand, the mother is abandoned in her ward as a ward of the state, treated as indigent, when both her son and her husband could afford a better circumstance for her future. She dies in Bedlam four years after her admission.

The death of his younger sister, when he is eight, and the abandonment and death of his mother, when he is twenty-five and twenty-nine, leaves a scar, insofar as women are concerned. Then there is that intervening loss, in 1796, at Margate, when "vows of fidelity were exchanged" with "the sister of a former school-comrade," but because of Turner's inability to communicate with the young lady once he starts a tour of Wales and the Midlands their courtship ends in an ellipsis. Bailey puts it this way: "Turner left on tour; she received no letters from her lover, possibly because they were kept from her by her parents, and she then yielded to the importunities of another proximate suitor. Turner turned up again too late, and the disappointment . . . soured him for life." This may be an extreme conclusion but it does bear out Turner's later reticent relationships with women—widows older than he and widows he does not marry. In 1869, eighteen years after Turner's death, C. R. Leslie's son Robert writes to his father from Deal that "my next-door neighbor was an old lady of the name of Cato; her maiden name was White; and she told me that she knew Turner well as a young man, also the young lady he was in love with. She spoke of him as being very delicate, and said that he often came to Margate for his health. She seemed to know little of Turner as an artist."

Turner never appeared the same man after his father's death . . .

• • • as reported by old friends of the Turner family.
Later on Turner himself will commonly refer to
his body of work, particularly in terms of preserving it for the nation,
as his family. Besides his mother, there are three principal women in
Turner's life: the widow Sarah Danby; her niece and Turner's house-
keeper, Hannah Danby; and the widow Sophia Booth—more or less
in that sequence. There is no real evidence that his relationship with
Hannah—who joins in service at twenty-three—is other than busi-
nesslike and Dutch uncle, though there is much speculation; along
with William senior, Hannah runs the day-to-day Queen Anne Street
household life of Turner, and survives both father and son as a kind of
relic among what will be left of the artwork in Turner's house and his
Harley Street studio and gallery. Both Sarah and Sophia are discreet
if not secret partners in Turner's life—"a love-in-the-corner thing,"
as Bailey (1998) puts it. Turner takes up with Sarah around the time
of his mother's commitment; their troubled relationship lasts long
enough for him to father two daughters by her, Evelina and Georgi-
ana T., and to include them in an annuities inheritance (by name) in

his will. The birth of Georgiana T., in 1813, marks the end of "their affair." Since boyhood, Margate—a sea town at the extreme coastal foggy end of Kent—has become a healthy escape from the truly bad air of London: in many ways Margate is to Turner what Hampstead is to Constable. In 1827, he takes up with Sophia Caroline Booth, who runs a Margate hotel, in a relationship that will last out his life. "Eventually," writes Peter Ackroyd (2006), "he took her to London—to a secret cottage in Chelsea, naturally by the river—where they . . . lived as if they were man and wife." So much so that Turner is thought of by locals as Mr. Booth; Admiral Booth, in fact, from Margate.

Hannah Danby plays a role not unlike Turner's father insofar as the running of the house orders and duties are concerned. She also, like his father, becomes the London caretaker of his day-to-day as well as his artist's life. Over time her role as caretaker becomes more like gatekeeper; she is known to many tested visitors as "the witch," an appellation meant to cover both her person and her appearance. At her best she becomes an extension of the stability yet dependency Turner's father represents. And what Turner's father represents is an archetypal emotional upside-down connection, or as Bailey puts it, "With the years, the father-son relationship is reversed; the son acquires an almost parental concern for the father; and now"— with his father's death—"he felt as if *he* has lost an only child." Life becomes, for most of us, a series of losses of one kind or another, then there happens the loss of losses. For Turner, losing his father is such a loss.

The processing of tragedy can take a while, and it can take different forms and be read through and into different symbols. Turner's *Death on the Pale Horse*, finished or unfinished depending on whose opinion matters, is a case in point. It is not even clear as to

when, exactly, Turner lets it go as a work of art, somewhere in the five-year period or decade in the middle of which his father dies— 1825–1830 or –1835, scholars disagree. Nor is it clear as to the painting's title, be it its apocalyptic Book of Revelation reference or the more descriptive *A Skeleton Falling Off a Horse in Mid-Air.* In keeping with its other ambiguities, it seems to have suggested several sources. Does its theme join other roughly contemporary Revelation works by Benjamin West and William Blake or does it allude to a deadly outbreak of cholera in the winter of 1831 or to the failure of the economic Reform Bill in 1832 or to what becomes known as the "Captain Swing riots," also in 1832, in protest of the mechanization of agriculture? Whether all art is about or sourced in other art is a question; whether art—good or great—is tied directly to the topical is another kind of question, usually reductive. Lawrence Gowing, of the Museum of Modern Art in New York, believes that this oil rendering of Death or its skeleton falling off a horse in midair is an answer to Turner's father's death, as both therapy and teleology.

Whatever its emotional or aesthetic context, this finished/unfinished painting of skeletal Death falling into the abyss from a pale horse midair, midflight—midnowhere—is amazing. It follows in the hierarchy "the central picture in Turner's career," according to Ruskin (2005): the mythic Homeric rendering of *Ulysses Deriding Polyphemus,* though this painting is more like a blinding of the one-eyed Cyclops than a deriding, and as raw material it is more like an excuse to paint yet another elevated marine subject with a ship in full magnificent sail. Ulysses and his cohort are actually escaping the Cyclops's cave, which is located in muted fiery red at the left of the picture. The true setting of this heroic escape is more likely the Bay of Naples and the true subject is the painting's Apollo-

nian "treatment"—"a kaleidoscope or a Persian carpet" of color, as one reviewer claims; or a "historical painting in startling prismatic hues," says another. The smoky coloration *is* truly gorgeous, and the ancient sails and the allegorical brilliant glowing of the sky are classic Turner with a further, quieter intensity—behind both the silken furl of the sails and the white celestial burst in the sunset is a sort of phosphorescence, as if the whole scene is lit from within. This is a work completed the year of the father's death, the year of his dying. Heroic Ulysses stands in direct mythic tension with Turner's riding-bareback skeleton.

The next year, 1830, and worked on for who knows how long after that, Turner's almost surreal, symbolist vision of Death on a pale horse employs similar coloration to *Ulysses* in the service of a sky illuminated from hell, which is to say the terms are turned around: the source of light (now brightness browned with yellow) is at the bottom, the darkness and fire at the top. The figures of the horse and the outsized skeleton of Death mediate the colors of the top and bottom. Death is grotesque, a parody of the human body sans the scythe and cloak.

> Even the position of the skeletal figure is a puzzle, for although it appears to be arching backwards as it falls, the spinal column seems to be uppermost. The difficulties are compounded by Turner's unconventional technique, which included a great deal of rubbing and scratching at the paint. It has the effect of veiling the image in a way that is comparable to the erotic watercolours he confided to his sketchbooks around this time. Ruskin later destroyed many such drawings because he thought they revealed a degenerate side to Turner's personality that would

damage the artist's reputation. Like them, *A Skeleton Falling Off a Horse in Mid-Air* may be an expression of Turner's inner life that was too personal for public scrutiny.

Barry Venning (2003) is right about one thing for sure: *Skeleton* is precisely an expression of Turner's inner life—at 60 × 75.5 cm it is a statement as well as a powerful evocation of grief, transformed into an apocalyptic inversion of the sun-god Apollo (whose implied presence is so splendidly alive in the *Ulysses* painting), draped over the back of one of his horses, his beautiful body, his golden hair, his perfect health burned away to bone in a pitch of hellfire. *Skeleton* or *Death on the Pale Horse*, by all accounts, was not intended to be exhibited; it was private, not public, though it is now public at the Tate. (One rather wonderful ironic detail is the Apollonian horse's head, which Turner apparently models on one of the unsurpassed Elgin Marbles just recently displayed at the new British Museum.) Much of the power of this marvelous work is the power found in a great deal of Turner's later oils and watercolors—its "unfinished" nature, its open form, its absence of closure, its lack of resolution, its refusal to end, and so on, and its turmoil of heightened color. Turner's rubbing and scratching at the paint, as if to physically enter the painting's space, as if to destroy the framing proscenium, speaks not only to his emotional and spiritual connection to his subject but also to his need to change his relation to the painting's actual applied materials, namely, the paint itself and the color of the paint.

In his catalogue copy for the Turner show he curates at MoMA, in 1968, Lawrence Gowing writes that "Turner isolated the pictorial effect, as one skims the cream off milk. He proceeded to synthesize it afresh with an almost excessive richness. To complete

the product he was apt to add synthetic details; we do not always find them convincing. His essential creation did not require them, and eventually he realized it. He had isolated an intrinsic quality of painting and revealed that it could be self-sufficient, an independent imaginative function." Gowing then puts a finer point on his point: Turner "imagined colour as a separate fabric, fragile and vulnerable, yet sacred and sufficient in itself to supply all the reality that is required from a picture." Gowing is obviously making a case for Turner as a Modernist, but then, in their individual idioms, Wordsworth, too, and Coleridge and Keats are Modernists, as is the critic Hazlitt. For those Romantics who move their art forward, the nineteenth century, perforce, is the progenitor of the twentieth. But the one or two things in Gowing's argument that ring with insight—the imaginative, independent functions of the texture of the paint and its color—are timeless and as true of Rembrandt as they are of Cezanne.

*He has been particularly successful in seeming
to mingle light itself with his colours.*

This workmanlike take on Turner's color technique by
contemporary and fellow artist John Landseer fits well
with Gowing's century-and-a-half-later assessment of the function of
texture and color in Turner, though Gowing is not necessarily pro-
moting an idea of paint and color for their own sakes—which will
become a test for twentieth-century painting—but imagining them
as content: "fragile and vulnerable, yet sacred and sufficient." Standing
behind the feeling life of Turner's color scale is the energy of the sun,
whose emphatic effects of light as color transcend tonal contrast or
what Constable likes to call chiaroscuro. This textural color burden of
"content" accelerates as Turner's sense of figuration disintegrates and
disengages separation. Figuration becomes a flow.

Gowing's other strong insight is that a major part of Turner's
long-term growth is learning to divest his work of the "excessive
richness" of "synthetic details," of which the disciplined, dark sym-
bolism of *Skeleton* is a perfect instance. (Turner's best and late water-
colors, by virtue of their means, purify their potential for too much

"richness" as well.) There is no signification, as such, of ground or sky in *Skeleton*, only up and down; it is as if the horse is moving within a fiery Turner vortex or at an abstract hellish edge. This is the territory of expressionism, of an archetypal image from the Book of Revelation. This is an idea somewhere between projection and hallucination. There is no intervening narrative here except the direct object of the symbol itself. Fragility and vulnerability have always been two of the fundamental qualities of the emotional intelligence of the elegy, and beginning in the era of the 1830s, soon after his father's death, the elegiac will purge the substances and elevate the light-as-color effects in nearly every painting Turner touches.

For John Ruskin (2005) the ten-year period marked by *Ulysses Deriding Polyphemus* (1829) to *The Fighting* Temeraire *Tugged to Her Last Berth to Be Broken Up* (1838) is the time of Turner at his best. It is interesting that both of these culturally ladened pictures, and many others in the years between, are so-called marine landscapes; both highlight famous ships in forms of stress; and both underwrite themes of loss and heroism, one mythic, the other historical. And both play into Ruskin's Victorian values as much as Turner's Romantic ones. Within this same time frame Turner paints other well-known marine pictures—*Staffa, Fingal's Cave* (1832), *Keelmen Heaving in Coals by Night* (1835), and *Regulus* (1837)—all thoughtfully thematic and grounded, and also praised by Ruskin. Considering his advancing taste for precision, balance, clarity, and statement, it is no surprise that Ruskin would find this particular decade to be Turner's most significant. What is a surprise is that the groundbreaking text in which he celebrates Turner's best work is entitled *Modern Painters*, although the use of the term "modern" here is relative and any complaint as to its meaning is probably a quibble.

Besides the *Skeleton* painting there are, however, in this same period, watercolors and oils Ruskin is not necessarily all that fond of, with the possible exception of *The Burning of the Houses of Lords and Commons*, a further confirmation, in Ruskin's view, of Turner's nationalism. But perhaps his Monet-like watercolor of those same prefire government buildings fading into the far background is another kind of example of lapsed lineation and clarity, in a marvelous crepuscular picture called *The Scarlet Sunset* (c. 1830), which is impressionism before Impressionism: everything in it is muted tones of soft reds and blues (mostly the blue paper showing through), with a couple of piers providing perspective off to the left; the real beauty, though, is the setting sun itself and its yellow squiggle floating on the Thames toward the viewer. The oil painting of the *Wreckers—Coast of Northumberland, with a Steam-Boat Assisting a Ship Off Shore* (1834) could be another example of indistinctness, in spite of its named coastal "landscape." The wreckers are men and women who have lured an unsuspecting ship too close to shore and are cashing in on the salvage, but it is the total mist in which the picture is conceived that is the compelling part, with the stormy white and blue out of the sky dominating the high white waves at the shoreline; the sketched-in wreckers seem to be at one with the sandy, stony shore while the castle in the distance melts away, stone into vapor.

The interiors at Petworth present a similar sublimity, with the added marvel of being landscapes of the inside rather than the outside of the house. The now famous Turner spends a good deal of time at the great residence at Petworth Park (Essex), the Earl of Egremont an early and off-and-on patron of the artist, and someone he grows closer to after the deaths of his good friend and patron Walter Fawkes and, more importantly, his father. For nearly ten

years, a visiting Turner has his own Petworth painting room to work in, though another room in the house becomes the subject of the two most visually interesting "interiors," both of which turn out to be elegies following the Earl's death in 1837. When art historian Michael Bockemühl (2007) writes that it is the tension in ambiguity that "brings about the wealth of aspects that renders the interpretation of the work of art so inexhaustible," he seems to have paintings like these Petworth interiors in mind. As a pair they work as a sort of diptych in which *Mourners at Petworth* necessarily precedes *The Apotheosis of Lord Egremont*—both date from the year of the Earl's passing and each has a subtitle—*Dinner in a Great Room with Figures in Costume* and *Interior at Petworth*, respectively. The mourners in the first picture resemble costumed figures in a masque—abstract, allegorical, certainly indistinct; they appear to be moving around the white stone solidity of a sarcophagus, which makes "dinner" in the title suggest a wake, and may forgive the "costumes." Ambiguity or mystery is built into the atmospherics.

The architectural detail of the central archway at the back of the "great room" in which the "dinner" is occurring is like a doorway into a series of such open structures, implying an infinity. This detail becomes crucial at the center of the second picture, the *Interior*, which word itself speaks to further, deeper interiors or entryways. Bockemühl literalizes this interior landscape by describing it as "a closed white room with gold ornamentation and a high arched portal in the wall opposite the observer. It could be that large windows on the right are darkened by means of yellow curtains or blinds, the room thereby appearing to be filled with muted warm golden shade." He thinks he can see into the "adjoining room, visible through the arch in the centre . . . illuminated with dazzling

brightness." He even adds mirrors and an "unveiled window": the entire scene determined by brilliant sunlight. And true, the room is bright but it is dark too with color; the darker objects disappear into one another in the light.

Then the overall picture changes depending on the angle of light striking it from outside the frame: the great room as a whole now and then a mass of dark reds and browns and pale gray-greens vaguely delineated into brume areas of furniture and walls and a ceiling, like a great abandoned furnace, claustrophobic, emptied, without people, but a space that seems to be teasing the viewer to join. The one way out—or is it in?—is the blinding archway, which is filled with a ghostly off-white shapelessness that hints at a shape like a shroud or apparition, denoting the apotheosis of the spirit of a man. (It is not possible to see beyond this opacity into any adjoining room.) This second of the Petworth paintings, so aptly conceived as an *interior*, is exactly that, an invitation to enter a darker place from even the one in the *Mourners* painting. In its soul it is more like *A Skeleton Falling*, with the same old purgatorial fires within, a parallel death-figure-idea evoked.

Under evening light . . .

"Perhaps there is no more impressive scene on earth than the solitary extent of the Campagna of Rome under evening light." Ruskin (1834) writes this as part of his conclusion to *Modern Painters*, his young and brilliant but exhausting book that is essentially a defense of Turner in relation to the history of the great English and European landscapists and against the narrow tastes of the provincial Tory *Blackwood's Magazine* among contemporaries. On the other hand, in almost the same breath, Ruskin also celebrates, near the end of his text, the new Romantic decadence called the Pre-Raphaelites.

I would further insist on all that is advanced in these paragraphs, with especial reference to the admirable, though strange, pictures of Mr. Millais and Mr. Holman Hunt; and to the principles exemplified in the efforts of the other members of a society which unfortunately, or rather unwisely, has given itself the name of "Pre-Raphaelite"; unfortunately, because the principles on which its members are working are neither pre- nor

post-Raphaelite, but everlasting. They are endevouring to paint, with the highest possible degree of completion, what they see in nature, without reference to conventional or established rules; but by no means to imitate the style of any past epoch. Their works are, in finish of drawing, and in splendor of colour, the best in the Royal Academy; and I have great hope that they may become the foundation of a more earnest and able school of art than we have seen for centuries.

There is no point in arguing the niche the Pre-Raphaelites occupy in art history, but it is a niche only and hardly "the foundation of a more earnest and able school of art than we have seen for centuries," unless "school" (as in the School of Athens) is the operative word here, while the very best artists fit no school. Turner, most especially, would be included in the no-school category. The Pre-Raphaelites seem an odd group for Ruskin to embrace, since they are, prima facie, less interested in representing the multiple textures of real nature than in producing an illustrated, selected, idealized version of those textures. They are post-Romantic if anything, in spite of their passion for the romantic narratives of Keats. They are Victorian, Tennysonian. (Ruskin's instability of taste will finally show itself later in the lawsuit with J. M. Whistler, whom he accuses of throwing a pot of paint in the face of the public in a work called *The Falling Rocket*. Whistler will cite Turner as one of his most important influences.)

It is the "tinted steam," the breakdown of line and separation, the melting colors, the mist in Turner, after 1839, that will worry Ruskin and that will lead him to think that perhaps his hero has lost it. No wonder Ruskin has little or nothing to say about the murky

Petworth interiors. Nor even less to say about the most prominent Turner exterior in the Louvre, a wonderful oil entitled *Landscape with a River and a Bay in the Background* (c. 1840). "The world as portrayed in the picture," according to Michael Bockemühl (2007) high in importance, "is not what it is in reality but rather in a state of continual development, a never-ending process of creation, reconstruction, disintegration." The intense color combinations in *Landscape* are familiar; they are not that far from the mix of colors in the rooms at Petworth: red-earth-browns, white skein of a sky with a hint of pale blue off in the upper right, part of a tree at the right margin, a very faint suggestion of a bluish bay midpicture, with another suggestion of a river (the color of the bay and sky) running to it. The dark obstruction across the river is like blockage or a bridge, and *like* is important here. Bockemühl looks at the scene as to how "Various shapes—hills, a valley, a tree, water, clouds—develop out of formations on the surface in gentle transitions and modulations of colour, and then reconstruct themselves. It is no longer possible to give anything—no matter whether pictorial or representational—a precise and indisputable definition."

A further comment by Bockemühl may be helpful: "A pictorial form in which the sketch could no longer be differentiated from the completed painting was unable to fulfill the expectations of the early 1840s public." Ruskin is a fair leader of that attitude among the public. What is happening in the method and to the tone of Turner's later work is more than simply the transference of watercolor spontaneity into the finish of oils or the reverse talent of investing in the watercolors the authority of oil painting—what is happening is that the oil or watercolor is being achieved and presented as a sketch, as visual art in the moment of its conception and representation, as its

fluid form and vivid color call attention to themselves as shape and pigment even more than the "subject" they resemble. Turner, now in the last full decade of his life, is creating landscape as mist, as something ephemeral, as an open text, as an image, as idea, so it is no wonder that the French would admire him as a symbolist.

A better reading of Turner's peak period—as opposed to Ruskin's favorite ten years—might extend from 1830 through 1846, and include, as an instance, *Calais Beach at Low Tide: Poissards Collecting Bait* (1830), in which the human figures come over as quasi-aliens compared to the royal beauty of the setting sun, in a fusion of yellows from the sky to the beach, while midpicture the sun literally sets between dark (black?) storm clouds. The sad beauty of the piece derives from the distances conveyed and the emptiness created—the beach itself as flat and endless as a desert. From 1846, you might place, in order of importance, one of the late Lagoon of Venice paintings, say, *Returning from the Ball (St Martha)*, another "yellow" rendering also burdened with perspective, with the city latent in the background and a "butterfly" boat just off-center left to establish scale. The yellows are mitigated with dark scratchings in the sky and reflected dark, and darker on the water, all of it a summer evening cast in sunset light. This is a happier melancholy than *Calais*.

Yet an even better closing of the parentheses of Turner's strongest phase might not be literal landscapes at all, and could therefore begin with *A Skeleton Falling Off a Horse Mid-Air* (1830) and end with, likely, Turner's strangest of all oils, *The Angel Standing in the Sun* (1846). *Angel*, like *Skeleton*, takes its cue from the Book of Revelation—is the angel Michael?—"And I saw an angel standing in the sun; and he cried with a loud voice, saying to all the fowls that fly in the midst of heaven, 'Come and gather yourselves

together unto the supper of the great God; That ye may eat the flesh of kings, and the flesh of captains, and the flesh of mighty men, and the flesh of horses, and of them that sit on them, both free and bond, small and great." Turner's actual angel is considerably less menacing than the one in Revelation, perhaps, in part, because his angel is feminine rather than carnivorously masculine. Regardless, Ruskin finds the picture the result of a "mental disease," and only further evidence "of a gradual moral decline in the painter's mind," indicative of an emotional state in which "he becomes gradually stern, wilful, more and more impetuous, then gradually more sensual, capricious—sometimes in mode of work even indolent and slovenly . . . What I call the 'sunset drawings.'"

"Sunset" here denotes decline as well as the consistent evening coloration in the later work, and as collateral with the evening sun, terms such as "impetuous," "sensual," and "capricious" might well describe Turner's attitude toward method in these later years. Ruskin's problem is that he moralizes his meditative aesthetics. This may be a fallen world, but Turner's angel appears to be rising in midair at a level well above the hell furnace of air the figure of the horse in *Skeleton* is moving through. Around the angel are concentric circles of light, the most intense of which start around the head and emanate out and up into a celestial realm of a sky full of sun and birds, while below, in a nether, darker metaplace, toil human figures in obvious stress, as if acting out a tableau of guilt, even sin. In spite of what seems to be an apocalyptic vision, compared to the *Skeleton* of sixteen years before, this angel, with its lifted baton pointing to something higher, feels transcendent, floating serenely above the mortal fray of things. Turner, in his lifelong search for the grand sublime in great nature and his need to achieve a sense of reconcili-

ation within himself, especially in these many years after his father's and several of his respected colleagues' deaths, has begun to realize a different kind of sublime—lowercase, personal, and intimate. It has been a realization manifested, for some while, in a different way, which is to say as a different truth, of art. Contrary to Sam Smiles's (2000) conclusion that *Angel* represents Turner's "pessimism at the human condition . . . at its bleakest," at the supper of the great God Death, flesh is nothing, the spirit and the soul everything: they are the angels.

*He was seen eating a peach off a tree
with both hands in his pockets.*

H*e* is James Thomson, eighteenth-century Tory Brit-
ish poet of the pastoral and of "nature," a poet much
admired by both Constable and Turner as well as Wordsworth. What,
more or less precisely, is a landscape? Thomson's popular and influen-
tial "epic" *Seasons* (1730) is credited with shifting the subject of poetry
from humanity to nature, but what kind of nature—the ploughman
fields of Burns and Clare, the mountain passes of Wordsworth, the
moorland walks of Coleridge, the garden worlds of Keats?—what
kind of nature is discovered in Thomson's *Seasons*, his debt to wealthy
patrons and their estates, and to his own growing up in the Cheviot
region of the Border country of Scotland? Thomson scholar Douglas
Grant thinks about his poet as one might see a painter:

> When Thomson . . . stood upon high places about his home,
> and turned his back to the hills, he would see laid out before
> him the long sweep of a delightful pastoral landscape. The
> English countryside owes its beauty to the cloistered grace of

many particulars, a brook, a coppice, a beanfield, or a handful
of primroses in a hedge . . . in the Borders these particulars lose
their identity in the panorama. The eye moves down the valley,
follows it until it widens and enters another, and continues on
across a plain which is bounded only by the horizon. This land-
scape is ordered into foreground, middle distance and distance,
as deliberately as though it had been arranged by some great
seventeenth century artist.

If this sounds like a world that would appeal to Constable, yes,
but with much less "cloistered grace" and much more order "into
foreground, middle distance and distance." Thomson is often praised
for "the Claudian light" he casts over the scene and just as often crit-
icized for turning his patronage pastorals into "lists and catalogues
of wealth." In the final analysis, nature in Thomson's *Seasons* seems
to be at its best with the long view, assuming a close proximity to a
Lord's mansion on Lordship property, "where / Majestic Windsor
lifts his princely brow." Thomson's blank verse can be magnificent
while otherwise so "munificent" with gorgeous generalized land-
scape evidence as to blind the reader with descriptive profusion.
His elaborate word pictures, therefore, lose their edge and sacri-
fice tension. They become patently picturesque as opposed to word
pictures, as if "the boundless landscape," "the pendent woods," the
"softly-swelling hills" have been planted by the garden architect
Capability Brown, in just the way that Brown cultivates the park-
land surrounding a great country house. More than a century and
a half later, in *English Hours*, Henry James will invoke "places to lie
down on the grass in forever, in the happy faith that life is all a vast
old English garden, and time an endless English afternoon."

Is garden nature, then, to quote Andrew Marvell, "a green thought in a green shade" or is it, vis-à-vis Alexander Pope, "a painted scene"? Well, it can be both if it is a formal garden or the space "under a greenwood tree." But "wild" nature, that is, trekking in the Lake District or tracking through the Alps, is something else. (Turner, of course, spends time in both Cumberland and the Swiss Alps; and he loves Pope, Pope's garden, and laments *Pope's Villa at Twickenham During Its Dilapidation.*) What is the difference between a working pastoral and the genuinely picturesque? And what is the difference between landscape and out in nature? Even though he knows better, sometimes in Virgil, the "goats shall walk home, their udders taut with milk, and nobody herding them; the ox will have no fear of the lion . . . Then grapes shall hang wild and reddening on thorn trees and honey sweat like dew from the hard bark of oaks . . . The soil shall need no harrowing, the vine no pruning knife, and the tough ploughman may at last unyoke his oxen." And so forth on into Utopia, where, as Marvell, again, puts it, "Stumbling on melons, as I pass, / Insnar'd with Flowers, I fall on Grass."

Everything not us is, to a degree, nature, even those parts of it we subdue, tame, cultivate, and claim as our own. The quality of the cultivation and the artfulness with which we do it may account for the picturesque; the work of growing, of planting and harvesting—having been expelled from the original Garden—is exactly the work of the pastoral. The word "garden" covers a lot; the word "farming" is more restrictive. Landscape, as Constable teaches us, can master both—to the extent that gardening can be an art form or a form of farming. The inadequacy of the language inevitably forces approximations. No one wants pretty when we can have beauty; no one wants mere beauty when we can have the sub-

lime. Nature as landscape is awesome; it is also familiar, next door, right at home. Nature transformed as landscape requires witness, whether in the eyes of an admirer or artist. Landscape turned into a garden—whether for beauty or bounty—requires labor. Much of Constable's genius is the authority he brings to his experience as a son of his father's business. There is no gainsaying the depth of the root system that holds Constable to his birthplace and the ground of his growing up; it would be easy enough to say that the River Stour, the Dedham Valley, and East Bergholt become the microcosm of the larger, macro-world Turner occupies and thrives in. But Constable does not seem to see his sources as narratives or analogues for something more than themselves. They serve no mythic function. His paintings are what they are, nothing more, nothing less; as moral choices, they are the realities of what they represent: which is local, thorough, textured, complex, and at the same time art, which is to say, they effect the illusion of three dimensions, the corollary of actual colors, and the invented tableaux of human scene after scene from memory. His people pick the peaches.

I imagine myself driving a nail

" I am much worn, having worked very hard—& have now the consolation of knowing I must work a great deal harder, or go to the workhouse. I have however work to do—& I do hope to sell this present picture—as it has certainly got a little more eye-salve than I usually condescend to give them." There is so much attitude in this 1826 Constable remark to his friend John Fisher that it is hard to know which driven nail to pull out first. Someone has observed that one of the ironies of knowing both Constable and Turner is how capable Turner can be, when he wishes to be, in a social situation; and how awkward Constable can be, no matter if he tries, in similar circumstances: the irony being in their respective backgrounds—Turner the son of some poverty, Constable the son of some wealth. ("The Landscape painter, though of a manly nature, was eminently sarcastic, and was very clever at saying the bitterest things in a witty manner" [Redgrave].) Selling your work does demand a certain social salesmanship, and condescending "to give them . . . a little eye-salve" may not be the best position from which to negotiate a sale, especially if one is acting out of an anxious fear of the work-

house, a legitimate fear considering more than one artist has endured this nineteenth-century debtor's experience. Constable has a similar socializing problem with the Royal Academy, which may in part account for the yearslong delay in his becoming a full member. Constable is not typical member material. The "them" in his complaint may refer to the Academy as much as the buying public.

The painting in question is a near six-footer finished the year after the River Stour series Constable hopes will make his reputation. Originally entitled, rather flatly, *Landscape*, then later *Drinking Boy*, this new work eventually finds its truth title as *The Cornfield*. On the surface, at a fast look, the painting's narrative seems simple enough, except this time the "story" takes place "inland" (Constable's word): the setting is a bend on a path called Fen Lane, a path Constable has traveled as a boy on his way from East Bergholt to county school in Dedham. The framing device of trees—large elms—is familiar enough in a Constable, those on the left closer in perspective, those on the right at the edge of a middistant "cornfield" (ripe wheat). It is harvest time—late July/early August—and there is a laborer seemingly preparing for the task, behind whom, at the far horizon line, lies a suggestion of a village, with a church tower. To add the further pastoral touch, in the foreground of the picture, about a dozen sheep (or lambs) are being herded along the path (in the direction of the field) by a dog distracted by the sound and flight of birds (pigeons?) lifting from the tallest elm. There is a donkey, too, with its foal, up under the closer tree area, feeding. (It is yet another beast "unburdened" that could have been borrowed from the central casting of Benjamin Haydon's *Christ's Entry into Jerusalem*.) Unlike the preceding six six-footers, farm-life rhythms here are at rest, including the "business" of a boy (who is probably a

shepherd of an age to be Constable's stand-in schoolboy) face-down drinking from a pool, plus the laborer or farmer at the open gate leading into the field. Constable likes red jackets, so that is what the boy is wearing, as if to emphasize his place (just off to the foreground left) in the total picture. The man is wearing a country hat. Constable by now has mastered clouds, so that their full cumulonimbus beauty fills whatever sky is left above the trees. The piece, as a whole, qualifies as Constable's most English "English arcadia."

Earlier in 1826, Constable is hard at work on the ambitious and, for him, unusual *The Opening of Waterloo Bridge*, a painting that for some time is mastering him as much as the other way around. It is, essentially, an urban scene, with very different kinds of boats abreast on a very different kind of river, looking at it all from the Whitehall Steps, and a goodly distance. It is intended to be his chief entry in the spring's Royal Academy show. But it becomes clear, early on, that *Waterloo* is not going to meet the deadline—by years. Hence, in order to come up with *something*, he turns to the more conventional Constable-like subject of *The Cornfield*, a painting he can execute, by comparison, fairly quickly—not only because of its setting but because it has, according to the critics, a built-in inheritance, ranging from Gainsborough's "lounging peasants" to Poussin's "Narcissus youth" to David's "dying adolescent" and so on, including flattering references to "balances of composition" in Claude.

Closer to home, Constable's botanist friend Henry Phillips sees something more focused about *The Cornfield*: "I think it is July in your green lane. At this season all the tall grasses are in flower, bogrush, bulrush, teasel. The white bindweed now hangs its flowers over the branches of the hedge; the wild carrot and hemlock now flower in banks of hedges, cow parsley, water plantain &c; the heath

hills are purple at this season; the rose coloured persicara in wet ditches is now very pretty; the catchfly graces the hedgerow, as also the ragged robin; bramble is now in flower, poppy, mallow, thistle, hop, &c." It is almost as if Phillips is competing with his friend, who has, at best, traces and hints of the botany detailed in this science of prose. Constable does, however, take pride in his trees, and writes to Fisher that the elms next to the cornfield "are more than usually studied and the extremities well-defined—as well as their species— they are shaken by a pleasant and healthful breeze—*'at Noon'*—'while now a fresher gale, *sweeping with shadowy gust fields of corn*' &c &c," quoting Thomson.

"I have dispatched a large landscape to the Academy," he tells Fisher, "upright the size of my lock—but a subject of a very different nature—inland—cornfields—a close lane—kind of thing." The one notable review, in *The Examiner*, cites its "sapphire sky and silver clouds, its emerald trees and golden grain, its glittering reflexes of sun-light among the vegetation; in fine, its clear, healthful, and true complexion, neither pale, nor flushed, nor artificial"; although on Varnishing Day the sculptor Francis Chantrey takes slight exception to the "shadow rot" under the sheep's tails, which he at first intends to cure with a tag of white paint but instead throws a dirty palette rag in Constable's face and takes off running. *The Cornfield*, after *The Hay Wain*, becomes Constable's most famous painting and in the years ahead is reproduced as a cliché on paperweights, biscuit tins, thimbles, cheap china plates, etcetera. Yet like the majority of Constable's work in his lifetime it does not sell. "Finally, after Constable's death in 1837, "one hundred and five friends subscribed for its purchase, including . . . Wordsworth, paying the estate three hundred guineas. Had they waited for the executor's sale a year later

they could have given the National Gallery half a dozen of Constable's greatest paintings for the same price!" (John Walker, Director Emeritus, National Gallery of Art, London [1978]).

Regardless—sold or unsold, reduced to popular consumption or even celebrated as a reflective advance over the "working" six-footers—*The Cornfield*, according to art critic Charles Holmes, is a painting of remarkable balance, beauty, and "technical orchestration . . . The picture is in itself practically an epitome of Constable's practice at its very best, where every device of solid and transparent painting, of scumbling and glazing, of pats with a palette-knife and delicate touches with fine sable, are perfectly blended and harmonized." This is written sixty-five years after Constable's death and seventy-five years after the work itself. Later readers of the painting look past its painterly virtues at the implied symbolic narrative: from foreground to background, Karl Kroeber (1975) sees "a diagonal progression of humanity . . . from boy to man . . . from youth to the hope of life beyond death within the context of nature"; Ronald Paulson (1982) sees "the signposts" of boy, man, and church in the distance as representing "some such topos as the 'Ages of Man' "; and James Heffernan (1985) goes so far as to ask, "Just what is this carefully assembled configuration of elements meant to signify?" except a Wordsworthian spot of time—the boy drinking, the sheep and the dog drifting, the man watching—"in which Constable represents himself in the very act of seeing again the boy he once was."

Or has Constable finally "turned his back on reality," and, to quote Michael Rosenthal (1987), created within his *Cornfield* "an illusory countryside," in which the drinking boy is an improbability, the sheep without a guiding shepherd an impossibility, the dog stopping to watch some birds unlikely, and the contemplative

man looking on unnecessary except as a device? Others disagree and find that the boy is occupied only for a moment, the sheep are in fact lambs and compliant with a dog barely distracted (they are already headed to the right turn of the path), and the man is taking a break from the big job of starting the harvest. The distant church is a common organizing principle in Constable intended to establish both perspective and village context for the pastoral life. Accuracy may be further established by the few men on the far side of the cornfield preparing for the arrival of the whole host of the harvesters, a preparation known locally as "flashing the brew." The trees and the details of the plow and the busted fences in the foreground perhaps add to the reality—Constable is marvelous with trees, not only as architectures in and of themselves but as textures of bark and broken limb and branching reaching, seemingly, into the clouds, the leaves almost liquid in sunlight. "The handles and the beam of the plough . . . are modelled rather than painted, shaped three-dimensionally"; the cast-off of the gate seems to grow out of the ground. Art historians Parris and Fleming-Williams (1993) take the painting's detail a step deeper: "Other parts, such as the stems and heads of wheat in the field on the left, are similarly treated—each stem a filament of stiff paint laid along the surface of the canvas," finished, refined.

There is a moral feeling in art as well as everything else.

For all sorts of reasons *The Cornfield* gives off the effect of being more "finished"—more "eye-salve"—than the large Stour paintings that precede it, perhaps owing to the fact that Constable very much needs to sell it, a motive that flies in the face of the future opinion that he is at his most interesting when his painting surfaces are rougher, seem spontaneous, or resemble serious draft stages. But in this case, the question of the relative "roughness" or "smoothness" of the picture is a false problem and looks to resolve a false choice. It is a work of art that has plenty of finish as well as rough edges, including the artist's famous "snow," an intensifying punctuation intended to bring to life the noon light breaking through the billowy clouds. When the painting does not sell at the Royal Academy showing, Constable displays it the next year at the newish British Institution, where it also does not sell. Perhaps the public is not literally "buying" the truth of the picture, its staged narrative content. For all the quality of the application of the paint itself, is there something missing from *The Cornfield* that distinguishes Constable's earlier work? Art historian Malcolm Cormack anticipates—by a

year—Michael Rosenthal's negative opinion that in spite of Constable's well-known commitment to realism, "there are some anomalous details. The sheep, who would surely have been shorn by July, are disastrously close to wandering into the cornfield, if the dog and the boy do not soon remember their duties. The field itself is without a proper hinged gate, which hangs broken and open. There is a remarkably reduced workforce, to cut a field of wheat in 1825, one of whom is already going home at noon."

Compared to the Stour six-footer series, is the wheat field *Cornfield* "an illusory countryside"? An invention rather than a rendition? Enlightenment poet James Thomson may be the established lyricist of the English pastoral tradition, embraced by both Constable and Turner, but by 1819 John Keats is one of the tradition's best poets, certainly in his final ode of September 19. Constable's Suffolk County pastoral is timed during an early harvest—late July, the start of August; the final harvest in Keats's Hampshire "To Autumn" is set on the next to last day of summer.

> *Season of mists and mellow fruitfulness,*
> *Close bosom-friend of the maturing sun;*
> *Conspiring with him how to load and bless*
> *With fruit the vines that round the thatch-eaves run;*
> *To bend with apples the mossed cottage-trees,*
> *And fill all fruit with ripeness to the core;*
> *To swell the gourd, and plump the hazel shells*
> *With a sweet kernel; to set budding more,*
> *And still more, later flowers for the bees,*
> *Until they think warm days will never cease,*
> *For summer has o'er-brimm'd their clammy cells.*

Who hath not seen thee oft amid thy store?
* Sometimes whoever seeks abroad may find*
Thee sitting careless on a granary floor,
* Thy hair soft-lifted by the winnowing wind;*
Or on a half-reap'd furrow sound asleep,
* Drows'd with the fume of poppies, while they hook*
* Spares the nest swath and all its twined flowers:*
And sometimes like a gleaner thou dost keep
* Steady they laden head across a brook;*
Or by a cyder-press, with patient look
* Thou watchest the last oozings hours by hours.*

Where are the songs of spring? Ay, where are they?
* Think not of them, thou hast thy music too,—*
While barred clouds bloom the soft-dying day,
* And touch the stubble-plains with rosy hue;*
Then in a wailful choir the small gnats mourn
* Among the river sallows, borne aloft*
* Or sinking as the light wind lives and dies;*
And full-grown lambs loud bleat from hilly bourn;
Hedge-crickets sing; and now with treble soft
The red-breast whistles from a garden-croft;
* And gathering swallows twitter in the skies.*

In 1826, the year of *The Cornfield*, James Thomson has been dead for seventy-eight years, Keats has been dead for five. Immortality takes awhile, as Constable, in his afterlife, will come to understand. It is Thomson whom Constable has in mind when he "half remem-

bers" a few lines from *Summer*—"A fresher gale / Begins to wave the wood, and stir the stream, / Sweeping with shadowy gust the field of corn"—in a letter to Fisher about an idea he has for his new Dedham painting. In 1819, when Keats is living at Wentworth Place in Hampstead, and when Constable has just about moved to the village, at Upper Heath, there is no evidence that in the next year they will have crossed paths. Are they each that obscure to the reading and viewing public? Both have been and will be featured in *The Examiner*, and both will have lived—once and in the future—on the same street on Hampstead's high Well Walk. And among Romantic poets who are acquainted with Keats, Wordsworth and Coleridge are fans of Constable's pastoralism; both of them have been equally committed to the textures and economies of country life. Perhaps it is generational, perhaps accidental that the elder painter and the younger poet never meet. Yet "To Autumn" is much more to the positive point of *The Cornfield*, as a work of art, than any genteel summering in Thomson.

The layout of the painting is, in many ways, much more sophisticated than its six-footer predecessors, with the framing device of the elms—large and closer on the left, smaller and farther on the right—not only flanking but closing in on the bending of the path the sheep are following, more out of familiarity than anything else. The prone boy is in the forefront of the picture, and just off-center, while right behind him is the donkey feeding, then the farmer in the half distance (plus the broken gate and well-polished plow), then the expanse of ripe corn, then a lone tree to suggest more distance, then the piece of a village with a church tower, then the horizon. Then the great sky birthing clouds. Everything seems to exist in a state of sudden stasis, emphasized by the distracted dog, the insouciant donkey, the boy with his face in the pool, and the farmer looking on or

watching the whole scene suspended in its moment, while behind him the good work of the world is waiting, as if to apply pressure to the foreground stillness. The painting is very much in half.

The Stour six-footers are more focused and straightforward; their whole pastoral matter is like a presentation piece, close up, right there, foregrounded, in front of the viewer, while *The Corn-field*, for all its literal "depth of field," is a good deal more than its deep-shot perspective. What to call the difference—tone, mood, the aura of memory? As a goal in his art, Constable has consistently referred to painting as "feeling," as the emotional equivalency of meaning. This does not excuse his other "home-body" oil studies from having feeling; it does, however, elevate the issue in *The Cornfield*, which explores an intimacy mostly otherwise sublimated or suppressed in previous country studies: with the exception of the cloud paintings, never before has Constable's authorial presence within the work been as apparent; never before has his defining nostalgia become so edged with personal memory. Without the controversial drinking boy this mature picture turns into another possible calendar-art example of propaganda for "Constable country." It is noon, it must be hot; there is real work to be done; the wheat, the corn is "ripeness to the core"; yet for the moment, held in time unto perpetuity, such "scenes of his boyhood made him a painter."

Thou hast thy music too—

The Cornfield is a wheat field, due for harvesting in mid-summer. "To Autumn" centers on a field of corn at the end of summer, starring the "careless," rather self-satisfied corn goddess Ceres; the harvest is half-in, "the stubble-plains" all too apparent. Constable's painting is set at noon, Keats's poem at sunset. Yet both promise a cornucopia: Constable employs sheep, a donkey and its foal, a curious sheepdog, a farmer in waiting, two distant farmhands, a soft summer sky, and full-sized elms to calmly overfill the hour's full cup; Keats employs the whole range of the maturing sun's harvest—fruit, gourds, hazelnuts, flowers, and, of course, the corn itself—to promote not only "ripeness to the core" but an equanimity of feeling bordering on being "Drowsed with the fume of poppies," a kind of work-done-for-the-day state of rich exhaustion, the evening's quiet closing down. "Ripeness is all," says old Lear at the end. In spite of their twenty years difference, neither Constable and certainly not Keats is old, but they are at an ending—Keats will be dead in a year and a half, and "To Autumn" will be his last great lyric poem, his last direct meditation on the rhythms of time and nature; Constable will move on

to Stonehenge and Salisbury Cathedral and overstated rainbows and dark, billowy beach skies, so that this moment with this young echo of himself taking a water break from chores, being watched as much by a witness as by the viewer, becomes his farewell to his seminal past and primary sources.

If Keats's poem and Constable's painting are farewells, in tone they feel like elegies to worlds, "hours by hours," deeply heartfelt and disappearing—even disappeared—yet alive again as art. For both of them the reality of the harvest landscape becomes the figure of a present-tense correlative for what is passing and what has passed. The "human" figure in either case may allude to the corn goddess or mythic Narcissus, but each work as a whole is a total figure too: a configuration, if you will, of the imagination as ekphrasis—poem as painting, painting as poem—in which the emotional resonance is both the underlying color and secret subject. Their combined tones imply a reconciliation with closure while their separate structures depend on remaining open; open to the skies, to "gathering swallows" and accumulating clouds. This is a tension—resolution versus dissolution—that generates power within each of their received, necessarily restrictive forms—for Keats, it is his established odal construct, for Constable, it is his established farmwork motifs and props—a tension enhanced by the fact that both the poem and the painting transcend, ever so much, their familiar, self-made formulas. Keats employs an extra expansive stanzaic line, forcing the moment of contemplation to linger that much longer; Constable asks his characters to suspend time from the routine of their work in order to hold and internalize the moment of the farmer watching, the dog looking and listening, the boy drinking but likely "facing" himself.

Ten years after *The Cornfield*, the year before his death, Consta-

ble returns to an old drawing from 1823 and tries it as a painting, beginning in 1833. "I have laid by the 'Cenotaph' for the present. I am determined not to harass my mind and health by scrambling over my canvas as I have too often done. Why should I? I have little to lose and nothing to gain. I ought to respect myself for my friends' sake and my children's. It is time, at fifty-six, to begin at least, to know oneself,—and I do know what I am *not*." He completes *The Cenotaph* in 1836. It is a singular piece and odd, based on a monument to the memory of Sir Joshua Reynolds that Constable's sometime patron Sir George Beaumont has had built at his country home at Coleorton. The memorial is a large sort of rectilinear urn-topped tombstone placed on a series of pedestals set in "the dark recesses" of the estate gardens. "At the end of one of the walks," as Constable writes Fisher in yet another letter about the experience, "I saw an urn—& a bust of Sir Joshua Reynolds—& under it some beautifull verses, by Wordsworth." In the painting the bust of Reynolds recedes in favor of busts of Michelangelo and Raphael that flank either side of the cenotaph—whether or not Constable adds these touches is an open question; some opinion gives the credit to Beaumont's original design.

Wordsworth's "verses" may be suggested as script but, from the viewer's perspective, they also, essentially, fade into the obscurity of the stone. Constable's aim, overall, seems to be an homage to both Reynolds and Beaumont and to the Royal Academy they both helped establish, which is curious since Reynolds was the Academy's president in those long years of Constable's failed applications to become a full member, and Beaumont, though publicly supportive, never purchased a single stick of work by Constable. In addition, the autumnal setting of the painting is antithetical to Constable's strong preference

for spring and summer, in this case made all the more emphatic by the chapel-like or cloister enclosure of the dark weight of the fall atmosphere provided by the looming mass of trees that surround the scene. The trees, in fact, dominate the picture, from the ground up to the limited sky. They are beautiful and haunting and in many ways a coda to the artist's great skill with and affection for trees, regardless of the season.

The most remarkable part of *The Cenotaph*, however, is the addition of the stag in the near center of things. The stag fits the autumnal shades perfectly, in exactly the protective walnut coloration of the atmosphere and trees. He is the most animate feature within the funereal stillness of the stone and wood, yet he is also still, looking back over his left shoulder at the painter. He is at once indigenous and anomalous to the scene, natural yet somehow symbolic. There is a lyric robin (red-breast whistling from the garden croft?) sitting on the right corner of the memorial, that may or may not be whistling, that offers both the only brightness as well as the possibility of song and flight, but whose presence nevertheless enhances the silence. The deer is silent, though expressive. This is close to being Constable's last painting, depending on how one dates its more than decadelong career. Why is the deer in the picture at all? The answer seems obvious if one is thinking strictly in terms of composition and content. The deer adds character to an otherwise inert event or nonevent, a picture without apparent motive. The deer also adds meaning as a flight animal caught for a moment in a place to which it offers, ironically, some humanity and reverence, a lonely, shy place, a place Constable seems to identify with beyond his vote of thanks to Beaumont—if for nothing else a thanks for access to Beaumont's art collection.

Is Constable the deer, at once the insider and outsider? Among Constable's acquaintances at this time was Samuel Rogers, well-known for his breakfast parties for the great, good, and talented at his house in St. James Place . . . Constable had a memorable London morning with the banker-poet in March 1836. Rogers told Constable he was on "the right road" as a landscape painter and that nobody could explain its history so well. Constable thought Rogers had the best private collection of paintings in London and particularly admired his Rubens. Rogers was pleased when Constable noticed the falling star in it. Constable watched his host feed some sparrows from the breakfast table; the sparrows seemed to know him well. Yet Rogers seemed also to tap into Constable's dissatisfaction and melancholy. He told Constable that genius had to put up with the burden of being hated. Constable surprisingly demurred at this, though he agreed it could be true "in nature." He wrote to Leslie afterward, "I told him if he could catch one of those sparrows, and tie a bit of paper about its neck, and let it off again, the rest would peck it to death for being so *distinguished*." The analogue here, in this brief encounter from the Bailey (2007) biography, is about recognition but even more about vulnerability. The deer is vulnerable, wary, but curious.

The other offering to the Royal Academy's show that spring is a watercolor of *Stonehenge*, a Turner trick of means and matter opposition: stone represented in water on paper. Constable has already referred to Turner's recent work as "tinted steam," but now seems bent on testing the idea by making his own sky over the great ancient monument "a tempestuous purple-black cloud with the inner and outer bands of a rainbow arching down in the background," against which the "standing, tilting, and fallen stones, and a few small fig-

ures, were spotlit." The effect, now famous, is also fairly melodramatic, a heightening of the inherent theater of the great blue stones so isolated on the Salisbury Plain as to appear otherworldly—"The mysterious monument of Stonehenge, standing remote on a bare and boundless heath, as much unconnected with the events of past ages as it is with the uses of the present. . . ." This last large historical (and vulnerable) watercolor makes for a powerful showcase pairing with the contemporary *Cenotaph*, both of which change the classic Constable landscape subject without much altering the elegiac tone. Both evoke grave markers.

*In Turner's work I find the deeper reality underlying the scenic,
the expression of what are sometimes called abstract imaginings.*

B y the time architect-turned-novelist-poet Thomas Hardy
writes these words, in 1887, Manet, Monet, Sisley, Degas,
Renoir, Whistler, et al. will have painted many of their masterpieces,
and artists like van Gogh, Gauguin, and Cezanne will be well on their
way. And Turner will have been dead for thirty-six years. Is he a precur-
sor or confirmer of an already established trend that begins, according
to Ruskin, with the Pre-Raphaelites? As far as Ruskin is concerned
Turner's best work is behind him, after *The Fighting Temeraire* is exhib-
ited on the walls of the Royal Academy in 1839; for others, much later
critics such as Sam Smiles, Michael Bockemühl, and David Blayney
Brown, 1839, or thereabouts, marks the beginning of Turner's mod-
ernist genius. The problem, as always, is that, in total, there is too much
Turner, and the taste for his oils and watercolors can lean toward the
past or toward the future, depending on the values and timing of the
viewer. His most significant forward-looking work, however, does fol-
low through the heart of his last dozen or so years.

One wonders just what work of "abstract imaginings" Hardy is

referring to, since after Turner's death it takes a while before some of the most representative of his "new" art is known and available to the public, particularly many of the best evanescent sketches, water-colors, and paintings of his final twelve to fifteen years, although in terms of his sketchbooks and notebooks his quick wash and water-color studies seem, early on, to have already learned how to "dissolve." The point is that Turner's ongoing spontaneous and sketchy experi-ence with pencil and brush becomes, at the last, his mature method and, according to critic Andrew Wilton, a "vivid indication . . . that a canvas was simply another sheet of paper on which he could 'draw.'" Or paint, for that matter. As mist or "tinted steam" or "vaporous sub-lime," Turner wants the "haze and indistinctness" of the moment to arrive mysteriously and intensely alive, which is why fire—whether it is the sun's fire as light or fire man-made as erasure—is his favor-ite primary element and primary color for creating immediacy and achieving transformation. The instability of surfaces quickens the quality of that moment.

Probably the most literal and well-known example of his vision of fire is his witness, in drafts and oils, of the burning down of Par-liament in 1834, but his most imaginative example may be the group of nine watercolors and gouache he "observed" in 1841 of the *Fire at the Grand Storehouse of the Tower of London*, in which the thin tex-tures of red are minimized in favor of pure whites, blues, blacks, and yellows, layered in a suggestive mix around the vague shape of the burning storehouse in the process—so it seems—of "failing" into the paper. The fire motif, generally, may be Turner's most graphic way of introducing the force of the sun into the absolute dark of night or of turning day into a night of color. Storms at sea have been another, more familiar version of his "fiery" transformations—

massive waves consuming the mere human element—be they of the famous didactic *Slavers* (1840) painting or the even greater painting, as a work of art, *Snow Storm: Steam-Boat Off a Harbour's Mouth* (1842). In both examples the explosive colors vary only slightly, with the incendiary power of water replacing fire.

Then sometimes, too, we need neither buildings nor boats as fuel for the "deeper reality" of Turner's fires. Part of Turner's genius is his embrace of the changing mechanical and industrial values of pre-Victorian England; much of Constable's genius is his implicit rejection of those values in favor of the pastoral working world he has grown up in, a world nevertheless directly impacted by technology and industry. Ships, for instance, for Turner, are machines—at rest, full sail, or under steam, in or out of trouble. They represent not only history but a kind of flight from the tired gravity of mortality. They are extensions as much as inventions. Yet they are as vulnerable as their sailors. No less a force are Turner's electric skies, which so often seem "industrial"—as if chemical—generated as dramas of ignited color and abrupt, angry movement, released from a furnace. Turner, as an experimenter, looks in the direction of the future; the past is at best of use to him as either inspiration or as material he can temporize. Traveling the length of Britain and the cities and landscapes of Europe, Turner understands the acceleration of technological change and the means by which that change is occurring. In 1844, in one of his last major paintings, he turns from the sea and sheer sky-torn landscapes and the sun in phase with the time of day to a whole other object of affection.

Rain, Steam, and Speed—the Great Western Railway sounds simple enough, if also more or less total in its evocation of locomotion. In 1844, trains in Britain are barely twenty years old, whether they

haul coal or people, and the railways that serve as pathways have "cut through countryside and cities with equal abandon," including parcels that violate Constable-like country. The great locomotives that pull the trains become objects of beauty, fascination, and necessity—not only are society and the culture changed but so is the landscape the trains pass through and corrupt with bridges, tunnels, viaducts, provincial stations, and metropolitan terminals. But beauty, first and last. Walt Whitman, in nineteenth-century America, celebrates the locomotive's "black cylindric body, golden brass and silvery steel," its "ponderous sides-bars, parallel and connecting rods, gyrating, shuttling" at its sides, its "great protruding headlight fix'd in front," its "long, pale, floating vapor-pennants, tinged with delicate purple, / The dense and murky clouds out-belching from" its "smoke-stack," and so on. Whitman makes of this masterpiece of technology, this engine of power and forward motion, this "Fierce-throated beauty!" a still life caught in the moment of its potential, a law unto itself ("Law of thyself complete . . ."").

In Britain, David Brewster declares in an 1839 edition of the *Edinburgh Review* that railways stand for "the most striking instances of the triumph of the scientific arts." Francis Whishaw, a London civil engineer, argues that railways represent "one of the greatest blessings ever conferred on the human race . . . and by far the most gigantic work of the kind, not only in Great Britain, not only in Europe, but . . . in the whole world." Hyperbole for sure, but then compared to the horsepower of horses, carriages, and coaches, rail travel is transformational, even if it is no substitute for walking among the fields, along trails, and on the worn paths through high country and mountains, a habit Turner enjoys as much as the likes of Wordsworth, Coleridge, and Keats. (And, within smaller compass, the likes of Constable.) And

while to cover the amount of ground Turner covers—both in Britain and the Continent—and while the railroad, for speed, surpasses the fastest coach, new train travel will essentially become a city-to-city, town-to-town operation, with as yet little intimate contact with the small spaces and corners of the land.

Turner, if anything, is flexible, whatever the territory, and employs whatever means required to take him from place to place, as often as not on foot or "crop-eared" pony or otherwise by coach or boat. There is, so far, no extensive rail travel; until midcentury it will be more urban novelty than necessity. William Rodner, in his 1997 consideration of Turner as a Romantic painter of the Industrial Revolution, writes that "Turner's inclusion of the corporate identification 'Great Western Railway' in the title of his painting confirmed his familiarity with what was arguably the most famous railroad of the 1840s." One observer thinks the Great Western the "most perfect and splendid railroad in Great Britain," notably its "carriages of astonishing dimensions . . . and its gigantic locomotives." Even more than the steamboat or the cotton gin, the engine that drives the train strikes the public as a work of art, just as the railway bridge it crosses, as designed by Isambard Kingdom Brunel, is a work of architecture. Turner's picture follows the specific track, according to Rodner, of emerging from the controversial tunnel at Box onto the fairly new, five-year-old brick-and-iron Brunel viaduct at Maidenhead where it traverses the Thames, "looking east along Taplow," the whole scene rendered in "blurred sections, often intense in color." Rodner adds that the artist's "fervent emotional involvement" in his material distinguishes this painting from almost everything else Turner is producing at this time.

*The voice of the civility of the Nineteenth Century saying
"Here I Am."*

Emotional involvement indeed. It is not as if Turner is the first registrar of the Great Western Railway. His famous painting follows in time the popular 1835–1840 lithographs of W. W. Young, titled *Illustrations of the Great Western & Bristol & Exeter Railways*, but Turner is the first English laureate of the locomotive itself, which Rodner identifies as the *Firefly*, a rather quaint-looking machine with a big wheel at its center, flanked by smaller wheels, and topped at its front with a stovepipe smokestack that, running, billows a longish coal-black cloud, though nothing approaching the size of "the great cloud darkening the land" in Whitman's 1865 elegy for Lincoln, as the funeral train passes from Washington to Springfield, Illinois. Turner's train is about life, not death—well, not exactly.

The early locomotives were true fire engines, with visible flame sparking from the sides in rhythm with the feeding of fuel into the open fireboxes. You can see Turner's suggestion of these "fires" in the daubs of bright red at the bottom left wheel rods of his charging engine, just as a blur of headlight seems to be leading his machine

into the future—or as one bystander remembers it all, "leaping forward like some black monster, upon its iron path, by the light of the fire and smoke which it vomits forth." *Rain, Steam, and Speed* is unique, even for Turner: its subject is landlocked, for one thing, in spite of the train being on a bridge over a major body of water; as a product of industry, it represents the vast time ahead rather than vast or recent history; forward motion, in fact, is its mission; moreover, it is traveling at some considerable speed almost directly at the viewer; so it is a threat as well as a gift, a harbinger as well as a messenger; and it carries mystery, as it seems to exist in neither daylight nor night but in a numinous twilight of timelessness. As for the painting itself, the "bottom portion," writes Rodner, "exposes a landscape of golden browns punctuated by touches of white, while the top half is tinged by the blue of the sky, a color echoed slightly on the meandering river to the left. This sky is stained by arched swirls of gold and white, which straighten around the advancing train, becoming vertical lines above and behind its carriages and parallel diagonals at and before the locomotive."

For whatever reason, Turner has added a few obscure onlookers standing and apparently waving from the riverbank, plus—to the viewer's far left—a small boat with a fisherman. And faintly on the left of the fisherman is the bridge bearing the Great West Road. Is there a rabbit dashing across the bridge just in front of the train?—if so, it is one of Turner's pointless jokes: pointless because, in the totality of things, this painting is profound and needs no apologies. Or as Whitman's American contemporary Emerson says of the locomotive's roar and whistle, "Here I Am!" The carriages behind the engine are open and in later years will be suitable for carrying coal or freight, but here the freight is third-class passen-

gers, who are standing because there are, as yet, no seats. Standing in the rain. (There have already been rail accidents, including, in 1841, a derailment—just ten miles from Turner's bridge—in which eight people die and seventeen are maimed.) Rodner's rendition of the lower and upper portions of the painting is accurate but only that. The same year, for instance, a certain Lady Simon and Turner meet on a train heading to Devon—in a thunderstorm. Coming in the opposite direction is another train. Turner, naturally, leans out of a window in order to observe "the effect of rain and steam from a train traveling at speed," according to critic Gabriele Crepaldi (2011). If this story sounds a lot like Turner's claim of lashing himself to the mast of a ship in a storm in order to take on a similar, if more extreme, experience, this one has the advantage of a witness.

More to the point of *Rain, Steam, and Speed* as a work of art, the novelist Thackeray responds to seeing Turner's painting at its East Room showing at the Royal Academy with the enthusiasm that all "these wonders are performed with means not less wonderful than the effects are. The rain . . . is composed of dabs of dirty putty *slapped* on to the canvas with a trowel; the sunshine scintillates out of very thick, smeary lumps of chrome yellow. The shadows are produced by cool tones of crimson lake, and quiet glazings of ver-million; although the fire in the steam-engine looks as if it were red I am not prepared to say that it is not painted with cobalt and pea-green . . . The world has never seen anything like this picture." Thackeray seems to be seeing a very modern means-and-matter correspondence between the actual event and the event as applied paint, as if the application were the subject and the announced sub-ject were the object. Still, the aggression of the painting, in some minds, is a question: so writes the *Morning Chronicle* in asserting that

it is "probably the most insane and the most magnificent of all these prodigious compositions," referring not only to Turner's other six submissions of the season but also to the competition on the Academy's other walls.

It is easy enough to think of Turner's "magnificent" composition in the context of Britain's industrial genius and its culture's acceptance of manufacturing as the basis of the revolutionary economy of the moment and the future. Easy enough to admire—with "reservation"—this Romantic example of the Victorian ethic of onward and upward, "to strive, to seek, to find, and not to yield." And while it is true that Turner has a penchant for occasional crowd-pleasing didacticism, such as his slightly sentimental version of *The Fighting Temeraire, Tugged to Her Last Berth to Be Broken Up*, this locomotive painting is not that—neither remotely sentimental nor didactic; if anything, it is an attack on having "designs" on the viewer, to paraphrase Keats. "The soft golds, blues, and whites of nature stand in stark contrast to the blacks and grays of industrial technology": here again, Rodner has his color scheme in order, but the energy behind Turner's own "technology" as a colorist and artist in this picture is of another order. *Rain, Steam, and Speed* is an explosion of velocity and muscle; "soft" is not the adjective for the way the melt of color in degrees of yellow-gold, brown-gold, white-gold, and black-gold emanates from the muscle of the train coming at us: it is at once a totality of subtlety and hyperbole formed and brought into the focus of the coal-black locomotive acting like a vector, all of it directed and contained by the equally coal-black dimensions of the rail bridge, while the headlight picks up the otherwise color and sends it ahead.

Fraser's Magazine "warned its readers to hasten to see the work lest the locomotive 'should dash out of the picture, and be away up Charing Cross through the wall opposite'" (Shanes, 2008). And not just the locomotive but the weather with it. Turner loves context—in many ways the best of his work is about context: the animating sky, the animate waters, their inherent colors; the towering architectures of mountain gorges and precipices and cathedral caverns; the long landscape, the obscurity of ruins; and sometimes the stillnesses of things, but always the intensities of light. Nowhere in his title does he notice the engine driving the action of his railway painting; it is the combining, gestalt effect of the sky full of rain mixing with the steam power of the mass moving at such a speed as to push the air in waves in front of it that brings everything in the picture together. The energy created on the canvas itself—that is, the painting as a made thing—becomes the driving energy celebrated in the title. Turner has once again closed the separation between making and meaning, but on a scale of the sublime at once intimate and transcendent. Ruskin, in an excited moment in *Modern Painters*, claims Turner to be the greatest painter ever. This picture of the *Firefly* flying does nothing but enhance that opinion.

Turner has some golden visions, glorious and beautiful; they are only visions, but still they are art, and one could live and die with such pictures.

One wonders which Turner pictures, in 1828, Constable could live and die with, since, in terms of his golden visions, Turner is only getting started. Italy will prove to be the gradual changeover from a compromised English sun to a honey light that seems to pour pure gold, marking a change from the beauties of fire to the beauty of that light. Turner visits Italy first in 1819, then again, more significantly, in 1828, 1833, and 1840, north and south, from Venice and Turin to Rome and down to Naples. But it is Venice more than any other part of this golden country and its city-states that fills out the painter's idea of the realities of a dream.

The interlude of Switzerland may be the other European setting, in Turner's late career, that best inspires and tests similar watercolor and oil effects of light passing through and transformed by the rare quality of Alpine air, particularly in the 1840s landscapes around Lake Lucerne, and specifically in oils like *The Bay of Uri from*

above Brunnen and *Sunset from the Top of the Rigi*, in which, as David Blayney Brown (2014) puts it, "Turner used a pale mushroom pink priming composed of several layers of lead white, chalk and purplish Mars red," then "worked up the motif with more lead white, vermilion, red lake and chrome yellow, mainly in impasto." The result of this "pale" Turner is the feel of a watercolor that comes as close as possible to a whiteout of disappearances, faded into "structures of light" filtered through a clarity of mist or, if you will, through a medium of "air-water," something like a conjecture or "stochastic" of the imagination brought to bear on a reality behind what seems apparent.

And these Swiss paintings may take the notion of Turner's so-called color beginnings to a further perfection but they will lack the warmth and commitment of his northern Italian Venetian studies, where his love of place turns absolutely "toward trying to represent form by colour rather than line" (Meyer, 1995). Venice as a floating city floats even more in Turner's space of indeterminacy, where form is subtle gradations of color, with the emphasis, as always, on context, on an intimacy of sea and sky as they interact with the smaller dimensions of the canals, personal palaces, pensions, and grand, ghostly churches. His countless pencil, gouache, pen and ink, and watercolor sketches in addition to the drawings and oils, make up a Venetian career in themselves. As studies as well as finished pieces, the substance and depth of the watercolors stand out and set a new standard for the medium—they build the mood and richness of oils without the sticky applied textures. *Venice: Grand Canal, with Santa Maria Della Salute, from Near the Hotel Europa* (1840), for example, is a complex combination of close-in and perspective detail, except the datum of the forms—the gondolas, near and far, the water avenue

of the architecture, the massive Baroque church—are all gathered through the watery veil of a late afternoon setting sun, just after a shower. Santa Maria dominates on the far left with its size and aging pallor, while the other buildings, on either side of the canal, thin out into a sweep of the half-blues and egg-whites of the sun. The remarkable aspect here is the reflective life of each form, quiet yet deep into the water, so that three soft parallel planes develop: the canal, the city, and the sky—distinct yet one in their visual and emotional impression.

This is probably among the most delineated of the late watercolors, along with a group looking toward Fusina at sunset on the Giudecca Canal. The same qualities of cool coloration and reflection obtain throughout the group, whether the artist is standing on a balcony or sitting on steps or in a boat, just outside the frame of the picture but well inside its tone. Much of Turner's genius is about his proximity to his material, visually arm's length, emotionally hands on. In all his water-set watercolors, Turner's use of reflection is especially intimate in the way it echoes—doubles?—his forms and their implicit gravity without adding weight: on the contrary, like the working boats, his civic and private buildings buoy over their self-reflecting selves as his skies melt into the water's surface. Among the best known and most original of the Venice watercolors is *The Sun of Venice* (1840), which depicts a combination of *bragozzi* (local fishing boats), particularly one drifting in an early morning calm of nearly whiteout heat haze, just at the edge of the entrance to the Grand Canal, with a fogged-in Santa Maria Della Salute and other sights blue-washed into the background. A sun sign and a crescent moon decorate the mainsail of one of the boats, likely Turner's pun on the painting's title, a title that refers to the possible name of the

fishing boat as well as the sun's phantom presence within the morning mist. *The Sun of Venice* is one of the most remarkable watercolors ever done, its beauty as much the result of what is subtracted as what is provided.

Most remarkable is the sensitivity, even delicacy, of the composition of the boats themselves, in which their reflective presence is inseparable from their actual central place. Over and under, they form a sort of broken line for two-thirds of the right side of the picture, with the bluish ghost of Santa Maria in the far background filling in the rest on the left. The line of figures—boats and church—occupies the full wide space just below the midsection; everything else we see is sky and sea in a pearl-shaded fog. A perfect fog. The boats are rendered with a minimum of touch: a couple of pale open sails suggest hints here and there of others; the coloration of a bit of blue and rust-red is spare; the whisper of the tall masts retreats in perspective once the pencil-thin two in front are established. The watercolor (on paper) as a whole hovers between representation and abstraction, as if Turner is between making a study and a finished piece all at once; as if, as in so much of his open-ended later work, he is allowing the process to become the product.

Three years later, in 1843, he turns his *Sun of Venice* watercolor into a *Sun of Venice Going to Sea* oil, an oil that, superficially, seems to be more traditional in composition though deeper in intention; it is more traditional-looking only because the mainsail of the piece is more or less in the center, flanked by background forms on the symmetrical far edges. Otherwise, it darkens its dawn motif to something closer to morning on its way to evening. The fog has been completely burned off in favor of "dazzling light." Art historian Gabriele Crepaldi (2011) outlines the setup of the painting in

the simplest of terms: "the famous palaces and churches form the background, banished into the vague distance—almost completely invisible because of the strong, dazzling light that floods the entire composition. Only the sailing boat in the foreground is portrayed with any degree of clarity, while the other elements appear undefined and hazy." Ruskin, in an 1845 letter to his father, sees the scene "with the early sunlight just flushing its folds," out of which emerges "a fishing boat with its painted sail full to the wind, the most gorgeous orange and red, in everything, form, colour, & feeling."

"Feeling," of course, is the operative word here, as it is for Constable. The difference is that, unlike Constable, Turner never speaks of his work in emotional terms—he simply performs what he feels. So that *The Sun of Venice Going to Sea* stands apart from his usual "Venetian pictures . . . of uncomplicated charm," as Barry Venning (2003) writes. It is classically Romantic or as Ruskin puts it, Turner often expresses "an extreme beauty where he *meant* that there was most threatening and ultimate sorrow." Venice is certainly a city of both beauty *and* sorrow: even in Turner's most "charming" Venetian watercolors and oils its architecture is veiled to disappearing in night mist and sunlit vapors. Since forever, to writers as well as painters, its perceived mortality is not only essential to its identity but to its eternity. This exquisite sense of transience is acted out especially in *Going to Sea*, as if the passage out is possibly terminal or at the least vulnerable. While the watercolor precursor calls attention to its picture's absences and recesses, the follow-up oil is rich in the forward presence of what appears to be the same fishing vessel: its full sails gorgeous, detailed, defined by their sun sign. And the grounding coloration is anything but soft, with the lead boat etched

in "bone blacks and red lake" and the second boat, to the viewer's right, in the distance, even darker, backed by muted "palaces and churches" deep into the obscuring haze, while the great sky and the sad sea are built up in layers of "vermillion, chrome orange, yellow, emerald green, ultramarine and cobalt blue" (Smiles, 2000).

At its 1843 showing at the Royal Academy, Turner attempts to reinforce his reading of the melancholy of the piece by attaching a few paraphrased lines from Thomas Gray's "The Bard" (lines that he also includes in his terrible epic *Fallacies of Hope*). "Fair shines the morn, and soft the zephyrs blow, / Venezia's fisher spreads his painted sails so gay, / Nor heeds the demon in grim repose / Expects his evening prey." Turner's didactic impulse invariably distracts from his artistic gift. The *Athenaeum* critic comments that Turner's "style of dealing with quotations is as unscrupulous as his style of treating nature and her attributes of form and color." The *Art Union* critic picks up the treatment-of-color theme and complains of Turner's favorite use of yellow—"Such extravagances all sensible people must condemn." Although no fan of much of Turner's later work, Ruskin (2005), to his credit, forgives the poetry and defends the artist's rare mix of color: "The wonderful splendor of the combination of colors in this painting make it one of Turner's masterpieces in oil." It *is* a masterpiece, one that transcends Turner's fascination with boats of all kinds in all kinds of stress or calm. It absorbs the evocative, understated technique of its watercolor predecessor and out of a unique recombining of brilliant morning color and light, with just the right amount of line and detail, achieves a new level in his art, one that is lucid without being literal and abstract without sacrificing accuracy. In its direct address to the viewer, the figure

of the boat is immediate and definite, yet it seems to be emerging from substances of air and water, sunlight and imagination. It is only a fishing boat, yet it casts the larger spell of a vessel more majestic, noble. Its sails are glorious, like Italian heraldic flags. It seems to be moving in the direction of a destiny. Its implied truth may be transience, but its "feel" is beauty, a place well past mortality.

A personal experience, a vision, an emotion felt . . .

One can understand Turner's fascination with Venice—
its personality as a water city, its dependence on boats,
its history as a cultural and political power, its unique architectural
beauty, its decadence, its special relationship with the sun, and perhaps
most of all its presence as—in and of itself—an act of the imagination,
a masterwork of art, at the same time vibrant and vulnerable, a liv-
ing and dying thing, as if it were both artifice and nature. This is the
loving theme of English novelist Evelyn Waugh when he writes that
if "every museum in the New World were emptied, if every famous
building in the Old World were destroyed and only Venice saved,
there would be enough there to fill a full lifetime with delight. Ven-
ice, with all its complexity and variety, is in itself the greatest surviv-
ing work of art in the world." Turner is a traveler who passes through,
in nearly equal portions, wild and civilized places and tests what he
looks at in notebooks and sketches: he has wide taste and is attracted
to the large, the dramatic, the overwhelming, such as the Alps and the
ocean and at the same time compelled by architecture and interiors;
he prefers overt or at the least implied action, actual or historical; he

disassembles topography in order to remake it; he sees in color and light as if the sight were a vision; and the vision is through a glass half-darkly, even in the sun.

Still, Venice, more than any other cityscape or landscape, permits Turner to understand the sublime in the most understated, warm, and mystical of terms, as through, literally, a curtain of mist. If it seems that he comes to this vision late in his life and later in his work, it has one of its beginnings following his father's death, though he has already lost his mother and a sister. "Vision" may be too strong a word, since whatever it is refers to a different way of seeing—as destructive as it is creative, disassembling as it is remaking: it fits, however, if we mean by it a totality or whole reconfigured in and by its parts. In Turner's late, great work everything becomes a ruin of its former, literal self. This vision obtains whether Venice is directly addressed or not, because as a point of departure that beautifully lends itself to reality becoming unreal, its meaning is portable. *Norham Castle, Sunrise* (1845) is a strange pastoral-like English setting supposedly unfinished, a fact that only enhances its vaporous oil configurations and coloration that are totally in keeping with his Venetian impressions. His *Heidelberg* (1846)—a sunset watercolor almost obliterated by its blinding brilliance and glow—may be German but its light is Northern Italian magnified to an almost hallucinatory degree, so that its golden and faintly azure tones suggest a heaven on earth if not a place more elevated. Even its choruses of dissolving choir-like figures gathered along either side of the sun-gold river—whatever they represent—look angelic.

But Venice is where Turner's formal vision of color and light as content moves to an inimical level. The years 1845 and 1846 date a sequence of four oils evoking going and returning from the Santa

Marta annual ball held at the Lagoon in honor of the livelihood and art of fishing, in honor of a boat like *The Sun of Venice*. The best in the series—*Returning from the Ball (Santa Marta)*—is the equal of the transformative *The Sun of Venice Going to Sea*. Indeed, as a dramatic composition, it is "filled" with richer qualification, which is to say there is more in it, however obscure. Yet the long horizon line of much of Venice itself is not obscure; it magnificently melds with the sea and sky in its blend of white-yellows and pale blues, with hints of orange, all of which colors are repeated and remixed in the early morning sky and still waters. The lower right corner (from the viewer's perspective) *is* obscure—an island? What is remarkable about this interval is Turner's connecting of background and foreground at exactly where the distant St. Mark's Square and the mass of island material in front of us are joined in a fierce smear of sunlight caught in the moment of perception.

The left-of-center part of the picture is another capture of a fishing boat as it is heading home (there seem to be one or two others well behind it). There is no telling whether it is *The Sun of Venice* all over again; it is too far away. Its special signature, though, is its butterfly sails in full furl—it looks as if it could fly and is on the verge of doing so. It casts a long, very dark shadow ahead of itself, which means the sun is rising behind it in a vast sky totally dawn bright. The shadow motif is picked up everywhere, with dark hurried cloudy rubbings of paint here and there across the entire space of the sky as well as below—though thicker—in the calm sea running to the bottom of the frame. The picture's overall composition is complex not simply because of the number of forms but because of their arrangement left to right and especially because of their relative positions in depth of field—there must be no fewer than four

or five different distances, front to back, starting with the "island," then the butterfly boat, then other boats, then St. Mark's, and then, around the corner, more Venice. What holds it together is the sun rising and creating specific, time-sensitive colors. It is a tremendous and wholly original painting: the future of painting, in fact.

It has had, according to Gabriele Crepaldi (2011), a circuitous career as a sold work of art, beginning with its immediate purchase "by Benjamin Godfrey Windus," then on

> 20 June, 1853 it was presented in an auction at Christie's (lot no. 2) and was sold for 610 guineas to Henry Wallis, a Pre-Raphaelite painter, writer and collector of paintings and ceramics. On 23 March 1854 the painting went to Joseph Gillott and was included in the sale of his collection which was carried out by Christie's on 20 April 1872 (lot no. 160), where it was purchased by Thomas Taylor, Earl of Bective, for 1,500 guineas. Later it was part of the collection of James Price, before it appeared yet again in an auction at Christie's on 15 June 1895, where it was purchased by Agnew's Gallery, which sold it to Sir Donald Currie. After changing owners several more times it became part of the collection of Sir Harry Oakes, a wealthy businessman. It was offered for sale by the gallery Mallet & Son in London in 2001.

Turner would have, no doubt, appreciated the value of his Santa Marta painting as a commodity, but must be wondering why, wherever he is, such a great work remains in commercial hands and not on the walls of the National Gallery or the Tate.

Perhaps Turner himself is to blame for the orphaned career of

Santa Marta. Perhaps he appears to be repeating himself, however varied the two pairings—less than a year apart—are. The Tate does own the first two paintings in the group—*Going to the Ball (San Martino)* and *Returning from the Ball (St Martha)*, both of which are fine, moody, closer-in pieces that are a little more defined if more monochromatic. The sun, in each of them, is subdued, the shapes more apparent, topological, the darker tone in tension with twilight and dawn. The boats tend to be heavy, dark, opaque. As a pair, the paintings are beautiful and typical of this late period when Turner knows what he wants and nothing else, no compromising attention paid to the viewer or potential buyer. Are they, as a pair, too much alike, regardless of the hour? Why did Turner try the same "subject" again, just a little later? Was he dissatisfied with these first attempts? These early versions did not sell, of course, and became part of the trust that was passed on to the public. They may have been too subdued, too personal for the artistic taste of the time. They may have looked too "unfinished," underpainted. They are certainly *feeling* paintings, haunted as much by intention as by discovery. And by rediscovery.

Faint veiled vestiges of dark vapour . . .

Constable paints his Hampstead clouds twenty years before Turner's final, and perhaps greatest, phase. The 1820s, in fact, mark Constable's most productive and important period. His 1821–1822 cloud studies are special—personally and aesthetically; those that survive are among what will become his best-known and lasting work, not including the River Stour and Dedham Valley landscapes of the same decade. His clouds—his "skies," as they are sometimes referred to—are special for lots of reasons: their very subject, their focus, their accuracy, their spontaneity, their investment, their instability (barely fifty of more than a hundred last), and, most of all, their "intimacy": they not only keep Constable close to home and close to his tubercular wife, they act as true correlatives for his inherent melancholy, especially what he is feeling right now. As we know, he paints them out-of-doors within walking distance of his front door, and he paints them in oils on paper, as if he can commit, at best, to their moment and cannot quite commit, at worst, to their future. (The constantly changing landscape of his Hampstead skies seems to

bear directly on the terms in which he is translating them.) Constable's fulsome clouds are different from Turner's scrim-like clouds in that instead of releasing the sun they mean to suppress it; they, essentially, become the sky, wall to wall, as vessels of held water and captured light, always, it seems, about to release or withhold their power. Constable's cloud studies are just that, studies of an isolated "object," meteorological, perhaps psychological, separated as much as possible from their natural context—from landscape and setting. They are, in effect, floating landscapes in and of themselves, in which their common cumulonimbus character resembles the crowns of Constable's favorite ash and elm trees.

One question is—beyond the idea of practice—why paint clouds as such at all? Therapy? Distraction? Popular critical opinion has it that insofar as Constable's classic identifying landscapes are concerned his clouds epitomize his attitude toward—as art historian Edward Morris (2000) puts it—"the illusion of solidity and recession" or the uses of "chiaroscuro"; or, as Constable himself puts it, in an analogy of how the spacing of light and shadow varies "the aspect of everything they touch . . . the moment we come into a room we see that the chairs are not standing on the tables, but at a glance shows the relative distances of all the objects from the eye, although the darkest or the lightest may be the furtherest off." Clouds, then, control "the nature and fall of the light" over the land. They help to bring to life the landscape they patrol. But what if we treat the clouds as the whole picture, self-contained?

In *Modern Painters* (1834), Ruskin seems to be defining one difference between Constable and Turner in their approaches to clouds and host skies:

With them (the old masters), cloud is cloud, and blue is blue, and no kind of connection between them is ever hinted at. The sky is thought of as a clear, high bright material dome, the clouds as separate bodies suspended beneath it; and in consequence, however delicate in tone their skies may be, you always look at them, not through them. . . . If you look intensely at the pale blue of a serene sky [as in the moderns], you will see that there is a variety and fulness in every repose. It is not flat dead colour, but a deep, quivering, transparent body of penetrable air, in which you trace or imagine short falling spots of deceiving light, and dim shades, faint veiled vestiges of dark vapour . . . whereas, with all the old landscape painters, except Claude, you may indeed go a long way before you come to the sky, but you will strike hard against it at last.

As a definition, this is overdrawn yet well drawn. Ruskin is distinguishing within worlds of whole landscapes. Quivering transparent bodies of penetrable air is a fair description of Turner's cloud transparencies, while "a variety and fulness in every repose" is a fair rendering of Constable's landscape-tethered clouds. But clouds isolated and framed as only themselves are another matter, in which "you always look at them, not through them," and which "faint veiled vestiges of dark vapour" secure a sense of dimension, chiaroscuro. There is no question that Constable likes to think that his attention to his Hampstead skies is scientific in a lay sort of way. He dates, on the back of his "canvases," the hour, wind speed, kinds of clouds, temperature, etcetera, in order to document and specify what he is looking up at. But these notes, as a reminder, are also, as we have seen, impressions: "Hampd. 17th October 1820 Stormy

Sunset. Wind. W.";"Hampstead July 14 1821 6 to 7 p.m. N.W. breeze strong.";"Hampstead Sept 11, 1821. 10. To 11. Morning under the sun—Clouds silvery grey on warm ground Sultry. Light wind to the S.W. fine all day—but rain in the night falling." As he goes along his inscriptions become longer, more attentive. There are no fall or winter sightings; spring and summer are his seasons.

Several of the cloud studies stand out, usually those of a darker cast—larger, more dynamic. These have the feel and presence of mountains of building air and water; like architecture, they fill the space, blocking out everything that is not them, except, now and then, there comes a streak of sunlight or relief. They are great structures—by 1822, the obsession has completely zeroed in on the magnificent shapes and combinations in such a way that Constable appears to be on par with them, as if he has climbed a wall or ascended Jacob's ladder. Constable is a great painter. Within his range and parochial reality, his landscapes as skyscapes alter what landscape painting is—he, literally, changes the subject from perfection to analysis ("Light—dews—breezes—bloom and freshness; not one of which has yet been perfected on the canvas of any painter in the world"), and from being stuck to the ground to being lifted into the skies. But his oil-on-paper cloud studies are a risk: they are not even intended for public consumption. They are his private matter; he justifies them as "skying" practice. Yet there they are, prominent and time-taking during three vital and peak years of his less-than-confident career.

Because, as he claims, the "sentiment" of a landscape lives in the sky, the sky becomes the most active principle (and principal) in Constable's 1820s and after outdoor paintings (more often than not finished in the studio), including the seascapes at Brighton and the

various takes on Salisbury Cathedral, and certainly including his heavy attempts to paint rain and rainbows. These landscape skies are contextual skies, sometimes zealous in their aggressive "realism." But they are not the one thing—that is, they are not the sky dismissed from the land and disappeared behind a world of clouds. His clouds in his cloud studies *are* the sky, which means that the best of these studies absorbs and distributes light however the sun and high winds dictate, as if there is a supernatural as well as natural force behind them. You look into the hearts of these cloud paintings and some days you see "large climbing Clouds under the sun. wind westerly." And other days you see "Strong Wind at west, bright light coming through the Clouds which were lying one on another." Some days there is brightness, brilliance; some days, cave-deep darkness, psychological as well as meteorological depression. Constable records what he sees but he also, brush in hand, projects himself into what he sees. These Hampstead moments may be about water vapor, the changing light, and the ephemeral wind; about here and gone; but they are also about Constable while being apparently about nothing, as Hazlitt once said of the content of Turner.

Looked at spiritually, the surviving cloud studies are about the invisible made, for the moment, visible. Here, then gone, then back again in a new manifestation. Drift and gather, gather and drift: nature emblemized in rhythm, in transition, in so many shapes and kinds. Yet not so different—on an infinitely different time scale—from a standing hundreds-year-old tree, season to season, potentially immortal in its own way, until disease or lightning or a man takes it down. Nor so different from the timeline of the corn, the planting, the growing, the harvesting. Drift and gather. Less than a year after Maria Constable's death, Constable goes back to an

1814 sketch of Hadleigh Castle in order to turn it into something, a good-sized oil entitled *Hadleigh Castle: The Mouth of the Thames— Morning after a Stormy Night*—a rather wordy descriptive title more in the manner of a Turner than a Constable. The cloud studies are now six, seven years ago, during the beginning period of Maria's marked decline, and now that time is over. The abstractions of the clouds have given way to another *other* landscape context, combining coastal land and the sea and a few updraft raven-looking seagulls and the painter's grief.

Constable's clouds will never, with this painting, float as free again of landscape gravity. Another kind of gravity will take over. Like a multicentury oak, the ruins of Hadleigh Castle are still standing, though with license the artist has narrowed the distance between the two main towers, perhaps for more than one reason. The move helps to fill the left side of the composition with more interest and it further reinforces "the desolation of the place" and concentrates "the spectator's attention on the dramatic view stretching into the distance over barren countryside to the glistening sea" (Walker, 1978). True enough. Even more, however, it emphasizes the ruins of not only the man-made but the very "nature" of the setting: the wild surrounding rock formations—out of which the towers themselves have doubtless been built—repeat the images of the wild formations of the still after-storm violence in the sky. Constable's clouds now look tighter and fiercer and are traveling at the speed of anger. The ground under them is like a graveyard, the sky in mourning.

Fifteen years before, when he is starting his first sketch of the scene, Constable writes Maria that "I walked upon the beach at South End. I was always delighted with the melancholy grandeur

of a sea shore. At Hadleigh there is a ruin of a castle which from its situation is really a fine place—it commands a view of the Kent Hills, the Nore and North Foreland & looking many miles to sea." The difference between these words on the setting and its "melancholy grandeur" and the 1829 oil is the difference between life and death, so that, in the end, the idea of ruins has become a correlative rather than a concept. Ruins will also, Constable discovers, speak to more than mere destruction—quite the opposite, in fact, they can speak to inspiration. (Turner, as we know, loves ruins, or, better put, he loves already ruins or the transforming of constructs into ruins, into something that breaks down the overall constituent parts in order to reassemble, reimagine them, whether it be a storm at sea, the burning of the House of Lords and Commons, or a sunset/sunrise blinding Venice.) So that for Constable the idea of ruins, in these last years, becomes less an aesthetic issue than elegiac, "inspired" in tone by Maria's passing, yet in keeping with his melancholy sense of things in the Stour and Dedham Valley paintings about the passing of a way of life. Indeed, in *Hadleigh Castle* he seems unable to help himself by adding the pastoral touch of a shepherd, with staff and dog, approaching the main tower, while off to the right, already arrived, is a farmer sitting, resting, with two of his cattle (dairy?) in tow. The shepherd is wearing the signature red vest.

At its showing, the Royal Academy catalogue for the painting quotes lines from Thomson's *Seasons* (1730), the first couple of which—"The desert joys / Wildly, though all his melancholy bounds / Rude ruins glitter"—parallel the emotion of the piece. The painting receives mixed responses. Leslie (1980) reports that Constable's friend, the sculptor Francis Chantrey, thinks the foreground is too cold, so takes Constable's palette knife from him "and

passed a strong glazing of asphaltum all over that part of the picture, and while this was going on, Constable, who stood behind him in some degree of alarm, said to me, 'there goes all my dew' "—dew being Thomson's "glitter." Constable's dew is in fact Constable's old familiar snow, borrowed from any number of his classic landscapes. Critic Jonathan Clarkson (2010) is more generous:

> The castle is used to invoke a sense of the sublime. The age of a ruin, when compared with the brevity of a human life, was a common trope of sublime literature. . . . Hadleigh Castle has been ruined by time, but it has also withstood those ravages. Its position in the foreground and relative to the horizon gives the taller tower a heroic quality that belongs to the painting rather than the actual monument. Constable also enlists the viewer's sense of sublimity through the depiction of the weather, which shows a storm clearing off to the southeast.

One could live with such pictures in the house . . .

What is a landscape? As representational art, as a picture of a configuration, an arrangement of parts, a whole of pieces, it may not be that different from a portrait, many of which, in assembly and detail of an interesting face, have the topographical integrity of landscapes. As a space in time, caught in a certain light, frozen within the potential of an action, alive in "the moment while the moment lasts," an attentive landscape may also be a still life, in which the objects are placed in a believable, natural order of emphasis and treated with a stop-time imperative. Landscapes are of the land and, apparently, of the water attached to the land. Landscapes are human models or wild beyond human artifice. The sky, too, according to Constable, is the crucial, emotional element of a landscape—that insight has his name on it. On the other hand, both Constable and Turner appeal to the "feeling" informing what they create out of what they see in a given landscape "scene." Such a scene is not neutral nor neutered; it implies a narrative both within and without its frame. The subtext of narrative is time, the subtext of time is emotion, the

subtext of emotion, therefore, is mortality. Both of these painters seek a deeper level, a transparency of something beyond what is apparent.

In the end, they both "ruin" what they see: they dismantle, they destroy in order to go inside or behind the topology of appearances and rebuild from there. Which is why for Constable his "drafts," his sketches, his early takes are often more exciting than the finished product, when he seems to have arrived one stop farther than his intended destination. The last thing either one of them should want is nth-refinement, which usually means, for any artist, the life force milled away. This quality of discovery of the mystery of a subject, of the transformation of imagined subject into contemplative actual object, is never, at its best, a cold process. It is quite the opposite: to create the object is different from being objective, as the transformation becomes the means of making the painted surfaces alive, tactile, and the materials—the canvas, the paper, the vehicle, the paint—warm, human. The cloud, the tree, the field, the shepherd, the shore, the sunset, the ship, the boat, the building, the fire, the rain, the mist, all become what they are made of, inspired light and color within their forms, while the instability of the forms becomes the source of their intensity. In Constable, the spring dew makes the canvas wet; in Turner, Parliament burning down sets the canvas aflame.

Yet these two very different landscapists, who, as one critic puts it, "stand at the culmination of a long-drawn-out development of sensibility towards landscape in England," are each credited with being the first true Impressionists and, ultimately, Modernists—or at the least the originals of influence. ("British critics, particularly in the late nineteenth century, argued that Impressionism was princi-

pally derived from a mixture of Turner and Constable" [Clarkson, 2010].) "Influence" is a tricky word here for the future value of their contribution. As early as 1824, Constable is writing Fisher that the "Frenchman who was after my large picture of 'The Hay Cart' last year, is here again." The Frenchman is art dealer John Arrowsmith, who has offered Constable too little money the year before and is now back with a considerably better offer (250 pounds) for *The Hay Wain* and some smaller pictures. In no time Constable is hearing praise from visitors at the Louvre. It bears repeating that

> My dear Constable, You will find in the enclosed some remarks upon your pictures at Paris. . . . The French have been forcibly struck by them, and they have created a division in the school of the landscape painters in France. You are accused of carelessness by those who acknowledge the truth of your effect; and the freshness of your pictures has taught them that though your means may not be essential, your end must be to produce an imitation of nature, and the next exhibition in Paris will teem with your imitators. . . . I saw one man draw another to your pictures with this expression, "Look at these landscapes by an Englishman,—the ground appears to be covered with dew."

This from younger fellow artist William Brockedon.

Barry Venning (2003) writes of Turner that "Despite the fact that few of his pictures had entered foreign collections, he had a greater impact on major European and American painters than on his own compatriots." Venning cites two of the most important Europeans: "Turner's modern reputation was given a more significant boost when the French Impressionist painters Claude Monet

(1840–1926) and Camille Pissarro (1831–1903) arrived in London as refugees from the Franco-Prussian War in 1870. Before returning home the following year they visited the exhibition of pictures from the Turner bequest on display in the new South Kensington Museum and were impressed with what they saw." *Rain, Steam and Speed*, at the Impressionist Exhibition of 1874, "was one of the few pictures that Monet would admit to having studied carefully." And Pissarro, in a 1902 letter to his son, comments that "As far as the division of colours is concerned, Turner confirmed to us its worth as a procedure." Artists such as Félix Ziem and Whistler become immediate Turner "disciples"; Monet's own *Impression: Sunrise* is Turner moved ahead.

Studying Constable and Turner is one thing, understanding what they are up to, as different as they are in subject and technique, is another. "Atmospherics" is a concept often alluded to when critics make the international connection, and true, both of these great English landscapists depend on light suffusing what looks like the layering of levels of air in their most influential pictures. The effect, invariably—if differently—is color, mood, and depths of darker tones. The critics also cite "modernity" as a virtue, even though this idea of the painter's sense of what this term means applies to the content in few of Turner's pictures and none in Constable's—that is, if one is talking subject rather than technique. It is technique, method, the application, subtraction, thickness, thinness, and depth of color in the paint that is "modern" in their work—as modern in the first half of the nineteenth century as it will be thought of in the second half.

It is Constable's "snow" and Turner's "tinted steam" that helps call attention to their strongest work—that, and the fact that the

viewer must keep a certain distance in order to put together what certain paintings are saying—and must accept the reality that Constable's genius invites a vision of what was and that Turner's genius demands a vision of what will be. Turner has the advantage of ten more working years. Constable dies in 1837; much of Turner's forward-looking oils and watercolors—inspired by his experiences on the Continent and especially Northern Italy—are finished in one form or another between 1836 and 1846. Therefore, the future, for Turner, has literal and complex connotations.

In his 2003 book on Turner, Venning looks beyond Monet to Neo-Impressionist Paul Signac:

> Like many others, Signac first thought of Turner as a precursor of Impressionism, but a visit to London in 1898 forced him to think again, whereupon he decided that the later works were "no longer pictures, but aggregations of colours, quarries of precious stones, *painting* in the most beautiful sense of the word." These views are characteristic of the critical theory known as Modernism, which dominated the explanation of modern art for much of the twentieth century. It emphasized the effect produced by the formal qualities of a painting but played down the importance of the subject, believing that anecdote and narrative were best left to literature.

The Abstract Expressionist Mark Rothko has fun with the notion of a non-narrative Turner when he comments, in an interview, that Turner learned a lot from him. Both Signac and Rothko have in mind a painting like *Landscape with a River and a Bay in the Distance* (1845), where Turner's disassembling, "dematerialized" vision sur-

passes the anonymous landscape/seascape scene as such to become a Symbolist work of art—in a vision that so baffles his English contemporaries they regard it as "unfinished" and unshowable in Turner's lifetime. The French love it.

The French, early on, love Constable too, but for different reasons. They see him rescuing landscape art from the classical pastoral idealism of Claude and Poussin in favor of the more representative and updated "natural dwelling place" of ordinary country life; they see him rewriting the narrative of nature within a human context but with the major focus on living trees, real weather, filled skies, working fields, and farm cottages as well as manor houses—a world, in a word, in which human labor and consequence are acted out "in sparkles and spots of impression." A world, too, disappearing into industry, since it largely derives from Constable's wishful memory of his childhood. That autobiographical element is missing—or dismissed in Turner. Turner lives in a different time zone, including his so-called history paintings, which are little more than dramas of present-tense settings reset in the past, and more often than not executed in competition with tradition. The life in Turner's paintings is kept, as much as possible, from the memory and machinations of his daily life. And though they both, Constable and Turner, admire Claude, Poussin, and the Dutch "realists," they see the old pastoral vision for what it is, a platform to build on and change. (Marcel Proust, poet of memory, thought Vermeer's contemporaneous city still life *View of Delft* [1658] the greatest painting ever.)

Influences, however, are ultimately beside the point. The work extant is the point. The wonderful originality of the application of the paint is the point. The new, within the gravitational pull of the past, is the point. The sublime is the point—but less the obvious

sublime of Burke's architectural awe, terror, and danger or Kant's mountainous "masses towering one above the other in wild disorder" (not to say oceanic risings "with rebellious force" and great waterfalls "of some mighty rivers"). Both of these philosophers would agree with Longinus, in his discourse on rhetoric (*Peri Hypsous*), that a sense of transport in the mind and heart of the viewer or reader is the sublime's first requirement, transport being at the source of what we experience as the beautiful. Yet words are not mountains nor, exactly, mountain passes. Turner spends a good deal of his younger years in search of what we might think of as the Burkean and Kantian sublime . . . in the Alps, at sea, and at the seashore. Constable finds—as much as possible—its equivalent in the energy, size, and unpredictability of great clouds. Wordsworth, in the 1805 *Prelude*, recommends the mists of "The immeasurable height / Of woods decaying, never to be decayed, / The stationary blasts of waterfalls, / And everywhere along the hollow rent / Winds thwarting winds, bewildered and forlorn / . . . As if a voice were in them." He is describing his experience at the Simplon Pass, an experience Turner would have responded to and Constable would have avoided, who, we remember, hated mountains.

But grandeur is one thing, eye level is another. "As if a voice were in them": the voice, the smaller voice of a more one-on-one, more intimate-sized scale of landscape experience generates Constable's and Turner's best work, whether it is summarized by an elm tree or a hay wain or symbolized in the morning and evening light luminous behind a Venetian fishing boat. Although it may be more apparent in the "atmospherics" of Turner than in the "snow" of Constable, it is as if the high ambition of both painters is to paint what we cannot see but sense, nevertheless, is there, so that within

their broken or disappearing lines and green fires and white fires of light is something numinous, something larger than individual feeling that, ironically, can be powerfully implied in the familiar and small moment. This "spiritual" dimension is true if relative in most important painters—Cezanne is deeper than Monet, in spite of the glitter; Rembrandt is more profound than Vermeer, in spite of the perfection. The small indelible moment: sometimes we have to look askance to really see it, see its value. "Tell all the truth but tell it slant," writes Emily Dickinson. Sometimes it is the off-painting, the rough oil sketch, the piece half-finished, the distracted and the quick—the plein air on paper—that surprises us, and speaks to us, tells all the truth, but slant. Such moments will, of course, at their best, have their own sublimity, but they will also, if they are going to last, have vision, even a tragic vision of an acceptance of the inherent mortality of what we are about.

Of all the works of Creation none is so imposing...

" . . . as the Ocean; nor does Nature anywhere present a scene that is more exhilarating than a sea-beach, or one so replete with interesting material to fill the canvas of the Painter; the continual change and ever-varying aspect of its surface always suggesting the most impressive and agreeable sentiments,—whether like the Poet he enjoys solitude." This rather roundabout attempt to say in prose what he says so much more effectively in paint is typical of Constable's formal (often uptight) Tory personality. No wonder Turner prefers to let his art speak for itself. This excerpt is from Constable's comments on *English Landscape Scenery*, subtitled *A Sea-Beach—Brighton*. It comes ten years after the brief time he has moved his family to Brighton Beach in hopes that the fresh sea air will benefit his wife's failing health; during much of the 1820s the family will triangulate between London and Hampstead and Brighton in the attempt to improve Maria's deteriorating condition. Brighton Beach is by no means Constable Country, and his exhortation on its behalf rings strange if not hollow when juxtaposed with his major pastoral work. But he seems to mean it. If anything,

the big beach is Turner Country. One could argue that among the doubtless several motives for his Hampstead cloud studies is the fact that Constable becomes bored with trying to turn the largely undifferentiated landscape of the Heath into something interesting—at least as half as interesting as the Dedham Valley. Yet except for the looming sky he has no real emotional attachment to this countryside on the edge of the city. For Constable the "sea-beach" turns out to be a remarkable, if anomalous, setting for the opportunity to stay off his signature country subject.

But why? To whatever possible extent, Brighton represents a change of venue—or in Turner terms—travel. In the far future, when the gods of immortality sit in judgment, it will be said of Constable that "by then taste was coming round to judging Constable's sketches and studies as superior to the paintings he finished for exhibition." The truth of this general critical opinion lies in the number of oil sketches and cloud studies that sit on the walls of the world's galleries and museums. These "preliminaries" parallel Turner's later work in pencil, watercolor, and "unfinished" oils as works in progress but works of immediacy and integrity, regardless of the setting. The spontaneity and discovery and sense of experiment single out these Constables and Turners as looking toward the twentieth century. Just so Constable's Brighton paintings. To repeat, "In Constable there is no false feeling. For me," says contemporary painter Lucian Freud, "Constable is so much more moving than Turner because you feel for him, it's truth-telling about the land rather than using the land for compositions which suited his inventiveness." Freud may have in mind the Dedham Valley in praising Constable's art, but his insight is no less relevant to the artist's dozen or more landscapes based on Brighton's holiday beaches.

The book on *Brighton Beach* (a June oil sketch on paper [1824] made during a return visit) is that "there is nothing here for a painter but the breakers—& sky—which have been lovely indeed and always varying." Breakers always vary, as does the sky where the land meets the sea. But none of this, more or less precisely, is what one sees in this beach painting sketch. "Vary" is not the word: both close-up and at a distance, the coloration and the lineation of sky, sea, and beach are practically monochromatic—deep purples (sky), deep blues (sea), deep browns (beach) that are layered like a Rothko, except that the layers are in different widths, beginning with the line of beach to the wider line of ocean to the widest line of sky in which seabirds knock about in the wind—well, slight white marks that resemble seabirds, and a couple of brushstrokes for two women, extreme left, walking the beach. The texture of the paint itself is thick, horizontal, back and forth, as if one were painting a fence. It is nearly Constable's darkest painting.

Constable's friend Fisher has said of the Brighton sketches that they are "faithful and brilliant transcriptions of the thing at the moment—nature caught in the very act." But they are more than that: like the best of the cloud studies, they are practically abstract art, developed out of earlier oil sketches such as *Weymouth Bay: Bowleaze Cove and Jordon Hill* (1816), done during Constable's honeymoon, and in keeping with *Rainstorm over the Sea* (1824), in which the artist responds to "the continual change and ever-varying aspect" of the weather, of a squall rising directly offshore out of the ocean: black rain, indeed, pouring back, in explosion, into a black sea. *Rainstorm*, specifically, pushes realism past the point of no return and ends up with an event close to melodrama; perhaps, for Constable, hysteria. His black rain is all streaks of black and blue hammering down,

paint calling attention to itself as both a metaphor for rain and art. The palette here is not that far from the indigo blues and purples of *Brighton Beach*, and, literally and figuratively, miles away from the "color of an old Cremona fiddle" as "the prevailing tone," which has been the serious recommendation of Sir George Beaumont for Constable's pastorals. The sun, it seems, is, again, consistently secondary for Constable, land or sea. Truly English, heavy, of a different magnitude of light and color weight from late Turner's Italian.

Coloration aside—and regardless of setting—the liquid, fluid, notational, responsive method of making oil studies in order to revise toward a final, finished product obtains right from the beginning of Constable's career (go back to *The Village Fair, East Bergholt* [1811]). The question is, why does he not recognize the vibrant, living quality and originality of the study over the refinement? Surely one answer is his ambition to become a full member of the conservative Royal Academy, which at the time prizes "finish" above all other virtues. Constable, apparently, cannot finish enough fast enough. He starts out as a probationer in 1799, when he is twenty-three; and as a Life School student the next year; then, on the verge of his most productive and successful work, in the summer of 1819 he is at last voted into the Academy as an associate member—he is forty-three. Nearly ten years later, following the death of his wife, he makes full membership by one vote—the president of the Academy, Thomas Lawrence, lets him know that he believes Constable is lucky, even at this late stage in his career, at fifty-two, to have been so honored since he is "only a landscape painter."

Another answer to the refinement question is Constable himself—his melancholy perfectionism. He never seems to be confident in his ability to live up to his intention. His exclamation, at

thirty-six, that "I detest the sight of my wretched pictures" may be a passing frustration but it also expresses a lingering doubt. Critic Andrew Wilton writes that Constable "formed the ambition to transform the practice of landscape painting by adapting the language of the sketch into a vehicle for creating large-scale exhibition pictures"—in other words, Constable hoped that size—say, a size that would compete with history paintings—would display better on the walls of the Academy, but size and meticulous detail do not necessarily sort easily with each other, which is why the surfaces of even the best of the Stour River/Dedham Valley paintings demand distance. The studies are not only more spontaneous, they are more immediately inviting, more generalized, more modern in their cast. Constable's drive toward "finish" is his need to resolve the separation between his "scientific" (experimental?) approach to technique and his aesthetic commitment to realism. This paradox only seems like a contradiction: he does, in fact, find a synthesis in his best oils because if—for no other reason—they are not "perfect," they carry over enough of their rough drafts to remain rough enough. Constable's snow, his touches of cloud-filtered light as a way to lift the leaves, the hard bright patches on the water, the thistle edges of things man-made as well as natural are more than reflections, they are self-reflective art. This is even more true of the storm-dark beaches at Brighton, which are almost luminous night scenes in midday light.

An exercise in what may be called the vaporous sublime . . .

At the very end Turner goes back to the open sea. In his fine summary biography of the artist, Peter Ackroyd (2006) writes that what he means by "vaporous sublime" is that in his last best years Turner's "material world is wreathed in a veil of majesty . . . in which the laying down of pure colour elicits the most powerful and profound responses." Turner, Ackroyd concludes, "was trying to create a new sense of form as an inalienable property of light." This sounds like a purist's dream—mist in the morning that soon burns off. But Ackroyd's example of his misty sublime is the rather concrete *Rain, Steam and Speed*, whose locomotive, with all its dark and magnificent machine presence, comes at the viewer like something—an animal—from prehistory. Turner never refers to the train itself, only the energy around it and what it displaces. It is the railway, not the engine, that he titles. It is the vapor made of rain, steam, and the headlong speed of the thing that is the "subject." Within a year Turner returns to his great setting, the sea, but with the freedom of vision he masters during his visits to Venice. Venice, above

all, is vapor, rain, and steam—and sublime, on a human, intimate scale, entirely at the mercy of the sea.

What Turner really returns to is something both new and old for him: whaling and where whaling takes place. Perhaps it is no surprise that the least interesting and least skillful parts of his 1845 small sequence of violent whaling pictures are the whales themselves and their perfunctory whalers and crowds. Too much figuration perhaps. It is no accident that when two of the four large-scale *Whalers* are put on display at the Royal Academy's annual summer show they are placed with four of Turner's vaporous Venetian scenes. What is wonderful about the whale paintings is, of course, the immersion of light and color—light as color, color as light—in which "indistinction" is the keynote, as if the whaleboats themselves are the stuff of sea and sky and their sails are clouds of ephemeral matter. Discounting the hunters in the one whaler Academy painting and the killed black whale in the other, what comes over is Turner's graduated intensification of white light, primarily in the sky but refracted in the scarred turbulence of the water. This is reality upped a degree or two; almost phantasmagoric, the viewer's eye turned inward, toward the imagination; Coleridgean, and, according to speculative scholarship, Melvillean.

Turner's ability with violence is axiomatic. Natural violence—stated and understated—has been a hallmark in some of his most powerful pictures, and it is as much violence of application as realization of the paint, whether by brush, handle, hand, fingernail, palette knife, who knows. Venice sublimates this stormy impulse into sunsets and sunrises, into a more subtle level of intensity—quieter, purer, mistier, form without edge. These values carry over to the *Whalers* to the extent that the awful hunt and death are absorbed,

"whited-out," so to speak, into the larger world of where we are in fact and in the painting as such: profound water, profound sky, elevated to an idea. Two preparatory chalk and watercolor sketches— *Vessel at Sea* and *Whalers at Sea* (1844–1845)—seem to belie the rich white intensity of the oils, since they feel like rubbings of chalk (and charcoal) against the pale gray of the paper; they *are* messy but no less "vaporous" and in their way consuming, in that the boats—in what has become the Turner touch—are at one with the darker water. They seem to exist between what he now sees as rendition and abstraction, in that twilight he has invented: they suggest, then they deconstruct, so that the truth of the medium itself—oil, watercolor, pencil, chalk—turns into the real subject. Figuration, topography, "realism"—for Turner, these have long been a distraction from what is inside or inherent within the material, or materials.

Two other chalk and watercolor preparatory pieces, *Sea Piece, with Figures in Foreground* and another *Whalers* (1844–1845), live even more beautifully between rendition and abstraction. There is more hint of color and eidolon image, as if the ghost forms of forms are deeper and therefore more real. A drawn horizon line makes *Sea Piece* appear to be later in the day, whereas in *Whalers* the horizon is nearly indistinguishable from sea and sky because of a noon-like glowing white chalk of sun. In oils, brilliance is more available for obvious reasons; in watercolor, which is thinner and tends toward the pastel, brilliance requires an inspired ingenuity. Turner seems not only to layer the dry chalk but to wet it or at least place it in direct contrast to his color combinations, which, themselves, are distinct if minimal. *Whalers*, in particular, references the haze and vapor textures of the Venice watercolors, even though the Italian setting is golden and warm and the killer world of the hunters is stark

and cold. It is the veil Turner's imagination sees through that makes the connection. When the Metropolitan Museum of Art acquired *Whalers* in 1896, according to curator Alison Hokanson (2016), the *New York Times* "expressed some reservations about its imprecision but otherwise admired its 'originality of conception . . . fearless of execution, and brilliancy of technique,' calling it 'the vague, dreamy fancy of a genuine poet.'" Vague and dreamy—precisely. The poet part, or Turner as a Symbolist, is at once accurate and indefinite, since the vocabulary of his art, notably his late art, has yet, at the end of the nineteenth century, to find a language.

You have to go down into yourself but you cannot do it alone, you need tools, a paintbrush and a canvas and a stick of charcoal or a pencil, chalk, and watercolors. You need the thing to look at that will pull whatever it is out of you, but you will not see it if it is not what you needed and wanted, if it is not already in one shape or form inside you and so much like what you are looking at, as if it has been imprinted—somehow, somewhere in the past—as a dream asking to be made real in the dream of art. Say a stream with a wagon in it; a sailboat fisher mirrored on water, shining in sunlight; a leaping heavy workhorse; a deadly storm at sea; a backdrop corn-field; a high mountain passage; Hampstead inland clouds or summer sunrise on Venice; the common life or the mythic—these are approximations, verisimilitudes of imagination dated from forever.

Which is more alive to the moment, Constable's 1836 watercolor of Stonehenge, with its tree-like treatment of the stones and its wild indigo sky and receding storm clouds ("The effect with which Mr Constable has judiciously invested his subject, is as marvelous and mysterious as the subject itself" [Leslie Parris]), or his simple, delicate pencil drawing entitled *Stone Henge*, done sixteen years earlier

as a preliminary study, no sky except the paper? Which is more powerful, Turner's chalk and watercolor *Whalers Boiling Blubber* (1845), with its fierce smoky blacks and burning reds, or his quietly understated, "unfinished" misty oil of a *Landscape with a River and a Bay in the Distance* (1845), in warm whites and blues and browns? In art, as in everything else, one has to choose, and the choices are based no less on what the viewer brings to the occasion than what the artist brought. Turner is both lauded and blamed for what critics call his tragic vision, but more often lauded or blamed for his "blurry" vision—or even excused, in his late years, for his madness. Constable, according to Ruskin (2005), is "nothing more than an industrious and innocent amateur blundering his way to a superficial expression of one or two popular aspects of common nature."

At one juncture, Ruskin assigns Constable a "morbidity" in his love of rural virtues. Melancholy perhaps, yes, but not a sickness of temperament surely. Constable's translation of the tragic is sadness—there is deep sadness invested in what he sees in his worlds, whether it is a simple cottage, an elm, or a field of golden grain in need of harvest. Sadness is his real subject, as death is Turner's.

I imagine two dishes, the one of gold, the other of wood.

The year before his March 31, 1837, death Constable delivers a series of five lectures on the history of landscape painting at the Royal Institution of Great Britain. He begins the last of those lectures, on July 25, by illustrating that the difference between those who are serious about art and those who are amused by it is the difference between

two dishes, the one of gold, the other of wood. The golden dish is filled with diamonds, rubies, and emeralds,—and chains, rings, and brooches of gold; while the other contains shell-fish, stones, and earths. These dishes are offered to the world, who choose the first; but it is afterwards discovered that the dish is but copper gilt, the diamonds are paste, the rubies and emeralds painted glass, and the chains, rings, etc. counterfeit. In the meantime, the naturalist has taken the wooden dish, for he knows that the shell-fish are pearl oysters and he sees that among the stones are gems, and mixed with the earths are the ores of the precious metals.

It may be unnecessary to tell if this narrative is more allegory than analogue—its judgmental tone suggests the former, its simplicity the latter. Constable understands that, unlike his contemporary Turner, he is not all that popular, as an artist or as a man. Nevertheless, on his best days he believes in himself and the lasting importance of his art. And he believes in the seriousness and complexity of the art of landscape. "The art of seeing nature is a thing almost as much to be acquired as the art of reading the Egyptian hieroglyphics." This is what he means by what he has spoken of as the "science" of seeing landscapes, that seeing the natural world, in the first instance, is itself an acquisition, and, further, that seeing it as art is the realization. He does not mean art as imitation, as a kind of picture taking—he means it as equal to, even superior to, history painting and portraiture. He means it as a way to try to read nature in all its richness and complexity; or perhaps he means it as a way to rescue nature from its richness and complexity. At any rate, this is where, for some contemporary viewers, he is as difficult as reading hieroglyphics. His familiarity with what is familiar can be confused, in the public mind, as topographical imitation—a hay wain is a hay wain, a horse a horse. But looked at, literally, this way is to miss the heart of the thing he is making, the investment in imagination and of identity; the claim on who he is, not what he is.

So that by becoming his content he ever so much changes it. He *interprets*, translates, projects, he *imagines* his realism. Even early on, Turner transforms, he dismantles what he sees in order to see its light and color. The truth is Constable is a transformer, too, but in the direction of restoration and resemblances, in which the *Study of the Trunk of an Elm Tree* is restored to art as a real thing, even though, in reality, it is something else, oil paint on paper, in two dimensions.

It is exactly what the title says it is, a "study," a reading of the sign and signature, an elm tree. Curious that Constable's great modern fan, a young Lucian Freud, pays homage to his hero by doing an etching of the very same subject based on the Constable in the Victoria and Albert Museum, because he finds "it completely impossible to paint such a tree from nature." Freud's piece, then, becomes a picture of a picture and "resembles" a book illustration rather than a plein air original. Yet whether in nature or at the easel, Constable goes no less inside what he is contemplating than Turner does; he simply disguises it more in the dress of appearances. And he refuses to disappear his appearances, as Turner does.

When he dies of acute indigestion—that is, a heart attack—the *Morning Post*, the next day, declares he has died of "an affection of the heart," which may be more metaphor than medicine, but it has the ring of wonderful truth about what he has been after from the beginning—an affection, a love of place, deepened with a sense of loss. There are other, less resonant, more pedestrian reasons given for his passing, reasons of temperament, such as his propensity for anxiety (which "hurts his stomach more than arsenic" Fisher); or a lifelong struggle with that same anxiety and a resultant ulcer. Anthony Bailey (2007) suggests that he "might simply have burned out his allotted store of vital spirit," which is a noble, soldier-like way of thinking about it. It could also be argued that Constable's soul-deep melancholy plays a part, and that the emotional tenor of his best work is longing—not so much for the remembered past as for a different kind of present, a present in which his art is respected and rewarded, a present in which he can marry the woman he loves without insufferable delay, a present in which Maria is healthy and his children are healthy, a present in which his vision of landscape

art is confirmed, accepted, understood. All of it starts with an affection of the heart.

He is buried, with Maria, in the Hampstead parish churchyard (just up John Street from Wentworth Place, where Keats, in 1819, writes "Ode to a Nightingale" and where, a year later, he experiences his first serious hemorrhage). Nine months after his death, Constable's estate sells, by subscription, *The Cornfield*, to the National Gallery. Painter David Wilkie and poet William Wordsworth are among the hundred five- to ten-pound-apiece subscribers. Then, a few months later, at the residence at Charlotte Street, a weeklong public auction is held, mostly involving thousands of underpriced prints and drawings, a good many representing reproductions by Titian and Claude, and originals by Richard Wilson and Gainsborough. Twenty-nine of the cloud studies sell for a bit over three pounds total. Many of the oil paintings and sketches do better at a whole price of 1,764 pounds, including *The Hay Wain*, *The Leaping Horse*, and *The White Horse*, while whatever of his own drawings, sketches, and oils that remain unsold are returned to his surviving children and Lancelot Archer-Burton, their now legal guardian. The problem with evaluating the money worth of his work is that Constable is not well known, and then when he is well known it seems easy to copy him or parody him on cups and saucers. Insofar as the next generation is concerned, survival becomes a question and scarlet fever the dark answer. One of Constable's children outlasts it (Minna) while two do not (Emily and John Charles, at widely different times). The oldest, Charley, trains as a sailor and ships out as a captain, so that whatever estate of Constable's considerable collection remains is left in Minna's and her sister Isabel's and their brother Lionel's hands. Inevitably, as with many family fortunes, the issues of ownership and what to do with

their father's art inheritance turns into conflict, which time, mostly, takes care of. As the sole survivor, in 1888, Isabel donates "the fortune" to the nation, namely and primarily to the National Gallery.

The French love him, they love his snow, the freshness of the sparkle in his leaves, the wet touches of vibrancy that will lead French landscape painting into the modern era. Ruskin hates him, hates his "morbid" attitude toward well-tended landscapes—that is, pastorals—hates the celebration of the common life of a "low order," hates the fact that "he couldn't draw," hates especially the want of "refinement." Ruskin praises Turner's skies and completely ignores Constable's clouds, as if they are part of a daily weather report, given and forgotten. Leslie, Constable's friend and biographer, writes in his *Handbook for Young Painters* (1855) that although Turner, the traveler, is great, Constable is "the most genuine painter of English cultivated scenery, leaving untouched its mountains and lakes." This odd comparative compliment is typical, condescending, and misses the point of what Constable means to landscape art—and what the French seem to have understood: Constable sees what is there and takes it at its word, and the word is "sublime"; he makes a virtue of autobiography, since what he sees is the narrative of what he has experienced and remembered; he believes, deeply, that the common life, the country life, the pastoral landscape of early nineteenth-century England is the one life that matters, all against the fact of the Industrial Revolution; he believes, like Wordsworth, in childhood; he believes in art, art as life; and he believes that painting as an act is a moral choice.

I am soon to be a nonentity.

The thing about Turner is that he seems, in the normal sense, to have no personal life. What he has is a painting life. Whatever appears to be personal appears to be merely functionary—mistresses, children, friends. Even his love for his father seems conditioned by the terms of William Turner senior's engagement with his son's painting life. He is a model purist. He calculates, he focuses, he pursues. He has the body of a bartender, bricklayer, ship's captain, and the stamina of a bull mule, all in service of his ambition. He wants to be great, and he is great. So great that he reinvents, periodically, what his greatness amounts to. But in his very last years, say, the last five, his "greatness" powers appear—emphasis on *appear*—to be on the wane, a loss Ruskin (2005) feels is more than just physical but moral. *The Angel Standing in the Sun* (1846) may be, in Ruskin's opinion, the most dramatic example of decline yet it is not, by any means, singular. Ruskin's phrase for this final period of Turner's art is "nonsense pictures," produced in "a state of senile decrepitude." Ruskin's puritanism may be offended by the plethora of nude poses found in notebooks after the artist's death; more than likely, though, Ruskin is

bothered by all the work of this final stage, whether it is too sensual, emotional, or obscure.

The majority of the totality of paintings, watercolors, and drawings found in the falling-down Queen Anne Street house-studio in January 1852—barely a month after Turner's death—is often labeled "unfinished" (in parallel with Constable's preliminary sketches and oil studies, now preferred to many of his "finished" pictures). Since Turner is mostly secretive about the how as well as the what of what he is working on, and given the "experimental" nature of the late art, it is no sure thing to say this watercolor is finished or that oil is unfinished, added to which "critical opinion of the value of the unfinished work was not uniform" (Smiles, 2007). John Burnett, in a rather hurried opinion in his 1852 study, *Turner and His Works*, writes of the "later" paintings—finished or otherwise—that they "are too poetical, too ethereal and prismatic . . . The dreamy, visionary character they embody removes them, certainly, from the solid, earthy substance of nature . . . it is difficult to exalt landscape painting into the regions of poetry." "Insubstantial pageants" is what he calls the work of the 1840s. Philip Gilbert Hamerton, in 1879, takes the contrary view: Turner "lived in a world of dreams, and the use of the world of reality . . . seems to have been only to supply suggestions and materials for the dreams." Turner, he goes on, "is always and above all things the artist. With all his study of objects and effects, he was never a naturalist. The real motive of every one of his compositions is to realize some purely artistic conception, not to copy what he saw."

Hamerton concludes that the work of Turner's "maturity in the presence of nature is true to nothing but his own emotion." How, then, to equate emotion with light and color; it seems easier to

equate sentiment with what is in the sky, to paraphrase Constable. Perhaps that is what Hazlitt means, all those many years ago, when he says that Turner's paintings are about nothing—light is nothing, except what it touches; color is nothing, except how the eye sees it. The dream that Hamerton speaks of becomes deeper and deeper as Turner's life goes on, and that dream reaches its richest dimension of "artistic conception" or abstraction in the course of his time in Venice—Venice seems to activate a vision of what for Turner is an afterlife, a life behind, theatrically, the sunrises and sunsets. We are what we see because of how we see it, and the shapes, the forms, the outlines are secondary to or irrelevant compared with the essences of their clarifying light and color. Dreaming, therefore, has the effect of a physical presence—a manifestation of cause. This sense of a source is Turner's sublime, sans—in his most mature pictures—the grandeur of obvious nature, and this sense takes us back to one of his earliest and caring themes: architecture. Turner's dreams of light and color are ghost architectures of the sun making sunlight.

The internal life. How far, finally, is golden Venice from No. 6 Davis Place, Chelsea, just above the mudflats of the Thames, looking across at the timber yards and chemical works of Battersea. . . . Turner, at the end, becomes himself a dream, a secret life, a borrowed identity. As the would-be husband of Sophia Booth, in his mortal years he slips, of his own will, into part-time anonymity, a quiet way of life all the more revealing for its modesty. Economic modesty especially. He is a wealthy man who hates spending money. The house he and Mrs. Booth have set up may be poorly placed but as a house it is not so bad—"a three-storey, mid-terrace house, fronted by a low wooden picket fence and gate that contained a cot-

tage garden . . . A wooden lattice porch over the front door housed potted plants and a caged starling"—as described by Franny Moyle (2016) in her recent biography of Turner. The house also has "front-facing windows" with window boxes and creepers. Very domestic, very un-Turner. In effect, No. 6 is Mrs. Booth's house, with visitor. One Turner touch, however, is an added iron-rail balcony built high enough for Admiral "Puggy" Booth to have a real view of the sweet Thames winding its way through much of London, including the area of Covent Garden.

He dies there, in that house, in December, at seventy-six, a shadow of himself, having subsisted on a diet of rum and milk for several months. It is by now the Victorian Era, 1851. Even Wordsworth is dead, the year before. Two of those invested in Turner's reputation—Henry Harpur, a cousin, and Philip Hardwick, a long-time friend from Turner's boyhood—feel the need to remove his body, immediately, from such mean and morally compromised circumstances and take it to his established residence on Queen Anne Street, as if *that* is where he has passed. It turns out to be a dark comedy of body-stairs-coffin misfits before he is finally situated in the house that is itself a shadow of its former self, personified in the haggard person of Hannah Danby, niece of Sarah Danby (mother of Turner's two daughters). From Queen Anne it is an easier, if fraught, journey to Westminster Abbey. The national press is not fooled, at least not totally: *Hampshire Telegraph*—"Some ten days ago a man who had resided in a squalid lodging, in a squalid part of what at best is squalid Chelsea, was taken seriously ill. . . . His name as far as the owner of the house knew anything of this, was Booth. . . . Then it was discovered the man—who seemed to shun the world,

who spent little and lived upon less . . . was none other than the semi-deity Mr Ruskin's Turner!"

Other reports have him buying the house at 6 Davis Place, which is not only not true but very much so. According to Bailey, a short time after Turner's death, Mrs. Booth is asked about the ownership by Ruskin's and Turner's friend, the artist David Roberts. "Turner had never given her money—not a farthing—towards their common living expenses nor the cost of the cottage. She assured Roberts that the only money she had had from him in eighteen years was 'three half crowns she found in his pocket after death, black, She says with being so long in his pocket & which She keeps as a souvenir.' " Roberts fills out his impression of his visit to Mrs. Booth's home by noting that the cottage was "clean to a nicety, and the walls covered with pictures, principally Engravings from his works." He adds that in addition to the black money, she kept "numerous *scraps of his poetry*—not the fallacys of hope (*for I put the question*) but Verses in honour of herself & her personal charms . . . What simpletons the greatest become when a woman's in the case."

This assumption may or may not apply to Sophia, but it in no way fits the "case" of Hannah, Turner's homebody housekeeper and cook. In the last weeks of his longest absence from Queen Anne Street, Hannah finds his Booth name and address on a piece of mail in a coat pocket and frail as she is—she is just ten years younger and dies just two years after Turner—makes her way, with a friend to lean on, to Chelsea and Davis Place, where she is told by a near neighbor that "two very quiet respectable people of that name had lived for years next door, but that the old gentleman had been very ill and in fact was supposed to be dying." Hannah and her com-

panion are too frightened to take the matter further and she never sees Turner alive again. Hannah, of all the women in Turner's life—certainly including his mother—has been the most steadfast, long-standing, and present. She has suffered it seems forever from a disfiguring disease that has left her face and figure in as ugly a condition as the Queen Anne house itself. Both have been collapsing from nature and neglect for years. Turner, long ago, has moved on.

Perhaps there is no more impressive scene on earth than the solitary extent of the Campagna of Rome under evening light.

There is a perfection of the hedgerow and cottage, as well as of the forest and the palace; and more ideality in a great artist's selection and treatment of roadside weeds and brook-worn pebbles, than in all the struggling caricature of the meaner mind, which heaps its foreground with colossal columns, and heaves impossible mountains into the encumbered sky.

—JOHN RUSKIN
Modern Painters, 1834

Selected Bibliography

Ackroyd, Peter, and J. M. W. Turner. *J. M. W. Turner.* New York: Nan A. Talese, 2006.

Bailey, Anthony. *John Constable: A Kingdom of His Own.* London: Vintage, 2007.

———. *Standing in the Sun: A Life of J. M. W. Turner.* New York: HarperCollins, 1998.

Baker, Christopher. *J. M. W. Turner: The Vaughan Bequest.* Edinburgh: National Galleries of Scotland, 2006.

Bell, Julian, "Turner: High Ambition for Deep Truth," *New York Review of Books,* November 24, 2016.

Berger, John. *Portraits: John Berger on Artists.* London: Verso, 2015.

Bockemühl, Michael. *Turner.* Cologne: Taschen, 2007.

Brook, Carolina, and Valter Curzi, eds. *Hogarth, Reynolds, Turner: British Painting and the Rise of Modernity.* Milan: Skira, 2014.

Brown, David Blayney, Amy Concannon, and Sam Smiles, eds. *J. M. W. Turner: Painting Set Free.* Los Angeles: J. Paul Getty Museum, 2014.

Butlin, Martin, Luke Herrmann, and Evelyn Joll, eds. *The Oxford Companion to J. M. W. Turner.* Oxford: Oxford University Press, 2001.

Cafritz, Robert, Laurence Gowing, and David Rosand, eds. *Places of Delight: The Pastoral Landscape.* Washington, D.C.: Phillips Collection, 1988.

Clarkson, Jonathan. *Constable.* London: Phaidon, 2010.

Cohen, Andrea, "Cloud Study," *New Yorker,* April 25, 2016.

Cork, Richard, "A Turbulent English Beauty," *Wall Street Journal,* June 8–9, 2013.

Coyle, Jack, and Gregory Katz, "John Berger, 90: Influential British Art Critic, Novelist," *Washington Post,* January 5, 2017.

Cormack, Malcolm. *Constable.* Oxford: Phaidon, 1986.

Crepaldi, Gabriele. *Turner.* Munich: Prestel, 2011.

Evans, Mark, ed. *John Constable: The Making of a Master.* London: V&A Publishing, 2014.

Gage, John. *J. M. W. Turner: A Wonderful Range of Mind.* New Haven, Conn.: Yale University Press, 1987.

Gombrich, E. H. *The Story of Art,* 16th ed. London: Phaidoess Limited, 1995.

Halpern, Daniel, ed. (1985). *Antaeus,* No. 54.

Hefferman, James A. W. *The Re-Creation of Landscape: A Study of Wordsworth, Coleridge, Constable, and Turner.* Hanover, N.H.: University Press of New England, 1985.

Higgins, Adrian, "The Landscape Architect Who Bottled Nature," *Washington Post,* December 16, 2016.

Hokanson, Alison. *Turner's Whaling Pictures.* New York: Metropolitan Museum of Art, 2016.

Hoozee, Robert, ed. *British Vision: Observation and Imagination in British Art, 1750–1950.* Ithaca, N.Y.: Cornell University Press, 2007.

Kennicott, Philip, "Creating Artwork Is a Sketchy Process," *Washington Post,* November 6, 2016.

———. "In Looking Back, Pre-Raphaelites Moved Forward, or Did They?" *Washington Post,* February 17, 2013.

Leslie, C. R. *Memoirs of the Life of John Constable.* Ithaca, N.Y.: Cornell University Press, 1980.

Meslay, Olivier. *J. M. W. Turner: The Man Who Set Painting on Fire.* New York: Thames & Hudson, 2005.

Meyer, Laure. *Masters of English Landscape: Among Others, Gainsborough, Stubbs, Turner, Constable, Whistler, Kokoschka.* English ed. Paris: Terrail, 1995.

Morris, Edward, ed. *Constable's Clouds: Paintings and Cloud Studies by John Constable.* Edinburgh: National Galleries of Scotland, 2000.

Moyle, Franny. *Turner: The Extraordinary Life and Momentous Times of J. M. W. Turner.* New York: Penguin Press, 2016.

Parkinson, Ronald. *John Constable: The Man and His Art*. London: V&A Publishing, 1998.

Parris, Leslie. *Constable: Pictures from the Exhibition*. London: Tate Gallery, 1991.

Parris, Leslie, and Ian Fleming-Williams. *Constable*. New York: Cross River Press, 1993.

Parris, Leslie, Ian Fleming-Williams, and Conal Shields. *Constable: Paintings, Watercolours & Drawings*. London: Tate Gallery, 1976.

Rodner, William S. *J. M. W. Turner: Romantic Painter of the Industrial Revolution*. Berkeley: University of California Press, 1997.

Ruskin, John. *Modern Painters: Volume I*. Boston: Adamant Media Corporation, 1834.

Schama, Simon. *Landscape and Memory*. New York: Knopf, 1995.

Shanes, Eric. *The Life and Masterworks of J. M. W. Turner*, 4th ed. New York: Parkstone Press, 2008.

Smiles, Sam. *J. M. W. Turner*. Princeton, N.J.: Princeton University Press, 2000.

———. *J. M. W. Turner: The Making of a Modern Artist*. Manchester: Manchester University Press, 2007.

Sunderland, John. *Constable*. London: Phaidon Press, 2014.

Taylor, Basil. *Constable: Paintings, Drawings and Watercolours*. London: Phaidon, 1973.

Thornes, John E., and John Constable. *John Constable's Skies: A Fusion of Art and Science*. Edgbaston, Birmingham: University of Birmingham Press, 1999.

Vaughan, William. *John Constable*. London: Tate Publishing, 2015.

Venning, Barry. *Turner*. London: Phaidon, 2003.

Walker, John, and John Constable. *John Constable*. New York: Abrams, 1978.

Warrell, Ian, ed. *J. M. W. Turner*. London: Tate Publishing, 2007.

———. *Turner's Sketchbooks*. London: Tate Publishing, 2014.

Wheeler, Guy. *J. M. W. Turner*. New York: Alpine Fine Arts Collection, 1982.

Wilcox, Timothy. *Constable and Salisbury: The Soul of Landscape*. New York: Scala Arts Publishers, 2011.

ART CREDITS

The White Horse, 1818–19, Constable, John (1776–1837). Widener Collection, the Frick Collection.
Photo credit: NGA Images.

The Hay Wain, 1821, Constable, John (1776–1837). National Gallery, London, UK.
Photo credit: Bridgeman Images.

Cloud Study, 1821, Constable, John (1776–1837). Yale Center for British Art, Paul Mellon Collection, USA Paul Mellon Collection.
Photo credit: Bridgeman Images.

The Cornfield, 1826, Constable, John (1776–1837). National Gallery, London, UK.
Photo credit: Bridgeman Images.

Boats at Sea, 1830, Turner, JMW (1775–1851). Tate Collection.
Photo credit: © Tate, London 2018.

Landscape with a River and a Bay in the Distance, 1840–50, Turner, JMW (1775–1851). Paris, France, Flammarion.
Photo credit: Bridgeman Images.

A View of Santa Maria della Salute, 1844, Turner, JMW (1775–1851). Tate Collection.
Photo credit: © Tate, London 2018.

Rain Steam and Speed, The Great Western Railway, 1844, Turner, JMW (1775–1851). National Gallery, London, UK.
Photo credit: Bridgeman Images.

INDEX